Modern Orthodoxies

Routledge Interdisciplinary Perspectives on Literature

Modern Orthodoxies

Judaic Imaginative Journeys
of the Twentieth Century

Lisa Naomi Mulman

Routledge
Taylor & Francis Group
NEW YORK LONDON

First published 2012
by Routledge
711 Third Avenue, New York, NY 10017

Simultaneously published in the UK
by Routledge
2 Park Square, Milton Park, Abingdon, Oxon OX14 4RN

*Routledge is an imprint of the Taylor & Francis Group,
an informa business*

Library of Congress Cataloging-in-Publication Data
Mulman, Lisa Naomi, 1963–
 Modern orthodoxies : Judaic imaginative journeys of the twentieth
century / Lisa Naomi Mulman.
 p. cm. — (Routledge interdisciplinary perspectives on literature ; 10)
 Includes bibliographical references and index.
 1. Literature, Modern—Jewish authors—History and criticism.
 2. Jews—Intellectual life—20th century. 3. Judaism and literature.
 4. Modernism (Literature) I. Title.
 PN842.M85 2012
 809'.88924—dc23
 2011052499

ISBN: 978-0-415-97212-3 (hbk)
ISBN: 978-0-203-08464-9 (ebk)

Typeset in Sabon by IBT Global.

Printed and bound in the United States of America on sustainably sourced
paper by IBT Global.

For Merritt, Miles and Jessa
and for my Grandfather, Jacob Marmor

Contents

Figures

Acknowledgements

These pages represent, perhaps more than anything else, the convergence of past influence and present preoccupation. They exist, therefore, as the result of many years of inspiring collaboration with scholars, artists, friends, and teachers, some of whom I will doubtless fail to mention here but who nevertheless had a part in their making. That said, I nonetheless attempt to single out several whose support is most deeply felt and appreciated.

My preoccupation with the then under-examined nexus of secular art, literature, and religion began when I was a graduate student at Duke University and was nurtured by the remarkable Tom Ferraro, a source of endless inspiration whose astounding example of how to write, think, and teach has shaped much of what I do. Michael Moses, Jennifer Thorn, Frank Lentricchia, and Sarah Beckwith graciously read and commented on this manuscript in its earliest stages, as did my friends Farley Kern, Sarah Townsend, and Christina Tourino. For spiritual guidance and friendship I continue to rely on Cary and Marsha Friedman, whose influence on this book has been profound.

Colleagues at Salem State University, most especially Nancy Schultz, Arthur Riss, Jeffrey Theis, Jan Lindholm, Theresa DeFrancis, Keja Valens, Michael Jaros, and Lis Horowitz are invaluable to me; I cannot imagine a professional life without their compassion and support. Ann Taylor was kind enough to introduce me to Horst Rosenthal, opening up a new door in my professional life. Cathy Fahey is an extraordinary proofreader who tolerated and meticulously transformed several quite messy drafts. I am grateful to them both, and also to my most recent contacts at Routledge: Elizabeth Levine, Catherine Tung, and Ryan Kenney.

The graduate students at Salem State University are in a class by themselves. They are extraordinarily dedicated, enthusiastic, and insightful, despite their many personal and professional commitments. It is a real blessing to work with them. I would particularly single out my research assistant, Justin D'Alessandro, who helped me with the final stages of putting this manuscript together.

Stephenie Young is a rare and devoted friend and collaborator. She has helped me to complete this project while somehow retaining my sense of humor and intellectual engagement, for which I am very much in her debt.

My mother's energy and my father's patience were both required writing this, and I think they know how profoundly grateful I am to them. My two beautiful children, Miles and Jessa, have put up with a distracted mother for what I am certain they have experienced as forever, and have done so with nothing but love and understanding. My sister, Sheryl is my best friend and consistent, unconditional supporter, and well deserves my deepest thanks. Although they did not live to see this book to fruition, my mother-in-law, Suzanne Mulman, and my cousin Phyllis Rubenstein inspired my vision what it means to be a true woman of valor.

Last, and most especially I must thank my husband Merritt, my true partner in every way. His constant love is more precious than can be expressed in these or any other words.

Introduction

Liberating Captivity:
Sacred Translations Of Secular Narratives

This book examines the significant, albeit subcutaneous relationships between Judaic religious tradition and seemingly secular works of imagination in the 20th century. Looking closely at formally disparate texts from several authors of Jewish origin, an artistic trajectory emerges that begins with the formal experimentation of the High Modernist period and ends with the fragmented and discontinuous graphic narratives of the Holocaust. What becomes clear from the juxtaposition of these readings is an "exile" of Jewish imagination from the biblical tradition of pure text into the seemingly assimilative moment of abstract pictorial expression. As many Jewish artists attempt this exile, however, they are paradoxically and repeatedly drawn back into the tropes and methodologies of their own seemingly lost faith. Indeed, and paradoxically, the formal discontinuities inherent in these works have clear and identifiable roots in rabbinical modes of interpretation and traditional Jewish cultural modalities.

Within the framework of my chosen texts, a return to particularly Jewish forms of spiritual identity can thus be traced. This return is suggestive of an increasing—and increasingly urgent—mainstream consideration of the role that traditional Judaism plays in the theorization and practice of Modernist and Post-Modernist literature. Indeed, this return to a more religiously informed construction of Jewish imaginative identity has been elaborated in several significant scholarly works, including—but hardly limited to—the excellent scriptural style exegesis of Geoffrey Hartman, the "return" to Yiddish documented by Hana Wirth-Nesher, and the religious, historically based naming of the 20th century as "the Jewish Century" in the sweeping work of Yuri Slezkine.[1] However, in a special issue of *Modern Fiction Studies*, entitled "Modernism's Jews/Jewish Modernisms" editor Maren Linnett points to the ways in which scholars and teachers of Modernist literature continue to evidence a reluctance to discuss Jewish particularity for fear of "opening up a Pandora's box of contradictory responses in their students of their academic readers, or of themselves reproducing anti-Semitic discourses."[2] Indeed, the fear of reversion to stereotype, as well as the slippery intersection of race, religion, and culture in the theorization of Jewish identity make readings of texts through the lens of Jewishness often a perpetual

challenge. Linnett correctly identifies a deficit in fulsome examinations of Jewishness in Modernist texts:

> While this effort to maintain a non-racial view of Jews and Jewishness is commendable, it has inadvertently forestalled the thorough and wide-ranging analysis of the ways Jewishness figured in modernist literature that one would expect by now to find within the body of modernist scholarship.[3]

To remedy this, Linett calls for more specific, non-canonical readings of Jewish texts that are more deeply informed by the depth and complexity of both Jewish tradition and its multiple manifestations in secular culture. This book is an attempt to answer that call.

Late 20th century criticism has emphasized the blurred and constantly shifting boundaries between political exigencies and cultural identity, but has too often elided the influence of religious mystery in the theorization of aesthetic production. The categories of political imperative and cultural identity, ever encroaching on one another, are indeed constitutive of the complex machinery that undergirds Jewish continuity from the earliest translation of the Holy Scriptures from Hebrew into Greek, to a post-structuralist moment that calls the act of translation itself into question. Although there have been important theoretical interventions along the way, the issue of Jewish imagination has too often been incorporated into larger discourses of difference (such as race and ethnicity) or assigned only to those with a "special interest" in Jewish studies. Such appropriations necessarily elide many of the religiously particular ways in which Jewishness has influenced Modern and Post-Modern writing. More importantly, the multiform changes *within* Jewish cultural production during the 20th century are notable, and suggest a pivotal re-contextualization of Jewish tradition within and across the arts.

Modern Orthodoxies looks beyond underparticularized examinations of Judaism to better attend to the paradoxical claims of the Modernist movement itself. This rejection necessitates a rigorous attention to key works of the Modernist period; works that have too often been understood as complacent with the trope of Jewish alterity to the exclusion of authentic religious engagement. The fragmentation and marginality that characterize canonical Modernist writing mobilizes the Jewish concept of wandering, yet does so in the name and service of a literary/philosophic tradition that ascribes such homelessness to an agnostic (and hence universal) cultural despair. Restoring a Jewish theology and sensibility to these most enigmatic forms of Modernist experimentation can only, I believe, produce fuller and more responsible readings of the emergent texts.

In her study of Hebrew writers working during the Modernist period, Chana Kronfeld addresses some of these same ironies of the Modernist canon:

Modernism is famous for its affinity for the marginal, the exile, the "other." Yet the representative examples of this marginality typically are those writers who have become the most canonical high modernists. Their "narrative of unsettlement, homelessness, solitude and impoverished independence (Williams, 1989: 34) may indeed have been cast in minor, discordant tones, but these tones were composed in the major key of the most commonly read European languages: English, French, German.[4]

While Kronfeld's interest here is in the exile of minor native languages from the very Modernist discourse that claims marginality as a dominant trope, her argument is equally applicable to the expurgation of authentic religious voice from this same discourse. This expurgation is crucial with regard to the vocalization of a Jewish religious sensibility, because the Jewish voice in its most authentic incarnation embodies the very Modernist principles that the critical academy by and large ascribes to a wholesale rejection of religion. In developing a methodology for reading Judaism back into those texts that are considered most irreligious, I confirm not only the imperatives of my own tradition, but also the excellent instincts of critics who wish to place religion back in the center of literary discourse.[5]

Responding to this larger issue, Dennis Taylor recognizes "a need in our time for religious interpretations that are substantial enough to enter into a productive and competitive relation with the reigning critical discourses."[6] Although Taylor does not address his complaint to a particular denominational group, nowhere is this problem more evident than in the area of Jewish studies, wherein culture, race, and religious belief co-habitate in extremes of intimacy and aggression. With some notable exceptions, critics working to reconcile the relationship between a distant, and often perceived as archaic, religious tradition and the demands of the enlightened secular academy often adopt a methodological recourse to culture rather than engaging the more complicated nexus of religious tradition and spiritual imperative that is inextricable from Jewish "culture."

Exemplary of this tendency is the work of Walter Benn Michaels, whose influence on my own scholarship is immediately apparent upon perusal of the coming pages. Michaels lays no claim to the sponsorship of any type of Jewish studies; his work is, on the contrary, designed to address the instability of exactly such discourses of identity. For example, in *Our America*, Michaels places the intermarriage of Jewish and "white" people under the rubric of miscegenation, quite literally and definitively naming Judaism as a race and evacuating the all-important ways in which "Jewishness" cannot be productively separated from Jewish practice, Jewish observance, and Jewish tradition: Judaism. In actuality, there are significant distinctions between the anxieties engendered by religious difference, by racial difference, and by Jewish difference. Placing all of these eggs in the same theoretical basket, Michaels (perhaps quite intentionally) elides religious valence and

particularity, and in so doing, produces a critical discourse wherein race is not only all-determinative, but also homogeneous. Authenticity is marked, positively or negatively, by whiteness, and in Michaels' assessment, Modernist texts are attempts to reconcile the "problem" of whiteness.

But there are other ways in which authenticity is constructed; forms that speak to the contrast between whiteness and darkness, but that also speak to the difference inherent in an Eastern-European "other" with unique (and quite genuine) rituals and beliefs. Constructing authenticity racially (as opposed to spiritually, for example) dangerously subverts and ultimately deletes the potentially quite affirmative work of naming some of the actual qualities that comprise these very genuine differences. I am especially adamant about this problem because it has, as one tragic consequence, the reinforcement of a Jewish self-identification that focuses on persecution, anti-Semitism, and victimization, rather than a powerfully enabling history of belief.

Jonathan Freedman is similarly quick to distance his argument from any type of stabilizing theological discourse. In his analysis of the influence of Jewish stereotypes on the development of high and middlebrow culture in *The Temple of Culture*, he examines the position of Jewish intellectuals in the 1980's academy, noting:

> It is precisely at moments like this one, in other words, that the task of historicizing the matter of Jewish identity is most urgently needed. Doing so helps us recognize two somewhat contradictory things: that there is no such thing as a pure, unmediated Jewish identity because this identity has been shaped by non-Jewish discourses on cultural identity that worked to construct their categories, in no small measure, by representing the figure of the Jew; but, complicating the matter, that that identity has been shaped, in great ways and small, by the imaginative and creative efforts of assimilating (and nonassimilating) Jews, who have helped make the very notion and the very practices that are deployed to construct Jews.[7]

Invoking the spiraling litany of constructions that have come to serve as the metaphor for contemporary Jewish identity, Freedman fails to incorporate the complex set of ritually and textually-derived practices that constitute—in their employment as well as in their abandonment—a significant factor in Jewish identity and its residual impact on non-Jewish culture as well. It is indeed difficult to imagine the undoubtedly urgent task of historicizing Jewish identity without taking into full account the textual tradition that is understood by many Jews as the historical narrative of Jewish continuity. Focusing nearly completely on the ruptures experienced by assimilating Jews attempting to reconcile secular academic and "culturally" Jewish identities, Freedman's strategy hedges the distinction between assimilating and parenthetically "nonassimilating" Jews. In so doing, he replicates the very

problem that he attempts to name, replacing the reality of actual Jews and Jewish tradition with their literary and academic effect. The very constructions that Freedman claims compose "the fault lines lying beneath both the ideal of culture grounded on the high Arnoldian model and that of literary study built on the New Critical or philological plan,"[8] are thus named but never clearly explicated. These fault lines are located at the precise intersection of an insular, "hidden" Jewish tradition of ritual practice and the textual tradition that becomes, in its most radically assimilative form, literary experimentation. Freedman's insertion of the complications of the "continuing argument" that is Jewishness stall exactly at that point where Jewishness is understood as little **more** than a continuing argument.

Freedman's exposure of these fault lines enables my work by quite brilliantly dissecting and ultimately dissolving a complacent dichotomy between Jewish and secular academic discourse. Attending to the inextricable relationship between Jewish cultural aspiration and gentile culture-making, he clears the way for a more intensive interrogation of what it is that these Jewish and gentile culture-makers are—often unselfconsciously—responding to. *Modern Orthodoxies* acknowledges the dynamic cultural interaction named by Freedman, yet seeks to address the specific religious formulations Freedman consistently and unapologetically avoids.

I understand Freedman's caution, and recognize it as the justifiably tentative response to a tradition at whose center is an abstract God and an endlessly interpreted book. He shares the concerns of nearly all Jews, the goal of whose ongoing argument is a way of productively defining themselves both within and outside of the mainstream cultural categories that threaten at every moment to subsume them. Given this, it is no surprise that nearly all theorizations of Jewish identity have drawn much of their power from the rhetoric of otherness: in the absence of any clear sense of what Jews are, a rather prolific discourse of naming what Jews are **not** emerges.

I have no interest in negating this exercise. It is, in many ways, as valuable an endeavor as the one I undertake here. Yet, as this volume will attest, there are a plenitude of intersections between a quite specific Jewish textual tradition and the presumably quite secular modern aesthetic imagination. The particularities of text and ritual that find their way into the works considered here have a force that defies the very intellectual abstraction that is their conventional legacy. Indeed, many current studies that I have mentioned that de-emphasize religion themselves unsuspectingly bear witness to the very religious impulses they preemptively dismiss. Following the precedent of my own ancestors, I have been drawn continually back to the primary text, and have found there not only pieces of narrative that refuse to relinquish their imaginative hold, but also versions of community-making and gender relations that deftly traverse "cultural" and chronological boundaries.

Locating the Modernist period within the larger view of Jewish history that I share with Boyarin, Benjamin, and the rabbis of the Talmud, it is possible to understand the references to tradition during this time as the

visceral enactment of a continuous sacred imperative. This seemingly disconnected moment, situated within the larger tradition, hearkens back to the liturgical promise that God will gather in what has been scattered, not in one gesture, but as part of a perpetual negotiation between the sacred and the secular. These readings are thus structured as much by the presence of the dominant culture as by what is apparently absent: the Jewish God.

I thus attempt here to reconvene the pieces of Jewish identity as they appear in works of art and literature from what Slezkine has dubbed "The Jewish Century." I readily confess that my enthusiasm for this work seeks to quell a desire for Jewish specificity even as it gratifies my yearning to situate artistic endeavor within a larger discourse of religious belief and ethical fortitude. As a result, I have chosen works that seem overly determined to assimilate into the canon, often at the expense of intimate investments that they are unwilling or unable to explicitly name. That said, these works ultimately cluster not as parts of a conventional literary canon, but rather as examples of a remarkable moment in Jewish cultural history wherein textual language, always the crucial center of the Jewish imagination, gives way to or is forced to accommodate the visual. This is a moment of simultaneous return and reinvention, and paves the way for the even more radical historical recovery inherent in the works of contemporary Jewish writers and artists such as Jonathan Safran Foer, Nathan Englander, Nicole Krauss, and Art Spiegelman.

I begin this volume with a work that merges the immigrant experience with Modernist experimentation: *Call it Sleep*. A work of idiosyncratic brilliance, Henry Roth's text, while deeply influenced by Joyce, has remained outside of the mainstream canon despite its persistent reputation as a seminal text of Jewish American literature. Combining thoroughly Jewish sensibility with an aggressively High Modernist prose style, *Call it Sleep* engages the issue of language in flux: the crisis that ensues when Jewish religious tradition is simultaneously translated into ethnic street talk and intellectual literary discourse. *Call It Sleep* initiates the examination of Jewish forms of translation that will become a focal point of my analysis.

Interrogating the movement of Jewish writing from the innovations of High Modernism into the idiosyncratic style of the *avant-garde*, Nathanael West's *Day of the Locust* is the core text of Chapter 2. The web of parallel connections between West's novel and Canetti's *Auto-da-fe* offers a provocative entry into the construction of Jewish masculinity within the religious tradition and across continental boundaries. Looking at the theorization of trans-continental Modernism through the lens of West and Canetti led me to the work of Kalman Bland. Bland's refutation of Judaism as an aniconic religion was particularly provocative in light of the obsessive engagement with visuality apparent in Canetti, West, and Roth.

This movement into the realm of the visual provided the impetus for Chapter 3's focus on Modigliani. It seems imperative, in looking at Jewish narratives of the 20th century, to discuss the kind of Jewish narrative

that can only be produced wordlessly. Indeed, Modigliani's silence seems to foreshadow the radical annihilation of the Jewish voice that is the preoccupation of artist and writer Horst Rosenthal. His brief graphic text, *Mickey Mouse in the Gurs Concentration Camp*, is a template not only for Art Spiegelman's much later—and now canonical—*Maus* series, but also for a new, post-structuralist sensibility that necessarily widens the definitions of text, language, and translation to include visual representation. The graphic novel is, in many ways, the realization of Roth's vision, and thus provides a fitting conclusion to this study.

Modern Orthodoxies begins with "A Pious Translation: The Multiplicity of *Call it Sleep* and Henry Roth's Single Sin," revisiting the metaphor of imaginative Jewish translation as it appears in Roth's attempts to "translate" the experience of a Jewish immigrant boy into the language and style of High Modernist formal invention. Roth's narrative, despite his own disavowal of Judaism, looks oddly similar, in structure and interpretive hermeneutic, to the Talmud of his rabbinical ancestors. Indeed, as the chapter plays itself out, the very "universalizing" tendencies of Jewish writing in the 20th century that most reflect an assimilation of Modern literary praxis are revealed to parallel those of the Talmudic discourse from which the Jewish writer can never fully remove himself. Understood in this way, the radically assimilative move for the Jewish writer of this period is not the embrace of the fragmented narrative voice, but rather the rejection of that voice. This uncanny reversal of literary politics hides both a blessing (a formal method that, for the Jew, has the visceral resonance of the sacred), and an obligation (the imperative to tease an authentic moral identity from the formal play of the text).

In Chapter 2, "Converting Books into Bodies: Unorthodox Women and the Vanity of Art," I turn my focus to two surrealist works of the 1930s: Nathanael West's *Day of the Locust* and *Auto-da-fe* by Elias Canetti. The astonishing synchronicity of these two texts exemplifies the mysterious ways in which Jewish preoccupations and narrative methodologies function across cultural and geographic lines. Despite extreme differences in biographical and political circumstance, these writers create, almost simultaneously, narratives that position religion as both redemptive and aggressively apocalyptic. In each case, male intellectual production, a core Jewish value, is threatened by the development of a progressive social network in which such production is replaced by bourgeois domesticity. As a result of this, in each case the nexus of narrative disturbance centers on a tradition that appears to equate ideas and bodies apologetically and that thus struggles to maintain itself through the seemingly impossible normalization of Jewish gender relations.

These novels open themselves up to a remarkable re-reading of the precarious state of Jewish masculinity in the 20th century, particularly the way in which the dissolution of conventional (and religiously sacred) domestic relations simultaneously threatens and empowers male creativity. The

residual effect of traditional, *halackacally* based, family and community structures are underscored, in my reading, by the violence that is ushered in by their dissolution. The progressive devaluation of intellectual and artistic labor finds its most compelling metaphor in the self-immolation that marks the final moments of *Auto-da-fe*. Reminiscent of several sites of Jewish martyrdom where men were burnt while wrapped in the scrolls of the Torah, this scene bears witness to the persistent, inextricable relationship between the rituals of secular and Jewish scholarship, as well as to the social and political implications of both.

The third chapter turns from the world of Jewish letters to the seemingly quite disparate world of Jewish visual art. Looking at the life and work of Italian-Jewish artist Amedeo Modigliani, the chapter focuses on a method of interpretive vision that is the inspiration for Modigliani's unique representations as well as the byproduct of a deep sentimental attachment to the most radically humanistic elements of Jewish faith. Distancing himself from both cultural stereotype and pervasive, if misunderstood, religious prohibition, Modigliani paints Jewish souls. In this sanctification of the material world, he renegotiates the terms of Jewish artistic production and affirms the Jewish identity that is written on his own body.

Modigliani's work is suggestive of the powerful pull of human recognition that enables the Jewish artist to traverse the boundaries of religious and ethnic identity in order to see, and, in seeing, transform the vision of others. This is borne out most powerfully by a series of paintings of Modigliani's Roman-Catholic lover, Jeanne Hebuterne. In each successive rendering of Jeanne, Modigliani invokes the conventional and deeply Jewish movement between abstraction and specificity. The more abstract that Modigliani's paintings of Jeanne become, the more accurate the psychological portrayal. To further complicate this dynamic, the paintings reflect and replicate the ambivalent intertwining of Modigliani's life with that of his lover, a connection heavily weighted by his unwillingness to relinquish either his Jewish heritage or his unorthodox relations with her. The eventual convergence of identity evident in the final paintings evacuates facile, segregationist categorizations while simultaneously affirming the influence of Jewish tradition.

In reading these paintings, the book returns to the confrontation between Jewish religious identity and secular artistic culture, yet inverts the balance of power implicit in the role of the writing as author. In authoring a multiplicity of representations of Jeanne, Modigliani takes possession of his own religious tradition and places it, like a stunning veil, over the face of his beloved. This is in many ways the paradigmatic act of *return*. Returning to the secular realm of aesthetic production the burdens and the possibilities of his faith, Modigliani's work reflects the integrity not only of Jewish culture, but also of Jewish religious belief.

Finally, in Chapter 4, the parodic and painful manuscript of Horst Rosenthal, *Mickey Mouse in the Gurs Internment Camp* is examined.

This brief pamphlet, composed while Rosenthal was imprisoned at the Gurs camp prior to being murdered at Auschwitz, encapsulates many of the most significant issues emerging from this pivotal historical moment. Bitingly sardonic and self-referential, *Mickey in Gurs* evidences the crisis of subjectivity that will become the key issue for Holocaust testimony and Post-Modernist expression. Looking at this text in relation to its much later antecedent, *Maus*, a fascinating and paradoxical relation can be discerned between the representation of Rosenthal's "Mickey Mouse" subjectivity and the masking of identity that drives Spiegelman's text. In both cases, the connection between historical stereotypes of the Jew as mouse/rat, and the abstract and incomprehensible nature of Jewish speech and language are central. In coming back, in this final chapter, to issues of the "translation" of Jewish speech, and the radically altered understanding of Jewish subjectivity post WWII, a new version of Jewish imaginative continuity emerges from the ruins of history.

1 A Pious Translation
The Multiplicity of *Call It Sleep* and Henry Roth's Single Sin

It happened that King Ptolemy assembled seventy-two elders and placed them in seventy-two rooms, without telling them why he had brought them together. He went into each of them in turn and said to them: "Translate for me the Torah of Moses your teacher." God then prompted each of them and they all conceived the same idea and they wrote out the Torah. But they altered thirteen passages in it.[1]

This astonishing and paradoxical moment foreshadows Judaic cultural production, as it will be examined in this book. Here a (mis)translation is used as a truth-text: the unwavering veracity of God's word is underscored by the fact that seventy-two independent scribes render the same monolithic text—the Torah—right down to a series of thirteen **identical** alterations. These alterations are generated by the awareness of the Greek "audience," who, by virtue of the fact that they are not Jewish, misunderstand the text in ways that could be politically lethal. Already persecuted for their relationship to this text, the Jews have no desire to provoke, yet are religiously bound to linguistic accuracy. By "inspiring" the repeated alterations, God comes to the rescue, and writing itself becomes the survival strategy. This scene has compelling metaphoric implications for future understandings of the relationship between religion, writing, and political imperative. Identifying this, Naomi Siedman comments: "Equivalence, right from the beginning of Bible translation, is less a matter of linguistic technique than a ruse designed to deflect attention from political and ethnic difference."[2]

Understood as a "ruse," the miracle of textual "accuracy" (including collective inaccuracy) is overshadowed by its pragmatic political and social effect. The production of a collectively "perfect" translation proves the veracity of the spiritual Word; the communal will to omit demonstrates nothing less than the urgent intrusion of the material world. What would thus seem the verification of Judaic particularity (a Chosen people with mystical access to a very specific text) is converted, in Seidman's and other interpretations, into an act of political resistance that is arguably the insertion of the sacred into the secular, and thus the site of an important kind of holiness.

I want to begin by rejecting the dichotomy, suggested by Seidman and others, between the linguistic techniques employed in "translation" and the social and political imperatives that threaten to overshadow them.

Without losing sight of the precise power exerted by these imperatives in this and other sites of Judaic writing, one can nevertheless see the effort to produce an "authentic" translation as a sacred exercise, and certainly not only when one is translating a sacred text. Among other things, the above Talmudic example confounds what limited boundaries exist between conventional understandings of translation, and the mysterious imaginative act of individual authorship. Traditional Judaism holds that God himself "authored" the Torah and Moses "received" it, "giving" it in turn to the twelve tribes gathered at Sinai, ushering in a reciprocal process of transmission that occurs to this day. Whether Moses and the sages that followed him "translated" God's word or reported it literally is a source of deep debate in the world of Judaic theology, and a form of this debate is replicated in contemporary theoretical conversations focused on the concept of the author and the role of the translator and/or interpreter. In the Talmudic example, the responsive nature of the process is emphasized: the elders respond to the Greek King's request, God responds to the elders, and the text itself responds to the need for discretion and a degree of secrecy.[3] And while God gives something of the *imprimatur* of holiness to the process of translation by rendering it miraculously exact and equivalent, he despairs that the text needs to be produced. Indeed, after the Torah is translated by the seventy-two sages into Greek, the entire earth is plunged into darkness for three days. As always, transmission partakes of the ambivalence of the *pharmakon*; it is both blessing and the curse.

The writer shares this ambivalence with regard to textual production. If we understand the sages who translated the Torah not only as the "transmitters" of the sacred text, but also as the "authors" of the secular one, a constellation of issues becomes immediately apparent. One need look no farther into the Modernist critical canon than Eliot's notion of "tradition" to see that a similar trajectory of concerns regarding artistic originality are at the center of his conceptualization of authorship.[4] I would look a bit farther however, to the work of Harold Bloom, for whom the textual toppling of the father is the primal source of aesthetic inspiration.[5] With this in mind, it is difficult to envision a weightier task than that which the seventy-two sages were meant to do. This is not, however, the tortured work of a single writer. In an important way, the Torah example frees the text from the psychoanalytic context, and the contingencies of individual neurosis are eclipsed by collective history and communal jeopardy. The son expanding upon the work of the father now becomes the work of a nation for whom the only way to protect the familial legacy is to corrupt it not once but *twice*: first, into writing, and then into the foreign dialect of the dominant society. A fiercely dynamic relationship with the father is thus both solidified and severed by the production of a text whose form is quite precisely designed to assimilate difference. In truth the Greek Torah, a volume intended for placement in the library of King Ptolemy along with other literary "classics" is both creation **and** response, both secular and sacred.

Unlike the Torah given to Moses at Sinai, the Greek Torah is dialogic, and represents the collaboration of man and God. In this context of Jewish tradition, this is a moment of no small significance.

In bringing forth the translated, "politically correct" Torah, the elders not only dodge (for the moment at least) overt markers of difference, they also reveal a stunning accomplishment. The translated text not only conveys the spirit of God's word; it also uses very specific literary and linguistic techniques to flaunt its political savvy and aesthetic credentials. The act of translation/authorship both establishes and interrogates the authority and efficacy of religious faith. The word whispered by God to the seventy-two sages subsumes individual subjectivity in order to demonstrate the authenticity of faith, all the while acknowledging the very real material difficulties of Jewish life under Greek domination. This is a form of authorship that seems worthy of greater exploration.

Later writing by Jewish authors seems implicitly informed by this example. Often read as responding to a particular historical moment, much Jewish writing shares with the example of the Torah translation a commitment to negotiating secular culture, albeit without an explicit commitment to the enabling communal forms of faith. In the absence—indeed impossibility—of a definitive vocabulary describing the multiform Judaic spiritual tradition, critical attempts to understand Jewish writing *in Judaic terms* tend to seek recourse to more secular discourses, including a discourse of "Jewish identity" that is nearly always figured as ethnic and/or racial, rather than spiritual or religious. The categories of race and ethnicity, while implicated in the Judaic imagination in essential ways, nevertheless jettison the elements of religiosity that are apparent in even the most "secular" Jewish writers. Furthermore, the textual strategies employed by several prominent Modern and Post-Modern writers seem to harken back, in strange and fascinating ways, to the synthesis of Word and world that is represented by Torah translation. While Benjamin, Derrida, Levinas, Hartman, and others have extensively theorized this issue; there remains a scarcity of close textual readings that take it into serious account. Further, utilizing the tradition of Torah translation as a metaphor/methodology for literary authorship opens up the possibility for a more synthetic understanding of texts that clearly have their origins in precisely these marginal spaces between the sacred and the secular.

Complicating the "miracle" of Torah translation—and all reading and writing—are the religious and intellectual ambiguities of Jewish life. Indeed Seidman expands her analysis to examine some of them:

> "according to scholarly consensus, the Septuagint wasn't written for Ptolmy at all, but rather for the Jews of the second century B.C.E. Alexandria who were unable, for the most part, to read the Bible in the original Hebrew. That the official accounts blame the translation on Ptolmy's curiosity or paranoia is measure of how hard it was for Jews to admit their Hebrew illiteracy . . .

> . . . whatever shame there may be in reading or living in Yiddish translation (or building a "shetl" in a New England orchard), whatever sense there is for some of us Yiddishists-without-Yiddish that American Jewish life is without a belated or pale copy of some "authentic" original, is worth resisting. After all, Yiddish itself lived long centuries under the stigma of being the language of translation; Yiddish was the handmaiden that served "the Lady," Hebrew, by translating her sacred texts so women and "simple Jews" could read them. If we appreciate women, and simple folk, then accepting translation—can't be far behind.[6]

Surely, pious women and "simple Jews" need to find a language that is spiritually meaningful. Appreciating them, Seidman gestures toward and accommodation of the rhetoric of authenticity that has troubled both religious and literary debate for countless decade.[7] This is a noble goal that is not easily accomplished. The idea of translation of the sacred text implies more than a method of either instating or erasing difference. The assumption is that the translator has access to God's will, as expressed in the "hidden" meanings of the original Hebrew, in which is embedded a wealth of meaning presumably unavailable to either King Ptolmy or his more plebian subjects. A tension is therefore produced as the position of the translator/author becomes more "sacred" and the distance grows between the People of the Book and the Book itself. The only available way to reconcile this discourse of linguistic authenticity is to yield to the mystification of the text that mandates privileged access for a select few. Or, if God did indeed reveal himself to the sages, it was perhaps for the reason Seidman suggests: to make the Torah available to "simple" (or assimilated) Jews who could not read Hebrew.

Clearly, a text presumed to be "written by God" simultaneously confirms **and** challenges every contemporary notion of what a text *is,* since such a text is not the representation of the thing, but the thing itself. In the divinely written text there is no language and hence no absence (in the Derridean sense), nor is interpretation possible. But what to make of a text that is written by God but "translated" by authors into language in order to create a user-friendly secular narrative? What is most important about this (clearly rhetorical) question is that what is understood to be "religious truth" as rendered in the Torah, is not only subject to political and social construction, but that this very same religious and social pressure is itself part and parcel of religious truth.[8] Further, the history and legacy of Torah translation, here exemplified, is one in which linguistic ability, spiritual access, and political context all play a powerful and persistent role. Interventions and concessions to secular culture are not a movement away from authenticity (religiously figured as God), but are indicators of the intimate correspondence between material authorship and spiritual presence. Even if not understood as a religious miracle, the simultaneous production of seventy-two "authentic" translations seems an act of Divine Mercy as well

as a literary prophecy. Indeed, the salvation of the Jews, in this case as in many others, comes in the form of a text, with all of the mystery and difficulty that textuality implies.

Many centuries after the Greek translation of the Torah, we find an American-Jewish writer struggling to make narrative that mediates these same difficulties, translating his immigrant experience into the language of High Modernism with the obstinacy of Old Testament prophecy. This is a project that seems at odds with itself in many ways. Indeed, when we talk about the limitations of the text, particularly in the Modernist period, we are not talking about mimetic representation, but the production of something that looks more like Divine Truth than secular fiction. Mallarme diagnoses this early on[9]:

> Languages are imperfect because multiple; the supreme language is missing. Inasmuch as thought consists of writing without pen and paper, without whispering even, without the sound of the immortal Word, the diversity of languages on earth means that no one can utter words which would bear the miraculous stamp of Truth Herself Incarnate. This is clearly nature's law—I stumble on it with a smile of resignation—to the effect that we have no sufficient reason for equating ourselves with God. But then, esthetically, I am disappointed when I consider how impossible it is for language to express things by means of certain keys, which reproduce their brilliance and aura—keys which do exist as part of the instrument of the human voice, or among languages, or sometimes, even one language.[10]

Mallarme's theory of poetry implies that Divine Truth is univocal. This represents a quite particular way of looking at the concepts of both Truth and Voice, and one that runs counter to rabbinic hermeneutics. In the Judaic tradition, the Divine Word is embedded within the text and is endlessly interpretable. Mallarme invokes the Greek or Classical mode of symbolic unification as the ultimate (and humanly impossible) revelation of Divinity. Since the written text, particularly the Modernist text, resists these unities, it is seemingly incompatible with a religious sensibility. Mallarme's Divine Truth is silent, univocal, and, most importantly, firmly located *outside* the text. His recognition of the limitations of human understanding is identified with a deficiency of language. These same limitations are, to a writer working within the Judaic tradition, failures of *interpretation* or *translation*. Thus, it is possible to understand the multi-vocal narrative of the Modernist period as an attempt to recover the Divine, at least from a Judaic perspective. For the Jewish writer, the religious move is not to write himself out of, but more deeply into, the linguistic turns of the text. To do so is to consummate a vexed yet ultimately complimentary relationship between the High Modernism of the Harvard trans-continental elite and the bearded sages of the *Midrash*. Making a radical break with the formal continuities of classical literature,

my assertion is that Modernism at its highest does not reject religion, but rather embraces its scriptural antecedents.

If this is indeed the case, it would seem that a writer coming out of the Judaic tradition would in many ways exemplify the fragmented consciousness and reverence for the text that are the hallmarks of Modernist writing. James Joyce knew this, suggesting through his portrayal of Shem the Penman in *Finnegans Wake* that "the position of the Jew was analogous to that of the 20th century writer, the fragmented voice (re)defining itself through the word."[11] Jacques Derrida knows it as well, writing that in the Modern and Post-Modern era, "the situation of the Jew becomes exemplary of the situation of the poet, the man of speech and writing."[12] Ironically, coming from the Judaic tradition and writing into this fragmented consciousness is not only writing what one knows—marginality—but also ostensibly hastening the erasure of his own marginal position. He aspires to join what is already becoming a canonized literary movement (Modernism) articulated in the language of, and embraced by, the very same white Anglo-Saxon literary elite by whose criteria of "otherness" he defines himself as "Other."[13] Desiring to "universalize" their experience is, for early 20th century American-Jewish writers such as Henry Roth, the ultimate synthesis of religious (and I mean religious, not racial) identity, and politics. It is also the paradox of Modernism proper. The "universalizing" tendencies of literary Jewish writing in the 20th century that most reflect an assimilation of secular literary practice are also those that look the most like the Talmudic discourse from which many of the most significant Jewish writers can never fully remove themselves. Understood this way, then, the radically assimilative move for the Jewish writer of the Modern period is not the embrace of Joyce's fragmented narrative consciousness, but the rejection of that consciousness in favor of the linear and univocal. This uncanny reversal of literary politics hides both a blessing (a formal method that, for the Jewish writer, has the visceral resonance of the Sacred) and an obligation (the imperative, by virtue of its very sanctity, to tease an authentic moral position from the formal play of the text).

For proof that this obligation was very real for Henry Roth one only need look at this first (and for many years, only) novel, *Call it Sleep*. Desperately seeking ever-higher levels of literary and academic acceptance, Roth works within many of the same hierarchies, and straddles the same boundaries, as his Talmudic forbearers, without the advantages of Divine Intervention. Not wishing to think himself either a religious Jew or a religious writer, in *Call it Sleep* Roth nonetheless produces a narrative that articulates an ambivalent embrace of the secular world as well as a deep and loving desire to transcend its linguistic limitations. The textual "translation" of the childhood experiences and imaginings of David Schearl, a boy prophet who will (we can reasonably assume) become a writer, is situated in the New York version of the *shetl*, a haven of ethnic homogeneity that is ruptured, all too often, by unrecognizable voices. Seeking to eradicate the dangers of

difference, David creatively "translates" his experience to produce a narrative that gives way to assimilative pressure without relinquishing spiritual force. The effort to negotiate the distance between a translation that responds to other languages and one that is completely his own represents both the frustration and the triumph of the novel.[14]

Although *Call it Sleep* is astonishingly multi-vocal, its most compelling language resides, finally, in the series of virtually iconic images that recur throughout the narrative (I will explore, in later chapters, the increasingly central role that visual iconography will play in Jewish imaginative production). Indeed, this visual language gains power through its interplay with the other languages of the text. The stability of the textual iconography lends these images a sense of visceral authenticity, particularly when contrasted with the shifting and multivalent sounds of the Yiddish, Hebrew, and other ethnic "street talk" that filter in and out of David's consciousness. In this way, visual language is figured in the narrative as truth, achieving the status once reserved for Hebrew. Indeed, one of the most fascinating accomplishments of the novel is its sophisticated interrogation of Hebrew as the only "authoritative" Divine language. The status of Hebrew as a "pure" language over and against the linguistic hybridity of David's ethnic neighborhood provides a compelling entry into the issue of spiritual authenticity (as transmitted through language) that is one of Roth's principle preoccupations.

To contextualize the significance of Hebrew for the Judaic tradition, and by extension for Henry Roth: it is the language that is (until the establishment of the modern state of Israel) set aside for what is sacred. Indeed, there is a *Midrash* that affirms this by stating that God removed the Hebrew slaves from Egyptian bondage because despite their oppression, they retained their Hebrew names. With this in mind, Roth's attempt to usurp Hebrew signifies a radical departure from his own religious tradition. And, although David's narrative quest undoubtedly has religious undertones, its methodology vacillates between the secular (Catholic?) valorization of iconic silence and the Judaic prioritization of multivalent speech.

Ironically, then, Roth's concession to secular culture is not residual in his attention to formal experimentation—the normative modernist **and** Judaic position—but rather in his subtle discernment of an extra-linguistic symbolic structure that is figured as **more** sacred than language. In doing this Roth leaves the comfort zone of linguistic experimentation, which, although radical for his Modernist contemporaries, is part and parcel of his own tradition.[15] Underlying Roth's polyphonic and fragmented narrative is an ambivalent but ever-present movement toward unity and closure. This is not merely a broad spiritual impulse, but more particularly, and more significantly, an attempt to "translate" the Christian theological concept of an extra-textual divinity into the "voice" of a Modern intellectual Jew. Roth's narrative reluctance to fully accept the Judaic (and Modern and ultimately, post-structuralist) position in which

there is no end to text is indicative of a desire to flee from the cultural, political, and intellectual burdens of his own faith.

In this way the narrative parallels Roth's eventual, although never complete, rejection of both Judaism and the literary world. Like many of his Jewish contemporaries, Roth became an active member of the communist party, trading literary elitism for social action. For Roth this closed down the machinery of his craft for quite some time (the only other novel he produced during his lifetime was *Mercy of a Rude Stream*, published in 1994—a full 60 years after the appearance of *Call It Sleep*). Although other Jewish writers successfully merged a political with a literary identity, Roth's inability to do so is telling. No other Jewish writer of Roth's era attempted to participate in the narrative experimentation of High Modernism to the same degree. Most, in fact, chose to write more assimilative and accessible novels. My early example of Torah translation provides an apt metaphor for the way in which Jewish writing attempted to bridge the ever-growing gap between the idiosyncratic and (at least for the religiously-minded) oppressive demands of Judaic tradition and the more secular values of life in America. Unlike *Call It Sleep*, the novels written by Jewish writers in the 1920s and 30s are largely written for (to steal Seidman's terminology) the politically pious and aesthetically "simple." For Roth, staking out a place for himself in the literary canon meant participating in a project that he must surely have recognized to be culturally exclusionary.

The complicated narrative patterns of *Call It Sleep* thus constitute an attempt to reconcile the kind of secular humanism that Roth was no doubt moving toward as he was writing it with the traditional hierarchies of Talmudic hermeneutics and Modernist practice. Both of these positions reflect a religious sensibility, with the first tending toward an idea of mercy that is almost always figured as Christian, and the second a gesture toward textually revealed "truth"; clearly a Jewish imperative. The linguistic exercises of the text thus replicate the form of Modernism while subtly reconfiguring one of its most basic principles: the principal of formal "openness" stunningly exemplified by the two texts most frequently compared to Roth's novel: *Ulysses* and *Portrait of the Artist as a Young Man*.[16] Unlike Leopold Bloom, who is ultimately interested in return and reconciliation, David Schearl has revelation, of one kind of another, on his mind. In addition, Joyce demonstrates a deep fascination with the complicated and constructed nature of Jewish cultural identity.[17] Leopold Bloom is thus quite intentionally the Jew who is Jewishly identified but not *halackically* Jewish.[18] From an ethical perspective, *Ulysses* dismantles anti-Semitic tropes by exposing their placement along a subjective political and cultural continuum. Bloom's imaginative transformations lend credence to the notion that retaining or discarding Jewish identity is a painful, but possible, act of will.[19] For David, on the other hand, there is an authentic identity that exists outside of linguistic constructions, in the realm of the visual. Within this realm, David has access to a univocal "truth" that transcends the multiplicity of voices

and offers access to a real and stable version of self. Herein lies, I believe, the difference between Joyce's slippery and multifarious portrayal of identity and Roth's attempt to instantiate an objective and uncontested (albeit difficult to ascertain) resting point for the Modern consciousness. This distinction comprises what some have identified as Roth's "containment" of Joyce's narrative style.[20]

Importantly, a principal facet of Roth's debt to Joyce is David and Bloom's (and to an even greater extent, the young Stephen Daedalus of *Portrait*) shared experience of spiritual epiphany in so-called "ordinary" events. These moments communicate a similar sensibility and encourage readings of a connected search for spiritual transcendence within the texts. In fact, close analysis of Roth's novel reveals an attachment to objective meaning that limits its linguistic "play" and accounts for its reception as a "tamed" version of Joycean poetics. This resonates both formally and thematically, as David Schearl's experience is ultimately quite bound by his religious heritage and cultural moment, and he cannot think or talk himself "free" to the extent that Bloom can. With that in mind, the novel is less an act of self-*making* (as *Portrait of the Artist*) as one of self-discovery. Ultimately, David's quest is to translate a "real" identity out of a morass of patently false and painful options.[21]

Call it Sleep thus moves through the desert of language toward a "translation" of David's true identity. The initial moments of the narrative tell the reader that the imaginative journey will be to a land that is ostensibly, indeed primarily, safe. The concept of safe speech will assume central importance as David's desire for expression is constantly threatened by both his own tradition (in the form of Reb Pankower and Albert Shearl) and the urban street. The parenthetical epigraph to the Prologue "(*I pray thee ask no questions this is the Golden Land*)"[22] offers an ironic foreshadowing of David's actual experience in a land which is not golden, and lends itself to nearly constant interrogation.

We learn in the opening scene of the novel that the principal characters, a young, surly immigrant man, Albert, his wife, Genya, and their young son, David, are Jews, but not like the other Jews who greet each other at Ellis Island. "Jews wept, jabbered almost put each other others eyes out with the recklessness of their darting gestures."[23] The atypical nature of the Shearl's performance leads one to doubt, perhaps, their Eastern European origins, particularly because the woman is dressed in clothing that is clearly American. The boy, however, wears foreign garb, and a strange looking hat. The overall impression of these Jews is that they have, in some way, "put each other's eyes out," by creating an image that is difficult to visually read and interpret, not only for the reader, but for each other as well. A dynamic of desperation is communicated in these first moments that will continue for the remainder of the text. The language of the women, Yiddish, is not only at odds with her clothing, but also with the language and clothing of her husband, who is clearly trying to shed the image of the

immigrant "greenhorn" by wearing more American style clothing. As the father, Albert, assesses his son he notes first the offending hat, and then the size of the boy, who is large for his age. From this moment the question of David's age will be fraught with anxiety, as the father wonders who this child really is. Clearly, in Albert's mind, there can be only one true answer to the question of David's identity. Significantly, this is not only a matter of paternity (as we will soon see), but also one of race and, by extension, religion. As for David, the child, confronted with a diverse barrage of clothing, behavior, and language, he is already seeking a system of representation that will elide these troubling signifiers.

Turning to the languages of the novel, the depth and complexity of David's dilemma is obvious. The prologue introduces an erudite, English speaking omniscient narrator. This overarching voice "translates" David's unconscious thoughts from Yiddish to English. The narrator leaves many words and phrases in Yiddish (and Hebrew) for the reader to try to contextually translate. The "secret" of the plot, Genya's pre-marital infidelity and David's questionable paternity, has its own nuances and virtually unknowable symbolic language.

For example, when David overhears his Aunt Bertha and his mother discussing the distressing matter of Genya's past, he tries to gain a cognitive grasp of their conversation:

> The oblique nod of her head seemed to beckon her sister to join in the realm of another speech. For when she spoke again her words had fused into that alien, aggravating tongue that David could never fathom . . . though he pried here, there and Everywhere among the gutturals and surds striving with all his power to split the stubborn scales of speech, he could not. The mind could get no purchase.[24]

In this scene Genya and Bertha speak primarily in their native language of Polish, not the Yiddish that David is accustomed to. David's intuitive anxiety regarding the "meaning" of his mother's speech is here conflated with the inaccessibility of the language itself. Although he cannot fully articulate it, David senses that the core of his identity is connected to the ability to translate; if he could only understand Polish, he would understand who he really is. Fervently wishing to "split the stubborn scales of speech,"[25] he longs for a type of certainty that he simultaneously seeks and avoids throughout the narrative. Paradoxically, knowing that he is his father's son—and therefore fully Jewish—would consign him to a life of translation and the indecipherable language that is the inheritance of his faith.

This "indecipherable language" is also the discourse of the cellar, introduced in Book I:

> Darkness was all about him now, entire and fathomless night. No single ray threaded it, no flake of light drifted through. From the impenetrable depths below, the dull, marshy stench of surreptitious decay uncurled

against his nostrils. There was no silence here, but if he dared to listen, he could hear tappings and creakings, patterings and whispers, all furtive, all malign. It was horrible, the dark. The rats lived there, the hordes of nightmare, the wobbly faces, the crawling and misshapen things.[26]

What David "hears" in the cellar is a language whose malignancy is at least partly attributable to an absence of coherent articulation. The sounds of the cellar anticipate the sounds that his mother and Aunt will make as they discuss the "secret" of Genya's past in Polish. Again, without a clear sense of the symbolic structure of this "hidden" language, David is trapped in cognitive darkness. His powerful sense is that what he experiences in the cellar is not silence, but discordant noise, and he equates this kind of language to the noise of the crowd, wherein murmuring voices combine to produce "misshapen" articulations. In one of the final scenes of the novel we will see this concept expansively repeated, as the electrocuted David hears but cannot really decipher the multiple languages of the street crowd that hovers over his (seemingly) lifeless body. In each of these cases, linguistic multiplicity is not liberating, but terrifying. Indeed, the "misshapen" language of the cellar and the crowd are suggestive of the dangerous instability of multiple interpretative possibilities.

David's combined fear and fascination at the site of this multiplicity underscores the complex code of religious ambivalence that reaches its apotheosis in the final segment of the narrative. The "misshapen" language of the street and the cellar is not only difficult to understand but also contains fragments of anti-Semitic discourse. Coupled with linguistic free-play is the ever-present threat of David's Jewish identity. Several recent critics have identified the relationship between multiple, "misshapen" languages and anti-Semitism. Daniel T. McGee, documents the correspondence between jazz, African "nonsense" language, and Dadaism, linking all three to High Modernist ideology:

> That equation might seem undermined insofar as Eliot shared the Dadaists' preoccupation with racist representations of African "nonsense." But the more relevant ideology is Eliot's case is anti-Semitism, for while dada may have emerged as a kind of avant-garde minstrelsy, Eliot identified the degeneration of language not primarily with Africans, but with Jews. The link between Dadaism and Judaism was already implicit in the proto-fascist aesthetics of Charles Maurras. What Maurras provided to Eliot, in other words, was not just anti-Semitism as a political project, but anti-Semitism as a literary theory . . . Maurras imagined the material properties of language as a foreign, Jewish invasion infesting Europe like plague-carrying rodents.[27]

In David's innate fear of incomprehensible language we see Roth conceding, (yet again) to the High Modernist dictum most powerfully espoused by Eliot that all languages collapse into a transcendent, transparent unity.

Such perpetual linguistic free-play and "mechanical" interpretations are the cornerstones of traditional Judaic interpretation upon which daily observant practice is based. In traditional Judaic textual study, for example, it is common to interpret on the basis of textual adjacency. The most often cited case of this regards the origin of the governing activities forbidden on the Jewish Sabbath. In *Shemot* (Exodus) the text details a long list of the activities the Hebrews are commanded to do in order to erect the *Beit HaMigdash* (Holy Tabernacle). Appearing immediately before this list of necessary activities is the statement: "Verily my Sabbaths shall you keep for it is a sign between me and you throughout your generations."[28] The textual proximity between the listed activities and the commandment to keep the Sabbath is, quite literally, the source of the list of prohibited activities on Shabbat: each prohibited activity bears a relation to the "work" of building the Temple. Hence, the "truth" of daily practice is revealed through the praxis of linguistic interpretation. Similarly, the "meaning" that emerges from the convolution of voices David hears during the penultimate scene of the novel is derived less from their "coherent" sense than from their proximity to one another. In this way Roth's narrative trumps the High Modernist reading (but anticipates the post-structuralist one) in that it instantiates—indeed demands—this type of "mechanical" reading. At the same time, the text cannot thematically distance itself from the anxiety that the "cellar" of Jewish hidden language contains what is more pernicious to the secular (or Modernist) Jew: religious particularity.

Roth's use of the "cellar" is also suggestive of the relationship between *Kabbalistic* and normative rabbinic Judaism. Commenting on Gershom Sholem's work, Susan Handelman details the extreme and experimental nature of *Kabbalistic* interpretation as the foundational paradox of Judaism:

> Sholem investigates what had been consigned to the "cellar" of Jewish history; a subterranean, suppressed, subversive, esoteric tradition that had run "counter" to the official version of Judaism created by the Rabbis. In this cellar, Sholem finds "anarchic breezes," irrational, destructive, heretic, demonic impulses, and Gnostic myths. But a cellar is also the foundation of the house, and Scholem's startling assertion is that these impulses are the very foundation and vitality; they exist at the very heart of monotheism, that in this dark cellar lies the secret of Jewish survival.[29]

Sholem's understanding of the cellar provides a sophisticated articulation of the linguistic and interpretive discontinuities that threaten to engulf Roth's young protagonist. The radical abstractions and mysteries of *Kabbalah* appear to beckon religious anarchy and resist the unity and transcendent meaning that David seeks. Yet, in a religion whose history is one of discontinuity and exile, there is nothing more essential than the exercise of these imperatives. To leave the cellar is, for David, to exchange the frightening

locus of both identity and chaos (indeed, the identity is residual in the chaos) for the encroaching "melting pot" of the urban street. The cellar as a place of Judaic language represents refuge as well as pernicious insularity, isolation, and anarchic darkness. And, as *kabbalah* is to conventional Jewish practice, the cellar, precisely because it is multi-vocal and misshapen, is foundational to David's identity as a Jew and Roth's relationship with his secular literary milieu.

David's associations of the cellar with filthy, malignant, "furtive" life are characteristic of anti-Semitic rhetoric. The cellar is home of the "terlit"[30] of David's cousins, a dank and urine-scented place. In order for the Gentile boy, Leo, to sexually convene with David's cousin Esther, he must descend from his home on the roof into the Jewish "hell" where he is surely destined to sin. Jewish female sexuality here, as in other places, is a primal threat to the Christian male.[31] In order to enter the cellar (and Esther), Leo must not only offer Esther a material prize—the much desired roller skates—but must also approximate Jewish nomenclature and language:

> "*What's yuh name?*"
> "Leo-uh-Leo Ginzboig"
> "You ain' a Jew!"
> "Who ain'!" In his vehemence, he still had time to dart a triumphant glance at David, "Cancha tell by me name?"
> "Aaa, yuh a lia', she giggled"
> "W'at d'ye wanna bet? "Dontcha believe a guy?"
> "Yea, g'wan!"
> "I can't talk so good 'cause we alw'ys lived over on de Wes' side. But I can say sompt'n. Wanna hea' me?"
> "Yea!" derisively.
> "Shine maidel, dere! Dat's watchoo are. See? Tookis! Mm! Oh boy! Ain dat good."[32]

Leo's rehearsal of "Jewish" language (in this case, pidgin-Yiddish) is designed to gain him admission into the sexually, ethnically, and religiously marked territory of the cellar. To do this, he must enact a linguistic ruse to "prove" that he is actually a Jew.

In a reversal of the standard anti-Semitic trope, Esther is not the seductress peddling her sexual wares in order to enter the gentile realm, but rather the conductor of a verbal performance that will enable the gentile to enter *hers*. Esther knows, of course, before Leo even speaks that he is not a Jew; the "act" is a case of reciprocal mockery, wherein he condescendingly plays at countering her objections while she revels in his pathetic attempt to parrot her language. His choice of vocabulary (calling her a "pretty girl" in conjunction with the word meaning "bottom") reveals not only his lecherous intent, but also his dismissal of the linked—and potentially dangerous—nature of Jewish language and sexuality. For him, to be a Jew

you must speak like one, but "Jewish" speech is the innocuous rhetoric of flirtation, not a labyrinthine maze of hidden meaning.

This gentile appropriation of "Jewish" speech is also a ruse on Roth's part. Leo's choice of Yiddish, as opposed to Hebrew, consigns the childhood drama between Esther and Leo to the arena of ethnic, as opposed to religious difference. Leo is thus still, even in his use of Yiddish, utterly alien. Leo can "pretend" to be culturally, but never religiously, a member of the tribe. A member of the tribe, because he lacks access to Hebrew and, by extension, Judaic textual truth. As Hana Wirth-Nesher has noted:

> Roth treats Hebrew in the Jewish traditional sense of the sacred language as *loshn-koydesh* . . . For David Shearl, as for other immigrant children, Hebrew and Aramaic sound foreign and unintelligible despite their central role in his home culture. Although it would be accurate to call David bilingual in English and Yiddish, this designation would not account for the complexity of his linguistic world, due to *loshn-kodesh*. Yiddish serves him at home, English assaults him on the street, and Hebrew and Aramaic beckon to him as mysterious, sacred tongues that represent mystical power and that initiate him into Jewishness as textuality as opposed to the ethnic Jewishness that marks his street life.[33]

Abandoning Hebrew signifies, for David, abandoning the highest stakes of Jewish identity. Here Roth calls attention to the significant distinction between Judaic identity and Yiddish speech. Yiddish is ethnically, not religiously marked, and is thus subject to interruption, intervention, and corruption (as we see in the Leo example). Although there is an increasing—and increasingly important—interchange between Yiddish, Hebrew, and English throughout the novel, Yiddish is nonetheless strongly figured as the mediating language of assimilative ethnic urban life, so much so that it is spoken, albeit poorly, by the gentile Leo. The movement from Hebrew to Yiddish thus resembles the translation of the Torah from Hebrew into Greek, from the religious to the political. Yiddish is the language of translation; an intervention. The locus of fear and exhilaration, for David, is Hebrew.

In the world of the *cheder* (religious school), Hebrew provides the link between the realms of daily life and spirituality. David's success in *cheder* arouses ambivalence deep within him, because it threatens to move him into a world that is hierarchical and mysterious, the world of the rabbis. Furthermore, David is understandably confused by the contradictions in his *cheder* education: in the *cheder* one learns how to speak meaningfully to God, yet the sounds of the *cheder* do not form overt meaning. For David, the *cheder* sounds like one endless, repetitive drone. David's desire to "understand" Hebrew marks his urge to "translate," to convert the mysteries of the sacred text into the safety and relative clarity of the vernacular. The threat of punishment by Reb Pankower exacerbates the

conflict between textual meaning and linguistic repetition. "He happened to be bright enough to avoid punishment, and he could read Hebrew as fast as anyone, although he still didn't know what he read. Translation, which was called Chumash would come later."[34] Significantly, in Judaic terms *Chumash*—translation—refers not only to the conversion of one language into another, but more precisely to the overall interpretive study of the Torah text. To avoid punishment David not only needs to read, but also to understand. He needs to translate and interpret; in other words, to become an author.

But David is, at this stage in the novel, neither an author nor an "authentic" Jew. Indeed, it would seem that the parroting of the words of his tradition (both the Hebrew liturgy and the Torah) is analogous to Leo's "performance" of Jewish identity. The analogy fails to account, however, for the role of the visual sign in the construction of said identity. David's desire to "translate" is, in one way a concession to secular culture, a way of seeking an extra-textual meaning that is difficultly reconciled with Judaic religious imperatives. David's attempts at translation are as much efforts at conversion: the conversion of Hebrew into Yiddish, and eventually into the totally secular language, English. The translation David seeks will bring him closer to a comforting and moral God, and one that is understood as a univocal **sign:**

> Two months had passed since David entered the cheder. Spring had come, and with the milder weather, a sense of wary contentment, a curious pause in himself as though he were waiting for some sign, some seal that would forever relieve him of watchfulness and forever ensure his well-being. Sometimes he thought that he had already beheld the sign—he went to cheder; often he went to synagogue on Saturdays; he could utter God's syllables glibly. But he wasn't quite sure. Perhaps the sign would be revealed when he finally learned to translate Hebrew. At any rate, ever since he had begun attending cheder, life had leveled out miraculously, and this he attributed to his increasing nearness to God.[35]

Nestled within David's growing closeness to God—a closeness that has been cultivated through reading and hearing alone—is an implicit need for greater assurance, a relief from "watchfulness." This is not only the watchfulness that we see on the surface of the text; the one that protects him from his father, Reb Pankower, and the neighborhood bullies. It is also, and more importantly, the attention that must constantly be paid to interpretation. To relieve such watchfulness is to escape interpretation, to apprehend a Divine Truth that is singular, and whose compassion extends beyond the borders of textual scripture.

But this kind of voice does not, indeed cannot, exist within the logic of "pure" language cultivated by both Judaic tradition and Roth's own aesthetic. The Jewish God, rather than ensuring David's well-being,

promises nothing but the challenge of endless interpretation; a God who reveals himself most compellingly through withdrawal, contraction, and concealment: "The image of his absence is one of the greatest images ever found for his presence."[36] The "sign" that David awaits is something akin to the miracle of simultaneous translation described at the beginning of the chapter; a miracle of compassionate protection, but one that does not rely on textual transmission. Such a miracle would represent an extra-textual concession, a kind of concession of whose status both David and his Creator are uncertain.

Within a traditional framework, Judaic versions of both morality and Divine Truth are located within the text of the Torah, and are thus residual in language. But what does young David do when he can assimilate the idea of morality in language, but language itself, rather than bearing only the weight of God's word, instead demands constant translation and attendant subjective interpretation? The Hebrew Torah is not only a series of signi-fiers, but can also be understood as one single sign: the visual depiction of God's name.[37] The process of Torah study is then not only an attempt to affix meaning to the signifier, but also to visually apprehend it in a nonlin-ear, pictorial manner. David seizes this idea and converts it into secular, iconographic terms. This conversion allows him to move, temporarily at least, out of the cellar and onto the roof; a space of openness, cleanliness, and emotional relief:

> He stared in breathless irresolution from his own doorway to the roof-door overhead. The clean, untrodden flight of stairs that led up, beck-oned even as they forbade; temptingly the light swarmed down through the glass of the roof-housing, silent, untenanted light; evoking in his mind and superimposing an image of the snow he had once vaulted into and an image o the light he had once climbed. Here was a better haven than either, a more durable purity. Why had he never thought of it before? He had only to conquer his cowardice, and that solitude and that radiance were his . . . [38]

The constellation of images here, "snow," "light," "purity," "solitude," and "radiance" move from the particular to the abstract. The ascent from the apartment to the roof is a climb out of confusing material literality and into a singular purity of spiritual intention. David's association of cleanliness with the safety of secular/Christian culture is a standard fea-ture of Jewish immigrant writing,[39] yet here it signifies assimilation not only of culture, but also of spirit. The God of the roof is very distinctly **not** the God of the cellar, just as the God of Reb Pankower's *Chumash* is not that of Leo's rosary. David's quest for a "sign" is not fulfilled through the apprehension of the Hebrew text, but rather through the translation of spiritual language into something that is "cleaner" and "safer." His experience on the roof confirms his belief in a "sign," but the sign is not

the Torah visually apprehended, but is rather facilitated by the alternative hieroglyphic of the urban street.

This religiously assimilative idea of the sign becomes uppermost, as the narrative progresses and David looks more to visual images than a linguistic system to discover the "hidden truth." This can be seen in a pivotal moment in the text when David, petrified, springs from the cellar and runs away from home. Suspicious that he is becoming lost he is almost immediately comforted by the iconic presence of an endless series of telephone poles, their crosses black against the darkening sky. Passing each of the poles, David abandons yet another of his fears: "They dropped behind him. Three . . . Four . . . Five . . . Six . . . and drew near, floated by in silence like tall masts. And with them dwindling in the past, all he feared, all he loathed and fled from: Luter, Annie, the cellar, the boy on the ground."[40] The poles offer clarity and solace, quite literally erasing all the particulars of David's recent, painful subjectivity: "He remembered them still, but they were tiny now, little pictures in his head that no longer writhed into his thoughts and stung him, but stood remote and harmless-something heard about someone else."[41] Immersed in the trance of the poles, David hurries on, striding a clear path toward "sheer deliverance." The poles are, in a certain way, prophetic.

But what is their message? Commenting on the novel, Alfred Kazin says that "nothing is as close to us as our inner thinking," and Karen Lawrence asks what this means in a novel where

> Inner thinking is represented in a poetic and literary English already "translated" from a Yiddish largely unheard in the text? . . . Isn't Kazan's recourse to a perfectly interiorized thinking all ones own wish to imagine words so pure they do not circulate; a wish to purify the dialect of a tribe by keeping it at home? As even David's overprotective mother recognizes, this desire for an interior free of the bombardments of the world is an impossible dream." [42]

I would take issue with both Kazin and Lawrence. It seems to me that this scene with the telephone poles does not indicate absorption with "interior language"—the language of the cellar—but rather with the creation of an exterior language of pure signs. Indeed, while David seems wholly caught up in the concept of a pure language, this desire seems not to stem from an impulse to shun the exterior world, but rather from an urge to universalize and thus "perfect" his own painfully particular experience. The poles, like the rosary that will come later in the novel, represent a system of representation entirely free of dialect and without the negative charge of interpretive demand. The objects of choice—cross-like poles and the rosary—mobilize Christian symbolism and, in so doing, open up the possibility that David's conversion of his (Jewish) experience into an alternative, iconographic system is akin to the sage's translation of the Torah, transforming the (in this

case, iconographic) language of the dominant culture into a universally accessible revelation of spiritual truth. The poles are spiritualized not only because they are Christian symbols, but because they propel David into a state of solipsistic Grace.

Such universal modes of transcendence in the novel are nearly always co-terminus with the reality of Jewish marginality as displayed in terms of speech and translation. The fallout from David's pursuit of the poles is a trajectory of loss: the temporary loss of geographic orientation, and the threatened permanent loss of his home and his mother. Realizing that he cannot find his way back to his own apartment, David begins to cry, attracting the attention of various strangers and eventually the police. When questioned about the address of his home, David replied in his thick "Jewish" accent "Boddeh Street." The police interpret this as "Body Street," a not too subtle reminder of the cellar (sounds like the morgue," one policeman offers), yet eventually translate David's address as Bardee Street. Interestingly, they discover this through proximate analysis; the Talmudic method, as it was. Once they realize they have succeeded in translating David's address, one policeman remarks: "Barhdee Street! . . . be-gob, he'll be havin' me talk like a Jew. Sure!"[43]

A fascinating commentary on David's attempt to universalize his particular experience through an escape from language, this remark solidifies the sense that such a retreat from language is, in fact, nearly impossible. David must always revert back to "Jewish" speech; a speech whose inflections and implications are so specific that it actually poses a threat to gentile identity. Paradoxically, the insinuation here is that it is possible to learn to talk like a Jew conceals the fear that talking like a Jew will cause one to *become* a Jew. Within such gentile fear is emplaced an ambivalent Jewish hope; perhaps by **not** talking like a Jew one may cease to be one.

The final moments of this scene again suggest that for David this is a fraught desire. The universal transcendence inspired by the poles is nearly totally eclipsed by the joy of recovering his own mother, whose appearance at the station causes David to immediately drop his very "American" chocolate cake and run into her arms:

> "Mama! Mama!" The screaming of her name was itself sheer, stark ecstasy, but all bliss was outplumbed in the clasping of her neck.
> "Well, yer safe now be the looks of it," came the voice at the back.[44]

While it remains to be seen whether David is in fact "safe" in his return to his mother, the alternative ecstasy embodied by her very presence underscores the dichotomy between sensual and linguistic signification that is a prominent discourse in the novel. His mother's "name," joyous as it is in repetition, pales in comparison to the sensation of clinging to her—a visceral attachment for which David can find no adequate descriptor. The return to the mother is thus complicated by the dual threat of the seductive

telephone poles and David's own inability to articulate his attachment to her. Roth sets the scene for this reading much earlier in the novel, when he exposes the anxiety over speech through the depiction of a childhood game gone awry. Restlessly hanging around the local barbershop, David's friend Sidney, following the spiral of the barber-pole, peers into the window of the shop and taunts the barber:

> The rest squealed the words as he had done, but with increasing haste and diminishing lustiness and sped after him. By the time David's turn had come, the barber was already at the threshold fuming with irritation. David mutely skirted the doorway and scurried on.
> "He didn' say it!" they jeered.
> "Sca-cat w'yntcha say it?' Sidney rebuked him."[45]

The demand for speech illustrates a group dynamic in which speech is both necessary and dangerous. David "apes" the actions of his playmates, but lacks the courage to utter their words. Although he gets in the barber's face, that is the farthest point of daring for David. Language is yet another step in the process of confrontation—a step David refuses to take. Reciprocally, the barber seems poised to act only in response to David's speech. For both the barber and David, the only really inflammatory act is the speech act.[46] Furthermore, David must speak to gain entrance into the group, yet to participate in the group speech is to antagonize the source of representative authority.

This "game" immediately precedes the arrival of Albert's friend Luter at the apartment. David's fear that his mother is playing a sexual "game" with Luter distracts him from the actions of his friends and causes Yussie to tease him about the beating he "god" from his father. This series of events leading up to entrapment in the cellar pivots on linguistic omission, miscommunication, and aggression: David fails to participate in the speaking element of the street game, inciting his friends; Genya fails to make explicit the nature of Luter's visit; Yussie relates with exaggerated fervor the beating that David got from his father. The group teasing of both of the barber and later of David himself underscores the threatening nature of verbal communication. David's own narrative only enhances this effect, generated as it is from his own (mis)translation of actual events.

The visual image (David's face in the barber's window, or the telephone poles) here and in many other places in the narrative, offers the "safe" translation. A crucial facet of this safety resides in the fact that there is no narrative accompaniment. As David is repeatedly drawn to "a wordless faith, a fixity, mellow and benign" we see that wordlessness, rather than opening into endless abstraction, seems to signify a stasis of meaning, the ultimate safe haven. After meeting Leo up on the roof, David glimpses and is entranced by his rosary. The rosary is the sign that makes Leo "almost God-like."[47] When Leo asks David to explain the meaning of Judaic objects of observance, *tzitzit*, *tefillin*, and *mezuzot*, David offers a comic translation

of their meaning that is designed to confirm Christian stereotypes; a "safe" translation. This version of the items is as much for David's own benefit as it is to satisfy Leo's curiosity. Remaking the definition of these items is in a certain way, remaking the objects themselves, since they exist as much in description as in use. Indeed, in the traditional Judaic explanation, *tefillin* were not created out of matter, but from language itself. David's own linguistic recreation is a moment of power for him; it makes him, like Leo, "God-like," but he is not like Leo's Christian God, but like his own who made the world with a sentence.

David acknowledges the force of Leo's rosary, yet fails to understand it as an image of religious specificity. The God of the rosary, like that of the poles, is accessible to all that hold the sign. There is no linguistic test, no "translation" necessary. Yet, as David will later discover, the moment the visual sign *is* translated (a moment that is inevitable), there is no holding back disaster.[48] Thus, when the rosary falls out of David's pocket and onto the floor, his father attaches a narrative to the object that confirms his darkest suspicion about his own paternity:

> "God's own hand! A sign! A witness!" his father was raving, whirling the whip in his flying arms. "A proof of my word! The truth! Another's! A goy's! A cross! A sign of filth! Let me strangle him! Let me rid the world of a sin!"[49]

Albert's interpretation of the rosary is one of pious simplicity. The appearance of the sign can only mean *one* thing; it is quite literally the material incarnation of the truth that the text of David and Genya's behavior has pointed to all along. Unwilling to trust the narrative that he has been constructing, Albert, like his son, waits for a singular "sign," clear, unequivocal proof. Yet the "truth" disclosed here is, because articulated in the language of the visual sign, rather than the text, "another's" truth: "a goy's."

The "goyishness" of David's identity finds its parallel in Albert's own. Albert places as much, if not more, faith in the appearance of the rosary as David does. Uncomfortable, like David, in the world of multivalent signification, Albert endows the Christian symbol with more power than his wife's words of explanation. This is a grave sin, indeed. It is a sin not of cultural, but of spiritual assimilation, indicating a willingness to believe more completely in visual signs than linguistic or textual discourse, and a faith that icons can reveal what language cannot. Here we again see a form of translation intended for both "gentiles" and "simple Jews." It is a betrayal of the father in a narrative whose initiating tragedy is precisely that threat.

Yet, the trajectory of this betrayal is circuitous. The mythic subtext of the novel does, indeed, flirt with those forms of faith and meaning that are residual in the iconography of the dominant Christian culture. David's attempt to translate his vexed Jewish spiritual identity into something "pure" consistently leads him toward a visual language that veers away

from his own Judaic tradition. But, as the initial example of Torah translation demonstrates, the idea of a "pure" voice begins to collapse long before this narrative is written. Accommodations are everywhere, and David's authorial father, Henry Roth, seems to know this. He embraces precisely the mutivocal, polysemous construction of meaning that is the true heritage of Judaic culture. The experimental narrative techniques of *Call It Sleep* represent a recuperative move on Roth's part. In writing himself into the world of literary Modernism, he simultaneously writes a more authentic translation of the Judaic textual tradition; one whose concessions to secular culture are practiced precisely where they matter least: in the thematic, and not the hermeneutic, facets of the text.

Right around the middle of the narrative, David hears (not sees) an evocative scene. A young boy is squatting in a water closet, watched by his two friends. Needing to clean himself, he tears off a piece of the Jewish newspaper. As his friends are quick to remind him, it is already dark outside, Shabbat, and it is a sin to tear paper. Furthermore, this is a "double-sin." Why?

> "Cause its Shabis." The righteous voice below meted out. "An' dat's one sin. Yuh can't tear on Shabis. An' because id's a Jewish noospaper wid Jewish on id, dat's two sins. Dere!"
>
> "Yea!" the other chimed in. "You'd a only god one sin if you tord a English newspaper."[50]

It is indeed a sin to tear paper on Shabbat, but no more so in Hebrew than English, assuming that the writing is secular and not religious in nature. In this case, however, the sin is marked not only by the words on paper, but also by the fact that it is a newspaper. The newspaper is a suggestive reminder of David's father, whose job, early on in the narrative, is that of a "pressman" at the Dolman press. As a result, his fingers are always stained with ink, an aspect of his physicality that David connects with repulsive, unyielding strength. David's father participates in the production of a text that he does not himself understand, a metaphor for his monolithic version of paternity that must be usurped, or torn, in order to free David, and the narrative, from the limitations of translation. The tearing of the newspaper thus signifies liberation from both the father and the text, yet it is unclear whether either David or Roth desires such a radical form of freedom.

The appearance of Hebrew letters on a page bespeaks its own kind of holiness, and the instinct that to destroy such language is a sin, an absolute betrayal, seems somehow right to me. If *Call It Sleep* is the kind of translation that, like the Greek Torah, concedes much, it does so in the form of a rupture, not a tear. Roth's sin, like that of the translating sages, is also a kind of miracle bridging the gap between secular iconography and Judaic reading. And perhaps in the very same way, it ushers in an ambivalent darkness—a silence that lasts not three days, but nearly sixty years.

2 Converting Books into Bodies
Unorthodox Women and the Vanity of Art

Moreover the LORD says, Because the daughters of Ziyyon are haughty, and walk with outstretched necks and ogling eyes, walking and mincing as they go, and make a tinkling with their feet, therefore the LORD will smite with a scab on the crown of the heads of the daughters of Ziyyon and the LORD will lay bare their secret parts. In that day the LORD will take away the bravery of the anklets, and the tiaras, and the necklaces, the eardrops, and the bracelets, and the scarves, the bonnets, and the armbands, and the belts, and the perfume boxes, and the amulets, the rings, nose ornaments, the cloaks, and the mantles, and the gowns, and the handbags, the gauze, and the fine linen, and the hoods, and the veils. And it shall come to pass, that instead of a sweet smell there shall be a stench; and instead of a girdle a rope, and instead of well set hair; baldness, and instead of a fine dress a girding of sackcloth; instead of beauty a brand.[1]

The first, and most literal level of scriptural analysis is called, in Hebrew, *pshat*.[2] To find the *pshat* of Nathanial West's *Day of the Locust* I turn to Geoffrey Hartman's discussion of the work of Walter Benjamin. Hartman, discussing the return of theology into secular systems of thought notes that "pure secularism is simply another religion, its gods or ghosts will appear at some point."[3] He goes on to draw attention to Benjamin's famous parable of a little hunchback within, directing the movements of a puppet who plays and wins chess games against all opponents. In Benjamin's parable, the puppet is identified with historical materialism, the hidden hunchback with theology. The critic is

> Inexorably a figure of pathos of aesthetic play. He is a latter-day clown, close cousin to the little hunchback. The Romantic, or religious passion, in all its calculating if displaced strength, may be the hump he cannot shake off. Wizened, shrunken, crippled though he may be, we know there is a power there, if only because we show it instinctive fear and keep it out of sight.[4]

Clearly, the horrible power of *Day of the Locust* emanates from the "hump" of its author, Nathanael West. Like the hunchback in Benjamin's parable,

West's deformity is his hidden strength. And, like the hunchback in the parable, all of his potential moves are laid out on the chessboard. The mythology of the novel is thus identical to that of Benjamin's parable, right down to the specific tropes of deformity, calculation, return, and displacement. West, like Henry Roth (whose *Call It Sleep* was published a year after *Day of the Locust*), seizes the formal experimentation of Modernism in all its difficulty at least partly because it bears an uncanny relationship to the Judaic hermeneutic tradition: he gets to defy his rabbinical forebears using their own discontinuous and ultimately paradoxical methodology. What's so *pshat*—simple, yet remarkable—about *Day of the Locust* is that West, unlike Roth, dispenses with metaphorical abstractions and gives us the hunchback himself, in the form of the Jew Abe Kusich. He also gives us historical materialism, in the large form of Los Angeles, and the more contained form of beautiful aspiring starlet Faye Greener. West's protagonist, Tod Hackett, thinks of Abe Kusich "in order not to think of Faye Greener."[5] Our author, Nathanael West, may well be said to think of Faye Greener in order not to think of Abe Kusich.

Trying hard not to think of Abe Kusich, West was not, by his own account, much of a religionist. Although a prolific reader and dabbler in things spiritual, particularly during his college years at Brown University, his religious interests seemed largely vituperative, and were hardly unusual in his circle of cynical young dandies with intellectual and literary pretentions. West's extensive knowledge of the Catholic saints provided, for example, fertile material for conversations designed to debunk institutional mythologies such as the existence of God and the veracity of biblical texts.[6] Orthodoxy of any kind was anathema to West, who aspired to become the consummate satirist, a man who believed in nothing, and for whom existence was, above all, ironic. Not surprising then, is West's apparent total rejection of his own Judaic heritage, both in this life and his writing. The child of upwardly mobile and well-educated Germans who had already begun assimilating into secular culture prior to their abrupt expulsion from Europe, West never studied for *bar mitzvah*, and attended synagogue rarely as a child and never as an adult. Born Nathan Weinstein, he had, early on, changed his name.

West's work seems haunted by this absence of belief. Sigmund Freud, another reluctant Jew of German origin, developed the now ubiquitous theory of the "uncanny"—that terrifying thing that leads us back to what is familiar and long known but has undergone repression and re-emerged in mutated form. In this way, psychoanalysis, in its project of uncovering this secret repression and causing to resurface what has long been forgotten, is itself uncanny. From a psychoanalytic perspective, West's repression of religion in his life and its transfigured appearance in his writing is indeed uncanny. The deferral and displacement of religion can be understood as a facet of "secular" Judaism as well as a permutation of Judaic theology. Lacking an incarnate Deity, the Jew must rely upon the evidence of the text;

he is always the consummate interpreter or, flipped over, the eternal skeptic. In this context, West's religious ambivalence (which will be gradually discovered during the course of the chapter) plays itself out like the petulant and ultimately ineffectual defiance of an irrevocable destiny.

Strangely enough, the authorial presence of *Day of the Locust* seems to know this. Indeed, he is more than delighted to place his demons right on the surface of the narrative, dressed in such symbolically ostentatious garb as to make them completely impossible to ignore. In this he defies those critics (and there are many of them) who would be label him a surrealist. Unlike the surrealists that West studied and admired so much, in particular Louis Aragon, Huysmans, and Andre Breton, West's attachment to the random image is quite limited. Rather, he offers up a landscape of the uncanny, where characters and images demand specific, meaningful attention. Further, unlike the surrealists, West points his novel in the direction of moral closure. While this would appear to undercut his own anti-religious sentiments, all he is really doing is putting his own ironic distance from the narrative to the ultimate test, and challenging the reader to do the same. In this, he raises the stakes of his project substantially, and places *The Day of the Locust* in a generic category of its own. Written at the outer cusp of the Modernist moment, *Day of the Locust* re-imagines that moment by ironically interrogating, rather than dismissing, the possibility of a God-centered universe, and in so doing, disrupts Modernist narcissism and self-referentiality, particularly in its evocation of the relationship between gender and intellectual passion/production.

The results of West's experimentation, in this novel at least, reveal that his investments are not what they appear to be. Moving through the degraded, corrupt city of his own creation, Tod Hackett the artist gradually unveils the convergence of religious prophecy and aesthetic vision. Similarly, Nathanael West, in creating the mural that will become Tod's (and his own) masterpiece, disempowers the ironic tone of his narrative by juxtaposing those facets of the uncanny that are most universally horrific with a more subliminal version of terror that is religiously and culturally specific. In other words, Tod's text, like Freud's, is about sexual fear and aggression; sex is the "uncanny" threat that cannot stop reappearing. But in West's text, again like Freud's, what is at the center of the "Chinese boxes"[7] is not sexual pathology, but the threat of religion; not theorized, but **practiced** by actual male and female bodies. Keeping his Jewish heritage well out of sight, Nathanael West nonetheless re-envisions Modernism through traditional Judaic tropes of gender segregation, female domesticity, and male scholarship. Synthesizing these religiously particular elements into a significant cultural and historical moment, he suggests that the unorthodox nature of secular Modern art may well lead to Jewish self-immolation. Published in 1933, *Day of the Locust* is more prophetic than it knows itself to be.

Behold the mysteries of literary production. In 1935, Elias Canetti, a polyglot Bulgarian Jew, writes a novel in German originally titled *Die*

Blendung that appears several years later in England as *Auto-da-fe*. It will be published unceremoniously and even later in America as *Tower of Babel*. Like West's, Canetti's rise to literary celebrity was slow and wrought with difficulty. Unlike West, however, Canetti lived his entire life, quite literally, in exile. Fleeing temporary homes in Austria, Switzerland, and Germany, Nazi anti-Semitism forced him to settle permanently in England in 1939. His experience of political oppression almost certainly contributed to the fatalism and paranoia that characterizes much of his work. In addition to *Auto-da-fe*, Canetti is most known for a psycho-sociological study of crowd behavior entitled *Crowds and Power*. He was fascinated by the potential for destruction residual in mass ideological movements. His work, according to one critic, concerns itself with "the fascism of the soul, the tendency of the human mind to fortify itself with aggressive power-plays."[8]

Looking closely at *Auto-da-fe* alongside *Day of the Locust* one cannot help but notice astonishing synchronicities. Thick with literal correspondences of plot, theme, and characterization, both novels evidence the heavy weight of the German-Jewish intellectual tradition in the thrall of Modernist interventions.[9] More importantly, both texts struggle valiantly to preserve diminishing social order by asserting masculine control over "high" art, cultural production, and authentic scholarship. For both West and Canetti—and this is quite astonishing—this struggle is cast into significant relief by its relationship to religious language, prophetic event, and moral/spiritual identity. *Auto-Da-Fe* illuminates my reading of *Day of the Locust* because it names quite explicitly many of the issues with which West is deeply preoccupied, and because it, like *Locust* moves along a trajectory upon which religious tradition is both salvic and aggressively apocalyptic.

I additionally want to assert here some fascinating convergences of authorial biography and fictional creation. I do so at the risk of confounding literary, historical, and psychological discourses. The spirit of the argument I wish to make resides in those slippery borders where texts equal, or even supersede, the material lives of their authors.[10] To wit, in *The Torch in My Ear*, Canetti's autobiography, he describes "the most crucial day" in his life. On that day he was enveloped by and "dissolved" into a crowd of irate workers who burned down Vienna's Palace of Justice in protest over a controversial verdict. In that experience, he "found both theme and image for life's work . . . from that moment he resolved to dedicate his energies to the study of crowds and mass phenomena."[11] An idea for fiction also came to Canetti in 1927, but the novel was influenced more by Canetti's impressions of paintings—most notably Rembrandt's *The Blinding of Samson* and Brueghel's *The Triumph of Death*—as well as his fascination with the power of the fixed idea. At the age of twenty-four, he began to write what he thought would be the first of eight novel-length sketches of monomaniac characters—his tale of the "Book of Man's" descent into self-immolation, *Auto-da-fe*."[12]

The suffocating, self-dissolving atmosphere of mass chaos that Canetti describes as so pivotal to his work mirrors quite perfectly the equally

frightening final scene of *The Day of the Locust*. This is the moment in the text that inspires the completion of Tod Hackett's masterpiece of artistic invention, a giant mural entitled *The Burning of Los Angeles*. As Tod is being pushed and shoved along by the crowd he imaginatively fills his canvas:

> As he stood on his good leg, clinging desperately to the iron rail, he could see all the rough charcoal strokes with which he had blocked out the big canvas. Across the the top, parallel with the frame, he had drawn the burning city, a great bonfire of architectural styles, ranging from the Egyptian to Cape Cod colonial. Through the center, winding from left to right, was a long hilly street and down it, spilling into the middle foreground, came the mob carrying baseball bats and torches. For the faces of the members, he was using the innumerable sketches he had made of all the people who had come to California to die; the cultists of all sorts, economic as well as religious, the wave, airplane, funeral and preview watchers—all those poor devils who can only be stirred by the promise of miracles and then only to violence. A super "Dr. Know All Pierce All" had made the necessary promise and they were marching behind his banner in a Great united front of screwballs and screwboxes to purify the land. No longer bored, they sang and danced joyously in the red light of the flames.[13]

West's prescient Post-Modern instincts are fully deployed here, as we read of Tod's imaginative completion of his painting: a painting that exists in description only and pre-dates the action of the novel. We learn, early on, that Tod's talent is demonstrated by this very mural: "he was really a very complicated young man . . . and *The Burning of Los Angeles* a picture he was soon to paint, definitely proved he had talent."[14] From this passage it seems clear that that the description of the painting not only eclipses its actual presence, but also essentially negates the necessity of completing it at all. Canetti's novel is influenced by his impressions of paintings; Tod's painting is itself a novel. In both cases, the violent nature of the crowd and an overwhelming sense of social chaos birth the work of art, a work of art that is in both cases inspired by, but actually incapable of becoming a visual image.

The paranoia of social disintegration evidenced in West's work and Canetti's life bears only glancing resemblance to the mixture of apprehension and distain with which their Modernist peers approach the deteriorating, post-industrial city. Although critics are quick to point out that Eliot's "The Waste Land" was a "template" for *The Day of the Locust*, the divergences between the two works are telling. While the principal personage of Eliot's poem is effete, ungendered, and emotionally distanced from the events of the poem, West quite deliberately defies this stereotype of the Modern consciousness. Tod Hackett is both aggressively masculine and inextricably involved in the narrative action. Rather than floating, disembodied, above a corrupt city, he is the incarnation of said corruption, as

well as its antithesis. Further, Tod's perspective is one not of observation, but rather one of harsh, unrelenting moral judgment and unceasing terror. This is, of course, in spite of himself, since Tod is presumably ambivalent about religious art, and is consequently always vacillating between the roles of artist and prophet.[15] It takes *The Day of the Locust* nearly one-hundred and fifty pages of prose to conclude that for Tod and his authorial creator, Nathanael West, these categories are indistinguishable.

For Canetti, an exiled Jew living in Europe, the connection was, however, self-evident. Published to some critical acclaim and popularity in 1935, his novel *Auto-da-Fe* was nonetheless almost immediately removed from circulation by Nazi censors. Although it is difficult to say whether this was better or worse than the weak sales and lukewarm reception of *The Day of the Locust*, it certainly lends compelling evidence to Canetti's view, expressed most eloquently in his own novel, that the world of intellectual production was, in 1935, in deep and profound peril. Additionally, it seems not at all coincidental that Canetti's identity as a Jew accelerated and actualized what was, for other writers of his era, an abstract sense of disillusionment. West felt a similar urgency and a correspondent distance from those writers—Eliot among them—whom he most admired. Only a few short years after Eliot has imaginatively documented the dissolution of London into a wasteland of frustrated desire and futile expressions of faith, one of West's major characters, Homer Simpson, is rapidly and relentlessly having his head torn off.[16]

Perhaps not an accident, then, that the major sections of *Auto-da-fe* are titled: "A Head Without A World," "Headless World," and "The World in the Head." These titles relate quite intimately to the experiences of Canetti's protagonist, Professor Peter Kien, "a tall, emaciated figure, man of learning and specialist in sinology."[17] Kien spends his days in his massive and obsessively organized library, working though delicate oriental manuscripts. He only ventures out onto the street for brief periods every morning, when he peruses the bookstores of the city for new and interesting acquisitions. For Kien, the life of the street is a deception; only the life in his private library, the life in his head, is authentic:

> Knowledge and truth were for him identical terms. You draw closer to the truth by shutting yourself off from mankind. Daily life was a superficial clatter of lies. Every passer-by was a liar. For that reason he never looked at them. Who among all these bad actors, who made up the mob, had a face to arrest his attention. They changed their faces with every moment; not for one single day did they stick to the same part. He had always known this, experience was superfluous.[18]

For Kien, as for Tod Hackett, the world of the everyday is decisively less genuine than the world of imagination and intellectual production. This "deceptive" world of the ordinary is nonetheless full of sensory promise,

and neither Kien nor Hackett, despite their heightened awareness of its dangers, are invulnerable to its appeal. Shortly after the action of the novel commences, Kien is drawn into a relationship with his maid, Therese, a conniving woman who, sensing the worth of his vast library, stages a scene of seduction that will ultimately result in their doomed marriage. Kien is entranced by Therese's apparent affection for his books; later she will sell them to buy the material items she desires. When Kien tries to protest, he is locked out of his own apartment by Therese and becomes a resident of the very streets he most abhors: forced out of his library and into the "headless world."

Several elements of this capsule summary are worth noting. First of all, Kien believes that by marrying Therese, he is enacting a crucial transaction: the exchange of his scholarship for her domesticity. Significantly, prior to their pseudo-romantic relationship, Kien has already had a long-standing economic relationship with this same Therese, one wherein he pays for her to attend to his domestic needs so that he can study. Despite this, he nonetheless chooses to alter this relationship by transforming her from his maid into his wife. With this transformation, Therese becomes his erstwhile partner in intellectual production, gaining what he (mistakenly) believes she values more than money: mediated access to his noble pursuit of knowledge/truth. This arrangement is easily recognizable as the paradigm of the traditional Orthodox Jewish marriage. The Jewish wife attends to the home, a task that can include working outside the home, in order to ensure the economic and domestic comfort necessary for her husband to pursue his learning. In return, she is guaranteed a share of his glory in both this world and the next: the more brilliant a Talmudist the husband is, the "richer," in both spiritual and social currency, the wife is.[19]

The failed partnership between Kien and his wife leads not only to the destruction of Kien's library, but also, more significantly, to the destruction of his marriage. The failure of gender relations is thus central to Canetti's apocalyptic vision, a vision that mirrors with mimetic perfection the prophecy of *The Day of the Locust*. Furthermore, Kien himself imagines, in a dream that he has shortly after becoming attracted to Therese, the end of these unorthodox relation as the terrible immolation of books become people; a vision, like West's of ultimate judgment:

> Then suddenly the victim tore his bosom wide open. Books poured forth in torrents. Scores, hundreds, that were beyond counting; the flames licked up towards the paper; each one wailed for help; a fearful shrieking rose on all sides. Kien stretched out his arms to the books, now blazing to heaven . . . He saw a book growing in every direction at once until it filled the sky and the earth and the whole space of it to the very horizon. At its edges a reddish glow, slowly, quietly, devoured it. Proud, silent, uncomplaining, it endured a martyr's death. Men screamed and shrieked, the book burned without a word. Martyrs do not cry out, saints do not cry out.

Then a voice spoke: in it was all knowledge, for it was the voice of God: 'There are no books here. All is vanity.' And at once Kien knew that the voice spoke truth. Lightly he threw off the burning mob and jumped out of the fire. He was saved.[20]

This dream, "the worst he ever had," is motivated by his first romantic encounter with Therese, during which she pretends to disdain the behavior of "young people these days, when they go out on Sunday. Every factory girl has to have a new blouse. I ask you, what do they do with all their fancy stuff? Go off bathing and take it all off again. With boys too."[21] Therese's hard-line morality produces an erotic shock in Kien. Having never looked at a woman before, this conversation awakens sexual urges that have previously been policed by the demands of his scholarship. It is Therese's implied complicity in this very policing project that makes her an object of Kien's desire. Yet, Therese's own discourse alludes to precisely the kind of physical end-point of desire that Kien most fears. It is in this state of dread that Kien has the confusing dream wherein he jumps into the fire to save what he thinks are the burning books, but which reveal themselves to be actual human bodies. Simultaneously, he sees the destruction of a single, immense Book, one that evinces the dignity denied to the human sufferer: a silent death. He is saved only when he recognizes, through the experience of "God's voice" that it is only his own vanity that is converting the books into bodies. Kien's "vanity" is, in this case, residual in his shamed recognition that he himself is not a book, but a man.

Kien's dream conflates the imperatives of secular intellectualism with the value placed on a particular form of learning that is within the province of Canetti's religious tradition. Complicating his, Canetti locates the conventional Jewish stereotype of the weak-bodied Jewish scholar within the body of a gentile male character (and not only gentile, but suggestively anti-Semitic) at a moment of crisis that is clearly created by the appearance of a scheming woman as an as yet unmasked "enemy" of all learning. Needless to say, one needn't be of Jewish descent to experience the socioeconomic and cultural assault on male intellectual production that is of concern here.[22] Yet, Kien's anxiety is only partially that he will be judged for his self-satisfied attachment to his library. I would argue that the deeper disturbance for Kien (and for Canetti and West) is concern and ambivalence regarding a tradition that appears to equate ideas and bodies apologetically, and that struggles to maintain itself through the seemingly impossible normalization of traditional gender relations. Assimilating the acquisition of secular intellectual and/or artistic success under the rubric of Judaic learning poses yet another set of problems, since it seems that in both *Auto-da-fe* and *The Day of the Locust* that such endeavors must be consistently filtered through the lens of prophetic moral judgment.[23]

These issues are crystallized during a moment, much later in Canetti's novel, when Kien meets an actual Jew: none other than the deformed,

wizened hunchback of Benjamin's parable. Cast into the street by Therese, Kien attempts to purchase duplicates of his books, most of which still exist in his flat, but to which he has, because of his domineering wife, no access. During this period he stumbles upon an odd establishment named, quite ironically, "The Stars of Heaven." This is ironic because "The Stars of Heaven" is actually a dank, subterranean club filled with social outcasts, where an odd dwarfish figure named Fischerle dominates the scene, challenging all who enter to a game of chess. Kien, repulsed, describes the Jew this way:

> The tip of his strongly hooked nose lay in the depth of his chin. His mouth was as small as himself—only it wasn't to be found. No forehead, no ears, no neck. No buttocks—the man consisted of a hump, a majestic nose and two black, calm, sad eyes.[24]

Kien soon learns that Fischerle, like himself, is in the "book racket," only he is, unlike Kien, a fast-talking salesman who knows how to exploit any situation. Fischerle only participates in the "book racket" in order to open up space for his real life's passion: the game of chess. Indeed, according to Fischerle, "a person who can't play chess isn't a person . . . What's a man got brains for? He's got brains to play chess with."[25] What's more, Fischerle, although in the "book racket," didn't learn to play chess from a book, but "on my own." Fischerle stresses to Kien, during this first encounter, how unimportant all qualities; especially "looks" and "brains" are, if they are used in the service of anything other than chess. Indeed, once past his initial disgust, Kien comes to realize that

> once the little manikin had got onto the subject of chess, he was the most harmless little Jew in the world. He never paused, his questions were rhetorical, but he answered them himself. The word chess rang in his mouth like a command, as though he depended on his gracious mercy, whether he would add the mortal 'check mate.'"[26]

Of course, in Benjamin's parable, the chess player is a mere puppet, the material stand in for the real player, theology, deformed beyond recognition. Canetti's Fischerle predictably dispenses mercy while simultaneously invoking it in Kien. His pitiful surroundings and appearance belie his hidden power; trapped within the shell of the deformed Jewish "racketeer," he is nonetheless both passionate martyr and merciful judge.[27] Within a few pages of his entrance to "The Stars of Heaven," Kien moves from an attitude of revulsion toward Fisherle to one of compassionate empathy. This transformation occurs when Kien learns of the troubled relationship between Fisherle and his wife, a seemingly well-meaning prostitute who Fisherle refers to as "The Capitalist." This, because she owns and maintains "The Stars of Heaven," Fischerle's figurative "home," as well as

providing both money and chess partners for him by working on her back. Indeed, "The Capitalist" brings men to her flat who are interested in having sex with her. Unbeknownst to these sexual partners, the dwarf Fischerle is hidden underneath the bed, listening to these men and trying to ascertain, from their erotic discourse with his wife, whether or not they are capable of beating him at the game of chess. When he senses an appropriate challenger lying above him, he pops out and taps the man on the shoulder or nose, the man becoming suddenly aware "not of the insect he suspected, but of the dwarf and his challenge."[28]

Despite the fact that Fischerle's wife clearly loves him enough to offer up this ultimate sacrifice, Fischerle cannot help but call her a "whore" and "strumpet," even as she gazes adoringly at his hump, and thinks how much more handsome he is than the hovering, skeletal Kien. This adoration is based not only on Fischerle's obvious brilliant talent as a chess player, but also on his deformity: "his hump distressed her. She'd rather have overlooked it. She had a feeling as if she were answerable for the misshapenness of her child."[29] In Mrs. Fischerle's mind, her husband's deformity is converted from a liability to a romantic asset. Knowing that pity and arousal are conjoined, Fischerle, the ultimate racketeer, exploits this fact: "As soon as he discovered this trait in her, which seemed to him quite mad, he made use of it as blackmail. His hump was the one dangerous threat on which he could rely."[30]

Similarly, Kien, during the course of his encounter with Fischerle, comes to understand his hump as a physical manifestation of the dwarf's torture: the torture of being an intellectual man mated to a woman who cannot understand or appreciate his passion. Kien, although supposedly a reader of signs, is so completely involved in his own tragedy that he fails to see the significant distinction between Mrs. Fischerle and Therese, and imagines that Mrs. Fischerle **is**, in fact, Therese, sitting across the table from him, and that he is Fischerle:

> Since she had asked him for a present he knew who it was he had before him; a second Therese. He knew nothing about the rituals of the place, but one thing he recognized clearly—this stainless spirit in a wretched body, had struggled for twenty years to lift itself out of the mire of its surroundings. Therese would not allow it. He was forced to impose tremendous sacrifices on himself, never losing sight of his glorious goal— a free mind. Therese, no less determined, dragged him forever back into the slime. He saves, not out of meanness, his is a generous soul; she wastes it again, so that he shall never escape her. He has clutched at one tiny corner of the world of the spirit and clings to it like a drowning man. Chess is his library.[31]

The Fischerle marriage is not a replication of Kien's union with Therese, but a debased and inverted version of the utopic partnership that Kien had in

mind when he decided to marry. Significantly, Mrs. Fischerle provides the materials for Fischerle's passionate pursuits; even more significantly, these pursuits have nothing to do with her. On the contrary, Fischerle's romantic attachment to his wife is subordinated to the demands of his obsessive intellectual will, so much so that sex for the Fischerles is procreative only. Mrs. Fischerle has intercourse with other men in order to produce potential heirs to her husband's position as king of "The Stars of Heaven"; figurative sons who will challenge and unseat Fischerle not in bed, but in chess.

The female body thus functions as economic and reproductive tool, but both the product and the economy are deformed and corrupt; physical manifestations of intellectual "vanity." While Mrs. Fischerle does, in fact, share in and become aroused by Fischerle's abilities, these abilities, and their libidinous charge, are located within the shell of this deformity. As such, all activities of the Fischerle partnership emanate from the prison of Fischerle's "wretched body." Despite this (or perhaps because of it), Fischerle has succeeded where Kien has failed—his wife's sexuality is not a threat, but an essential element in his erstwhile success. Furthermore, he has achieved this success by offering up his disability as a form of piety. Kien's own "hump," his library, is not, to Therese, a "dangerous threat" that can be called into service at any time, but vulnerability so extreme that it has cost him his home.

At this strange and complex intersection of sex, economic (re)production, and physical deformity, we have full-on religious representation, written on Fischerle's small and "wretched" Jewish body. Fischerle is not a practitioner of either high art or Talmudic scholarship; he is the captain of a misshapen "den of thieves" and self-aggrandizing blackmailer, who pulls the strings of his own compassionate puppet, Mrs. Fischerle, in order to advance his own bizarre ambition. Fischerle's Judaic identity is nevertheless of the Orthodox variety, filled with ritual, and entirely dependent upon domestic partnership. Kien's sense of Fischerle as a man of spirit is not entirely wrong, either. As the novel progresses, Fischerle is eventually martyred to his hump and his "ideas"; murdered by one of his wife's bedmates who believes that "cripples and scum are the same."[32] Canetti's Jew bears the burden and the redemptive potential of the body as metaphor, yet it is his material body that suffers the consequences of physical difference. Fischerle's unconventional Orthodoxy demands that he master all strategic partners, but he cannot outmatch God, who has marked him, and placed him in the Modern city where women, even at their best, are whores, and bodies are not vessels of holiness, but instruments of betrayal.

If Fischerle were to have succeeded in his ambition of leaving his European home for the Promised Land, he probably would have made it, eventually, to Hollywood, California. There he may have met Nathanael West, an aspiring writer forced by economic circumstance into the screenwriting "racket." West would already know him, having written in his first novel *The Dream Life of Balso Snell,* about a Jew whose job it is to guide

the main character, Balso, a Jew "in name only" through the bowels of a wooden horse. Like Fischerle, this Jew resides in the dark, excremental cellar of the universe, and expounds vociferously about philosophy while trapped in the anus of a machine.[33] West would also know him because he resembles, in both stature and persona, the dwarf Jew Abe Kusich, one of the principal figures in Tod Hackett's painting and a pivotal character in *The Day of the Locust*.

The Day of the Locust begins in earnest when Tod Hackett recalls his first encounter with Abe in the corridor of his rooming-house:

> Despite the sincere indignation that Abe's grotesque depravity aroused in him, he welcomed his company. The little man excited him in and in a way that made him feel certain of his need to paint . . . He was on his way to his room late one night when he saw what was supposed to be a pile of soiled laundry lying in front of the door across the hall from his own. Just as he was passing it, the bundle moved and made a peculiar noise. He struck a match, thinking it might be a dog wrapped in a blanket. When the light flared up, he saw that it was a tiny man.
>
> The match went out and he hastily lit another. It was a male dwarf rolled up in a woman's flannel bathrobe. The round thing at the end was his slightly hydrocephalic head. A slow, choked snore bubbled from it.[34]

Tod's discovery that Abe is a man, and not a dog, is enabled by the dwarf's indignant demand for his clothes, which are being held captive by a woman with whom he has obviously just spent the evening, and who has thrown him, naked and in disgrace, into the hallway. The unnamed woman—"a lollapalooza-all slut and a yard wide"—has just given Abe the "fingeroo," something that Abe describes with great vindictiveness: "no quiff can give Abe Kusich the fingeroo and get away with it . . . not when I can get her leg broke for twenty bucks and I got twenty."[35] Tod recalls this scene in order to avoid thinking about Faye Greener, a woman whose insistence on giving Tod the "fingeroo" is one of the central conceits of the novel, and the agony of Tod's life. Despite Abe's bizarre and repugnant appearance, so markedly different than Tod's own, they nevertheless have something in common. While Abe prides himself on his street-savvy and ability to size up any "racket," he recognizes in Tod a man of "high" learning, a "know-it-all." In any case, Tod's book learning cannot replace Abe's "twenty." Far from buying into a partnership where Tod's "book-learning" is a valuable commodity, Faye Greener operates in a world where Tod, without economic resources, is totally unworthy of her attention.

The "accidental" meeting with Abe in the corridor is the pivot upon which the rest of the plot turns. Abe convinces Tod to move from his low-class rooming house to the equally low-class apartment where he himself lives, the San Bernadino Arms, referred to throughout the novel as the "San

Berdoo." While evaluating the rooms at the San Berdoo, Tod sees Faye Greener, and decides without hesitation to move in. From that point forward, Tod's obsession with Faye and his involvement with the men that circle around her will frame his life in Los Angeles. These include Faye's father, Harry Greener, a retired vaudeville actor who spends his days selling "miracle solvent"; Homer Simpson, a pathetic hotel accountant from the Midwest who has come to Los Angeles for a "rest"; and a pair of pseudo-cowboys, Earle Shoop and his Mexican companion, Miguel.

Abe's unseen orchestration of the events of the plot is not dissimilar to the activities of the other Jews in the novel, Hollywood producers and money-men who use the props and scenery of the culture industry to literally re-write history in the form of popular film. Because *The Day of the Locust* is a novel written by an American, such revisions are possible. Because it is written by a writer of Jewish lineage (even one who is not running, like Canetti, from Nazi censors), such historical revisions are imperative. Thus, the historical battle at Waterloo is refigured as "a Charles H. Grotenstein Production," and it is, importantly, left unfinished, botched by a director who, unable to see that the paint on Mont St. Jean was still wet, commanded the army of Milhaud's cuirassiers to charge. At stake in the error is not the fate of a nation, but the financial liquidity of the studio: "Big losses, however, were sustained by the insurance company in workmen's compensation. The man in the checked cap was sent to the dog house by Mr. Grotenstein just as Napoleon was sent to St. Helena."[36] West can take comfort, I think, in his mobilization of a particular cliché (and a Hollywood truth) wherein the Jewish investment almost always boils down to the financial. In the scene witnessed by Tod, and directed by West, however, as in the overall plot that has been put into motion by Abe Kusich, this is just another Hollywood façade.

Perhaps for reasons not wholly financial, in the world of West's production, the re-staging of Waterloo is deferred, set aside for a more appropriate day. This deferral is, quite obviously, the machinery that drives not only the Hollywood "dream machine," but also *The Day of the Locust* itself. Noticing this, Matthew Roberts want to understand the text as neither Modern nor Post-Modern, but rather deeply Adornian, "more fiercely committed to Adorno's theory of the culture industry than Adorno himself could ever be."[37] Roberts suggests that West relies upon and exploits Adorno's theory that the pleasure promised by the spectacle of mass culture is ultimately illusory and utterly dependent upon deferral for its effect:

> The culture industry perpetually cheats its consumers of what it perpetually promises. The promissory note which, with its plots and staging, it draws on pleasure is endlessly prolonged; the promise, which is actually all the spectacle consists of, is illusory; all it actually confirms is that the real point will never be reached, that the diner must be satisfied with the menu . . . There is no erotic situation which, while

insinuating and exciting, does not fail to indicate unmistakably that things can never go that far.[38]

Adorno's theory works here by illuminating the feeling of promise and denial that is shared by Hackett and the reader throughout much of the novel, quite specifically with regard to erotic situations that seemingly never "finish." This is true from virtually the outset of the narrative, when Tod attends a screening of pornographic films at the home of Mrs. Jenning, a high-class madam. The film, just at the moment of most extreme titillation, runs off the reel and its completion is delayed. Although the film is described in the minutest detail to this point, the reader is denied the rest of the description, although we know that Tod does go back into the screening room later and sees the end.

Herein lies an important complication of Adorno's theory as applied to the novel. For both Adorno and West, the concept of unfilled desire, linked as it is to perpetual seduction, is contingent upon an alternative formulation: a world of meaning where closure **is** possible. Such unfilled desire for meaning can be understood both religiously and erotically. In some permutations it is a displaced replication of Christ's martyrdom, in others a tacit if subliminal denial of material pleasure in favor of spiritual virtue.[39] In either case, deferred desire resonates with both the Judaic concept of an absent god and the crisis of faith that characterizes many works of secular Modernism. The perpetual catastrophe that **is** history in the Benjaminian sense is the longing for a messianic present, set over and against the real and urgent material circumstances that dictate an accretion of "homogenous, empty time."[40] Benjamin's work, rife with the tension between a redemptive future and a materially constructed/constricted historical fallacy, reveals his deep connection with Judaic theological tradition. This same nexus of material absence and deferred desire figured as messianic longing can be seen in the dual register of West's plot.

God's apparent absence in Tod's prophetic painting speaks quite cogently to this point. The people who have come to Los Angeles "to die" seem, in their endless search for material pleasures, not wholly unlike the Hebrews in the desert, burning their gold down to make an idol. This scene of spiritual weakness was presided over by Aaron, the high-priest, whose failed calculations as to the return of his brother, Moses, from Sinai caused the ultimate deferral: as a consequence of their idolatry rather than a brief sojourn in the desert that people wandered aimlessly for forty years. This story, endlessly replayed, is yet without complete resolution. Nevertheless, its power as faith-text is residual not in the element of seductive deferral, but in the more fulsome, sacred promise.[41] West not only knows this: he underscores its significance by assuring the reader that the prophecy has already come to pass, in the form of Tod's painting, before the narrative has even begun.

It is Abe, the calculating Jew, whose appearance assures Tod of the need to paint, to fulfill the prophecy. What about Abe produces this effect? His

very deformity, the smallness and oddness of his body, as well as what appears to be a "deformity" of spirit; he is a low-class gambler and racketeer. When Tod displaces his lust for Faye Greener into thoughts of Abe, and later into his painting, the complex cycle of Canetti's novel—from sexual/erotic longing, to religion, to intellectual/artistic production—is reenacted. For both West and Canetti, however, this trajectory is most powerfully articulated as a mind/body problem. This mind/body problem has a traditional Jewish solution that, in the debased Modern city, seems to have failed. The failure of this solution is the failure of the utopic Jewish marriage, emplaced in these narratives as a metaphor for the deeper crisis in faith that vexes the Modern Judaic imagination. In both novels, the culprit is the irreligious, "vain" woman, the woman who will not partner and thus poses a threat to intellectual production.

A central ritual of the traditional Jewish Sabbath is the recitation, usually by the male head of the household, of the following prayer, *Ayshes-Cha-yil*:

> A good wife who can find? She is more precious than corals. Her husband places his trust in her and only profits thereby. She brings him good, not harm, all the days of her life. She seeks out wool and flax and cheerfully does the work of her hands. She is like the trading ships, bringing food from afar. She gets up while it is still night to provide food for her household, and a fair share for her staff. She considers a field and purchases it and plants a vineyard with the fruit of her labors, She invests her strength and makes her arms powerful. She senses that her trade is profitable; her light does not go out at night. She opens her hand to the poor and reaches out her hands to the needy. She has no fear of the snow for her household, for all her household is dressed in fine clothing. She makes her own coverlets; her clothing is of fine linen and luxurious cloth. He husband is known at the gate, where he sits with the elders of the land. She makes and sells linens; she supplies the merchants with sashes. She is robed in strength and dignity and she smiles at the future. She opens her mouth with wisdom and the teaching of kindness is on her tongue. She looks after the conduct of her household and never tastes of the bread of sloth. Her children rise up and make her happy; her husband praises her: "Many women have excelled, but you outshine them all!" Grace is illusive and beauty is vain, but a woman who fears the Lord— she shall be praised. Give her credit for the fruit of her labors and let her achievements praise her at the gates.[42]

This conventional prayer epitomizes the traditional Judaic conception of domestic partnership, and is the paradigmatic view of Jewish womanhood. While it is unclear whether the assimilated families of Nathanael West and Elias Canetti recited this specific prayer, its residual cultural effects are obvious. Indeed, it appears that Anna Weinstein, Nathanael West's mother,

embodied many of the qualities of *Ashyes Cha-yil*, the righteous woman: "after the birth of her children she was absorbed in them; she appeared to one of West's close friends to be a "born mother" and cherished hopes for her son in particular. She was interested in home, in cooking, in comforts."[43] When West wanted to go to Paris, it was his mother who insisted that the family support his trip. Anna desired that her children be well-educated and cultured,[44] and was herself fluent in several languages. Although there is no evidence that Anna Weinstein attempted to transmit specifically Jewish values to her children, she was clearly a *Yiddishfrau* in appearance, upbringing, and moral stature. Throughout his life, West would say that his mother and his sister, Laura Perelman, were his models for the "ideal woman": "While strenuously suppressing any expression of romantic ideals, he (West) was personally inclined to idolize certain women. He spoke particularly of his sisters, especially Laura, and of his mother, as feminine ideals."[45] To the end of his life, Laura Perelman remained his standard for all women.

The extent to which this ideal of womanhood remained embedded in West's consciousness is quite obvious within his novel. As Susan Edmunds comments:

> West links Tod's crisis to a wider restructuring in the relationship between elite and popular culture—a restructuring that makes the modernist artist's authority over his (or her) mass cultural counterparts in matters of taste unnervingly open to debate. West attributes the restructured hierarchies of modern taste to the revolution in manners and morals and attendant changes in the cultural functions of women, the home, and the arts . . . at the heart of both struggles lies the historical displacement of the Victorian, bourgeois ideal of true womanhood by the modern, mass cultural idea of the body beautiful.[46]

Edmunds names West's erotic struggle with Faye Greener as an attempt to reconvene traditional hierarchies through aggressive mastery of the female body, and accounts for his desire in socioeconomic terms. Pitting the "body beautiful" against the Victorian ideal of true womanhood, Edmunds confines West's vision of gender relations to the realm of class, a realm that West clearly engages, yet one which can only scarcely account for the many disturbances of the novel. As the earlier liturgical passage demonstrates, the idea of pure, cultured, economically productive and sexually modest womanhood is not (or not only) an outgrowth of Victorian bourgeois society, but is also an essential component of a Judaic tradition that values the home above the synagogue, and claims all religious rituals as having their origins in the domestic activities of Sarah and Abraham in their desert tent.

Viewed in this way, Edmunds argument that Tod's interest in Faye is a thinly disguised metaphor for the struggle between "high" and "low" art

becomes significantly more complicated. Edmunds wants to re-imagine Faye as a kind of early version Madonna (the pop star), self-consciously exploiting her substantial physical appeal to gain economic power and a kind of cultural authority to which Tod has no access. Under the auspices of this argument Tod and Faye are not potential partners, but are rather locked in eternal competition for scarce resources. Again, referencing the liturgical quotation, I think the idea of such competition troubles West's most visceral instincts regarding male/female relations, and does not account for the possibility that Tod's problem with Faye is not her will to economic power, but her inability to achieve it. Faye's apparent disinterest in partnership or productive domesticity is consistently equated not with overall social and moral disintegration (the territory of Eliot), but with revolutionary—apocalyptic—implications. To emphasize this point, West creates a landscape wherein every single convention of Jewish domesticity is overturned by a culture that is "unorthodox" and thus, necessarily, inauthentic.

As such, our first vision of the object of Tod's affections, Faye Greener, is literally through the lens of a photograph. In his narration, Tod describes not Faye the woman, but Faye as she appears on a photograph he keeps on his dresser. His description begins relatively dispassionately: "she was a tall girl, with wide, straight shoulders and long, swordlike legs . . ." continuing to revise and raise the stakes of the description, moving from a cataloging of features to a full reading of their import:

> She was supposed to look inviting, but her invitation wasn't to pleasure, but to struggle, hard and sharp, closer to murder than to love. If you threw yourself on her, it would be like throwing yourself from the parapet of a skyscraper. You would do it with a scream. You couldn't expect to rise again. Your teeth would be driven into your skull like nails into a pine board and your back would be broken. You wouldn't even have time to sweat or close your eyes.[47]

The passage closes as Tod manages to "laugh at his language, but it wasn't a real laugh, and nothing was destroyed by it." Tod's laughter here is juxtaposed with the shocking nature of his final statement, a statement that confirms Faye's status as a symbol of violent sexual displacement and aggression, more compelling on film than in life. Although the machinations of Tod's imagination, "the world in the head," is here, as in *Auto-da-fe*, the world that is more genuine, this is, as in Canetti's novel, a response to what both narratives depict as a real material threat. In this case, intercourse with Faye would beckon precisely the kind of horrific chaos experienced by Kien when he is thrust out of the safety of his library and into the dangerous world of hypocrisy and fallen values.

As the narrative progresses, Tod tries various means of imagining Faye as a virtuous woman, all the while recognizing the futility of this effort. In fact, his most sustained interaction with her occurs when he attempts to

persuade her not to continue working for Mrs. Jenning as a prostitute, a line of work she originally entered in order to pay for her father's funeral. As much at the core of Tod's disillusionment with Faye is his recognition that none of the arguments that should matter to her can possibly be effective: "She wouldn't understand the aesthetic argument and with what values could he back up the moral one?"[48] Tod's prioritization of the "aesthetic" argument is misleading here, since throughout the course of the novel he is himself unable to disentangle the aesthetic from the moral, and is constantly vacillating between his role as artist and his obligation to moral judgment and prophecy.

Once again, it is the encounter with the potential partner that forces such categorizations. The only argument he can find that he feels he will be even moderately compelling to Faye is the "hygienic argument," wherein he lectures Faye on the many diseases that can arise as a result of "whoring," diseases that can permanently destroy her all-important physical beauty. In this argument, Tod enacts a bait and switch: he deploys the concept of physical cleanness in order to convert Faye to a state of moral purity.[49] Faye remains silent, but is clearly affected by Tod's rhetoric; shortly after her father's funeral, she quits working for Mrs. Jenning and establishes a domestic and economic partnership with Homer Simpson.

Faye's arrangement with Simpson epitomizes the inverted, deformed version of gender relations that comprises the real threat of the narrative. In a provocative twist on Kien's marriage to Therese, Faye moves in with Simpson, who provides her with money to buy clothes, thus theoretically enabling her to become the actress she has always aspired to be. As Therese slowly deprives Kien of his economic resources and consequently his means of intellectual production, so Faye drains Homer of his cash in order not to create art (high or low) but to create an illusion of herself as an actress. As Faye describes it to Tod, the only thing keeping her from becoming successful is her lack of the accoutrements of success; the clothes, the jewels, and automobile of a successful actress. Because Faye's only criterion for reality is the illusion of reality, she is comfortable with this set-up, at least for a while. Homer Simpson, whose relationship with his own masculinity is ambiguous at best, is also comfortable with the situation, a situation that offers him unlimited access to the beautiful Faye, as well as something to occupy his restless and rebellious hands: fixing Faye breakfast in bed, straightening her house, cleaning her clothes, and other domestic duties. Both Homer and Faye quite intentionally refer to their domestic relations as a "partnership" meaning, a solely economic arrangement. Although, as for Kien and Therese, Homer's interactions with Faye contain the nearly uncontainable promise of sex, unlike Kien, Faye makes no attempt to convert this arrangement from a purely economic to an authentic partnership, and Faye is unflattered by Homer's willingness to support her efforts. Faye is haughty, and believes that she deserves the attention of a good "wife" such as Homer.

All of Faye's activities directly oppose those of the "ideal woman" that Tod (and West) seem fixated on, and thus draw attention to the shifting status of male and female roles within the narrative. Unlike the biblical Sarah in her tent, who was known to remain in the background when visitors (even angels in the form of men) ventured in, it is Faye, and not Homer, who is the host when they entertain, appearing in her silk lounging pajamas, and assuming the role of the "lady": "it was her favorite role and she assumed it whenever she met a new man, especially someone whose attention was "obvious."[50] Homer, on the other hand, busily dispenses refreshments.[51] In an earlier scene, Faye feigns squeamishness when Earl and Miguel clean quail for dinner, yet once the birds are cooked, "For all her squeamishness, Faye ate as heartily as the men did."[52] Later in the same scene, she will outrun Tod, making impossible for him to gain the physical mastery of her that he clearly desires. Again, immediately following Faye's demonstration of these "mannish" qualities, Tod's imagination nearly immediately shifts to his canvas of *The Burning of Los Angeles*, and his conception of religiously-inflected violence. Like the cartoon-version Faye that Tod imagines, the real Faye seems more to be "playing" the lady than actually behaving like one. Significantly, Faye's "mannish" qualities consistently eclipse those of the male characters, particularly Tod, Homer, and Faye's own father, Harry Greener. The most compelling evidence of this occurs when Faye, in order to silence her father's grim, sickly laughter, launches into a cloying rendition of "Jeepers Creepers," an aggravating performance designed to silence him. When it fails, Faye literally punches Harry in the mouth, taking complete control of the situation. Although Faye feigns distress at having to behave in this aggressive way, just moments afterward she is comfortably planted at Homer's kitchen table, eating with gusto the salmon salad that he has prepared her.[53]

Again, while there is certainly value in the argument that Faye's appropriation of a traditionally masculine role is indicative of a positive shift in the valuation of the powerful woman—specifically the woman who acquires power through the cultivation of her physical attributes—it seems quite clear that West had not such valuation in mind while creating this particular narrative. Rather, the gender misappropriations of the text are constantly linked with an overall sense that such sexual confusion and female "resistance" is symbolic of a world in peril. Hence, the explicit flaunting of Faye's body takes on a double valence. While Tod views Faye's body with obvious, indeed overwhelming, lust, he himself recognizes at all times that the endpoint of such lust is always and only destructive. As such, it is Faye herself who seems to mediate the many detailed descriptions of her body: she stages a scene where men see her the way she sees herself. Indeed, she appears to experience as much if not more of an erotic charge as the vision of her own body as the men do. Like Therese, her acquisition of power is not in the service of a (re)productive partnership, but is ultimately self-serving.

During this middle section of the novel, West draws repeated attention to the dangers of such female narcissism. For example, while visiting Homer and Faye, Tod meets up with one of their neighbors, Maybelle Loomis, "eager, plump, and very American," mother to child-actor Adore, "the biggest little attraction in Hollywood."[54] Adore, only eight years old but dressed like a man, performs a suggestive, lascivious blues song for Homer and Tod. Adore's perverse performance points to a deeper perversity at the core of the mother-child relationship, wherein Mrs. Loomis, like so many of her kind, drags her son from casting call to casting call, waiting months and even years to show off what Junior can do. The apparently great sacrifice made by Mrs. Loomis on Adore's behalf is undercut by the overwhelming sense that he is a mere puppet to her vanity. The kind of self-serving sacrifice made by Mrs. Loomis cannot but have dire results, as Adore's role in the final scenes of the novel will evidence.

Immediately following Adore's performance Faye appears and poses "much more than pretty" looking "just born, everything moist and fresh, volatile and perfumed."[55] Faye's "freshness" contrasts sharply with Adore's precocious sexuality, signaling, again, an inversion: Faye is the object of lust masquerading as a child, Adore, the real child, mimes the actions of an over-sexed adult man. A somewhat different, but even more telling, masquerade occurs in a later scene at the "Cinderella Bar," when a female impersonator appears in a tight, silk gown and sings a lullaby:

> He had a soft, throbbing, voice and his gestures were matronly, tender and aborted, a series of unconscious caresses. What he was doing was in no sense parody: it was too simple and restrained. It wasn't even theatrical. This dark young man with his thin, hairless arms and soft, rounded shoulders, who rocked an imaginary cradle as he crooned, was really a woman.[56]

The young man's performance forms a striking opposition to Faye's theatrical posing, and recalls, with the darkest of irony, the attributes of the "ideal" woman. The young man, in his unself-consciousness, manifests the kind of sensitive, nurturing, behavior that is traditionally constructed as female and that cannot be found in any of the novel's biologically female characters. Stripped of his "ornaments," the female impersonator is revealed to be not less, but more of a woman, just as Faye's "ornaments," intended as enhancements to her beauty, mark her complicity in a flawed and inauthentic version of womanhood. Punctuating this, just prior to the performance of the impersonator, Faye forces Homer, who cannot handle liquor, to drink, insinuating that he is not a man but a "homo" if he doesn't acquiesce to her demands. When he is slightly drunk, and after a lullaby, he confesses to Tod that Faye has allowed Earle Shoop and Miguel to move into his garage and that they have brought their fighting cocks with them.

Homer tells Tod that he doesn't mind the roosters, but that he is totally repulsed by the scabby, black hen:

> "You never saw such a disgusting thing, the way it squats and turns its head. The roosters have torn all the feathers off its neck and made its comb all bloody and it has scabby feet covered with warts and it cackles so nastily when they drop it into the pen."[57]

Homer's revulsion regarding the hen is a thinly disguised metaphor for his growing awareness that Faye's beauty is actually ugliness: stripped of her feathers, Faye is as the black hen, a victim, rather than a beneficiary, of her own vanity.

Physical appearance thus becomes an increasingly slippery signifier as the characters are stripped of their outward ornamentation. In the penultimate party scene, after the cockfight, Faye appears scantily dressed: "the top three buttons of her jacket were open and a good deal of her chest was exposed."[58]

During the party, Faye relies wholly on her own affectations to engage her male auditors:

> None of them really heard her. They were all too busy watching her smile, laugh, shiver, whisper, grow indignant, cross and uncross her legs, stick out her tongue, widen and narrow her eyes . . . The strange thing about her gestures and expressions is that they didn't really illustrate what she was saying. They were almost pure. It was as though her body recognized how foolish her words were and tried to excite her hearers into being uncritical."

The concept of Faye's body recognizing itself propels her into the realm of seemingly pure objectification, removing her intentionality, just as she will, over the course of the evening, remove more and more of her clothing, eventually winding up in nothing but her underpants. In this state Tod recognizes her anew, able only to look at her and "gasp." Whether this is a gasp of arousal or astonishment is left to the imagination of the reader. In either case, Faye's immodest and overtly promiscuous behavior sets the stage for what might read as the harbinger of disaster: her miscegenous sexual alliance with Miguel.[59] Homer's discovery that Faye is not his domestic and spiritual partner but more closely akin to Miguel's scabby black hen decenters not only his delicate psyche, but the entire universe of the novel.

Considering the import of this moment, it is not surprising to find the dwarf Jew, Abe Kusich, very much on the scene. Just moments before the defrocking of Faye, Abe, who has been absent for much of the narrative, reappears at the cock fight. Abe, the seemingly consummate gambler, wants a piece of the action. Miguel tries to sell Abe Juju, a beautiful bird, for fifty bucks. Abe seems to want the bird, but he hasn't got the fifty and

also acknowledges, importantly, that "looks ain't everything." Meanwhile, Claude, the consummate producer, buys a cheap bird just to ensure that he will "see a fight." Abe begs Claude to let him handle the bird, who is obviously no match for Juju. Even prior to the beginning of the fight, Abe notices that his cock is defective, with a crack along the beak. Agreeing to fight nonetheless, Abe attempts to salvage the dignity of the deformed cock, who is "very gallant" despite his clear physical inferiority. As the red bird is savagely destroyed by Juju, Abe removes the bird and

> moaning softly, smoothed its feathers and licked its eyes clean, then took its whole head into his mouth. The red was finished, however. It couldn't even hold its neck straight. The dwarf blew away the feathers from under its tail and pressed the lips of its vent together hard. When that didn't seem to help, he inserted his little finger and scratched the bird's testicles.[60]

Abe's compassion for the bird (minus the sexual innuendo) is echoed, just a few scenes later, in Tod's attempt to mercifully save Homer from the mob crowd determined to destroy him.

As in *Auto-da-fe*, the figure of the racketeer Jew—in this case, Abe—both inspires and dispenses mercy. In both texts, compassion appears at the site of damaged, deformed, or destroyed masculinity. The final pages of the novel achieve closure in the full realization of this dynamic, as the aesthetic is fully converted into the moral by the completion of Tod's canvas, a mural wherein Faye, now fully naked, runs away from the men who would pursue her, her face no longer a mask, but a true window into her proud and startled soul.

Early in *The Day of the Locust* Tod describes the canyons at the borders of Hollywood proper:

> The edges of the trees burned with pale violet light and their centers gradually turned from deep purple to black. The same violet piping, like a Neon tube, outlined the tops of the ugly, hump-backed hills, and they were almost beautiful.[61]

At bottom, it appears that Tod, like his creator West, cannot laugh at, but must mourn, the lawlessness of all art, even his own.[62] The delicate balance between "authentic" and "inauthentic" representation is fully realized here, and one cannot help but feel the pressure of a religious tradition that attempts to stave off such "lawlessness" even as it threatens to enforce gender categorizations that both enable and restrict intellectual production. The alternative to law, writ large for Jewish writers West and Canetti, is the inauthentic and chaotic life of the street, the realization of apocalyptic prophesy, the burning of the books and the spiritual self.

Reconciling the ambivalence of these Jewish writers one must hearken back to and engage the hunchback who cannot escape religious passion, and who tries repeatedly to conjoin religious identity and intellectual vanity. This is not possible, of course, since vanity itself is nothing more than an intellectual trick, the strategy of the consummate critic. Religious identity, on the other hand, and as demonstrated by these two texts, is something more painful and permanent; something burned in.

3 Modernism's Inward Eye
Modigliani and the Burden of Moses

I am the LORD thy GOD, who brought thee out of the land of Mizrayim, out of the house of bondage. Thou shalt have no other gods beside me, Thou shalt not make for thyself any carved idol, or an likeness of anything that is in heaven above, that is in the earth beneath, or that is in the water under the earth: thou shalt not bow down to them, nor serve them, for I the LORD thy GOD am a jealous GOD.[1]

During the relatively short course of his life, Amedeo Modigliani accomplished what Nathanael West dreamed of and managed only to write about: he produced an astonishing and profound collection of visual masterpieces.[2] This is interesting only inasmuch as West, working his art two decades later and in an ostensibly more secular milieu, nonetheless succumbed to what can and has been described as his ethno-religious destiny. Regardless of talent and passion, West recognized his fate as inextricably tied to the world of letters, another in a long line of Jewish men of the Book. Modigliani, on the other hand, fashioned a new destiny for himself as a visual artist. Indeed, Modigliani could be the artist that West was writing about in *The Day of the Locust*, a displaced pariah in a deteriorating urban landscape—not Los Angeles, but Paris, a city that was, in the years from 1900 through 1930, arguably of equal dissipation. But Modigliani was not the prototype for Tod Hackett. He was not, in any sense, possessed of the prophetic. His interest was not in judgment, but in creation, the remaking of the world precisely through the re-*seeing* of the world. Although he was not alone in this—perhaps the most easily recognizable feature of Modern art is its attention to the reconfigured image-—within his particular vision one can discern an engagement with, as well as a rebellion against, the spirit and strictures of the Second Commandment.

In spite of, or perhaps because of this, Modigliani's work was profoundly influential in the development of precisely that aspect of Modernism that is most intimately and inextricably committed to the imperatives of the eye. The language of the second commandment is foundational not only because it carries the weight of Divine injunction, but also because it establishes the priority of language itself. This is suggestive of a litany of problems with visual representation that have haunted the history of Jewish aesthetic production from the time of the Golden Calf, and that continue to provoke scholarly discussion, both secular and religious.[3]

Regardless of their veracity, the stereotypes that place the Jew within the realm of the literary and interpretative, as opposed to the visual, abound and resonate. Because this tension between the visual and the interpretative realms characterizes Modernist aesthetics, this difficulty becomes, during the period from the late 19th into the early 20th century, a productive metaphor for the kind of boundaries that High Modernist writers and artists—not only Modigliani, but also Pablo Picasso, T.S. Eliot, Ezra Pound, and James Joyce—attempt to traverse. Not satisfied with mimetic reproduction, the Modern artist, visual or literary, understands the image as an invitation to interpretation, an imaginative process more than a literal representation.

Modernist literary experimentation imagines language as the genesis, rather than the end-point, of representation. Understanding and prioritizing language in this way, Modernist writers parallel rabbinic thinkers in their desire to cull truth not only from the word itself, but also from its formal placement in the text and its multiplicity of meanings. Like the jealous God of the epigraph, they create the universe with a word. A word, according to the Jewish scripture, and not an image.[4] This may go as far as the idea of religious prohibition toward explaining why Jews have traditionally avoided the creative visual arts, or at least why many Jews understand themselves as marginal to visual culture. From the perspective of the religious tradition, creation takes place in the realm of language, not only or even primarily because images are forbidden, but also because images lack the spiritual authenticity of text. The literal appearance of words on the page immediately resonates with the written Torah that is at the core of all Jewish theology.

The *halackha* supports the supremacy of the text although it does not endorse the wholesale abandonment of the visual arts that many Jewish thinkers have extrapolated from the language of the second commandment:

> Say what you will about the gifted Jews, they have never been, up until times so recent they scarcely begin to count, been plastic artists. Where is the Jewish Michelangelo, the Jewish Rembrant, the Jewish Rodin? He has never come into being. Why? . . . Is it possible that a whole people cannot produce a single painter? And not merely a single painter of note, but a single painter at all? Well, there have been artists among the Jews—artisans, we should more likely call them, decorators of trivial ceremonial objects, a wine cup here, a scroll cover there. Talented a bit, but nothing great. They have never tried their hand at wood or stone or paint. "Thou shalt have no graven images"—the Second Commandment—prevented them.[5]

Cynthia Ozick is wrong here in two significant ways. First, and most obviously, she fails to account for the fact that there have indeed been many quite influential Jewish artists and artisans, including—but hardly limited

to—Amedeo Modigliani. Second, and more important, Ozick invokes the second commandment without engaging its implications. Chief among these, for the purposes of this discussion, it is the fact that the intent of the injunction, from the perspective of the rabbis, is not to discourage artistic representations of the world that we imagine, but rather to discourage accurate replications of that which God himself has created. While mine is a shameless oversimplification of the actual *halackha*, the kernel of truth that it contains is essential, namely, that traditional religious thought makes a clear and significant distinction between mimetic and abstract art.

The residual effect of this law perhaps helps us to understand why there has been no "Jewish Michelangelo," and why Jewish visual artistry has experienced its own renaissance during the Modern and Post-Modern periods, as the nature of representation has become increasingly abstract. This point is particularly relevant with regard to representations of the human face, that which, according to Jewish law, is most like the image of God himself.[6] There are several instances of *halackhot* that discuss the significance of altering or distorting the human face-—even the face of the greatest sages—so as to ensure that it will not too closely resemble the face of an actual human being and thus be vulnerable to worship. For example, the figure of Moses, the most revered of prophets, has been rendered without a nose, or with one eye; an uncanny facsimile of the human face as often distorted by Modigliani, Picasso, and other Modern artists.

The traditional Jewish immersion in text is, in many ways, the ultimate manifestation of this type of disfigurement. Language is the space of creativity opened by God for the Jewish people:

> God separated us from himself in order to let us speak, in order to astonish and to interrogate us . . . He did so not by speaking but by keeping still, by letting silence interrupt his voice and his signs, by letting the Tables be broken. In *Exodus* God repented and said so at least twice, before the first and before the new Tables, between original speech and writing and, within Scripture, between the origin and the repetition (Exodus 32:14; 33:17). Writing is, thus, originally hermetic and secondary. Our writing, certainly, but already His, which starts with the stifling of his voice and the dissimulation of his Face.[7]

Derrida hits the nail squarely on the head here, I think, in his recognition of the necessary distance between human and divine, between origin and repetition. In his allusion to Exodus he points to the essential difference between the Tablets as written by God and those that are mimetically reproduced in Exodus. The commandments are then even further re-staged as they are filtered through the consciousness of Moses in Deuteronomy. The voice of Moses enlarges upon and elucidates the words of the first Four Books. From this moment, the Torah instantiates a precedent of interpretation, rather than exact repetition: art.[8]

Moses' repetition (foreshadowed by his reputed—and much discussed—"stutter") is not only, as Post-Modern aesthetics would have it, an act of linguistic play. The process of re-creation is the direct result of theological imperative and a response to moral crisis. In the last book of the Torah, Moses enlarges upon the commandments in order to admonish a people who have spurned the text for the image, a people whose punishment is the precise obfuscation of God's face to which Derrida alludes. Rabbinic scholars recognize in the minute variations between the original commandments and their repetition a seemingly irrevocable difference in the relationship between God and the Jewish people before and after the incident of the Golden Calf. While I am not suggesting that all art bears this moral weight, I am suggesting that the many various interpretations of Jewish law notwithstanding, Jewish art, even in its most secular incarnations, stands in the shadow of this originating moment.

Moses' burden is thus the burden of process, and one that resonates so fully with Jewish observance and culture that it often eclipses its own profound ramifications for Jewish art. In the space that has been opened for re-assembling the image of the Jewish God, we find the precision of Jewish rituals, such as the recitation of the *Shema* in the morning or the lighting of candles before sundown on Friday nights. Such rituals are significantly attached to time, rather than space.[9] Again, the theological claims of Judaism appear to be at odds with visual representation, which is quite clearly linked to this spatial, rather than temporal, apprehension of the universe. The Jewish commitment to process is solidified by these rituals that serve to sanctify particular moments in time, as well as to a pattern of articulation and refinement/interpretation that discourages the performance of an empty gesture: with each successive articulation comes the demand for increased spiritual participation.

In *The Spell of the Sensuous*, David Abram points to the absence of vowel sounds in the *aleph-bet* as testament to the highly dynamic and interactive correspondence between text and reader that is at the core of rabbinical hermeneutics. Because there are no vowel sounds, no breath sounds, in the Hebrew Torah, it is up to the reader to supply them, and, in the process of supplying, posit interpretation:

> Only in relation—only by being taken up and actively interpreted by a particular reader—did the text become meaningful. And there was no single, definitive meaning: the ambiguity entailed by the lack of written vowels ensured that diverse readings, diverse shades of meaning were always possible. Some form of active participation, as we have seen, is necessary to all acts of phonetic reading, whether of Greek, or Latin, or English texts such as this one. But the purely consonantal structure of the Hebrew writing system rendered this participation—the creative interaction between reader and text—particularly conscious and overt. It simply could not be taken for granted, or forgotten.[10]

Those artists who utilize formal abstraction and visual complexity to provoke participatory reading reinvent the process of forging interpretive relation, described here in terms of language. In the intensity of its formal requirements, Modern art thus mirrors the *aleph-bet,* and demonstrates an affinity with the hermeneutics of traditional Jewish thought. In Modern art, as in Torah study, the meaning to be extrapolated from the text is contained not only in the signification of the words, but also in their actual appearance and arrangement on the page and in relation to one another. Kabbalistic sources refer to the parchment of the Torah as "fire mixed with fire": the black fire which is the ink of the letters, combined with the white fire that is the pure manifestation of the Holy Spirit.

From precisely this traditional perspective, the *aleph-bet* thus produces more than an opportunity for participatory reading. The *aleph-bet,* arranged as Torah, is the source of God's name and essence. In the words of *kabbalist* Nathan T. Lopes Cardozo:

> The first letters to take form were those of the Tetragrammaton. This is the ultimate metaphysical name, the essential appellation of the transcendent Creator. From these four letters emerged the remaining letters of the Hebrew alphabet. *Sefer Yetzirah* tells us that the letters danced, joining into hundreds of combinations, starting with those of two letters—*aleph aleph, aleph bet, aleph gimmel*—and evolving progressively into longer combinations. These permutations became the names of God through which all the phenomena of the world were created.[11]

The repetition and interpretation of the letters of the *aleph-bet* is the ultimate process of the Jewish faith, as well as the core of Jewish mysticism. While Modernist writers do not share this Orthodox perspective, it is my argument that they evidence in their work a similar recognition of the interpretive possibilities of the kind of narrative that is produced through endless visual abstractions.[12] Modernism distinguishes itself from Post-Modern and contemporary literary genres in its fundamental premise that meaning, although opaque, is ultimately discernible through the process of interactive reading. Similarly, Torah scholars believe that attention to each detail of the visual Torah is designed to reveal a virtually unknowable, but eternally present, meaning. Looking closely at Modernism's overlapping commitments to textual abstraction and the search for meaning, it is not difficult to trace the trajectory from Torah study to Modernist literary aesthetics.

A more significant problem arises in my attempt to understand Modernist visual art within the parameters of this paradigm. How does the commitment to process, so deeply embedded in the specific process of language, translate into the realm of the visual? Like Modernist poetics, Modernist painting attempts to transform the image from mere mimesis to more abstract and deeper forms of meaning. As I have begun to demonstrate, those forms of Jewish engagement that seem most inextricably attached

to pure textuality are actually quite dependent upon their own visual representations, and are productive openings into an analysis of imaginative attempts to transform the way we understand visual images. To see how this is so, I will examine the work of Amedeo Modigliani, an artist of complicated Jewish heritage working under the watchful eye of Moses, and in the shadow of Sigmund Freud, Franz Kafka, and Pablo Picasso.

Amedeo Modigliani always began a portrait (and portraits comprise the bulk of his work) with the eyes. He explained that the eyes in his paintings

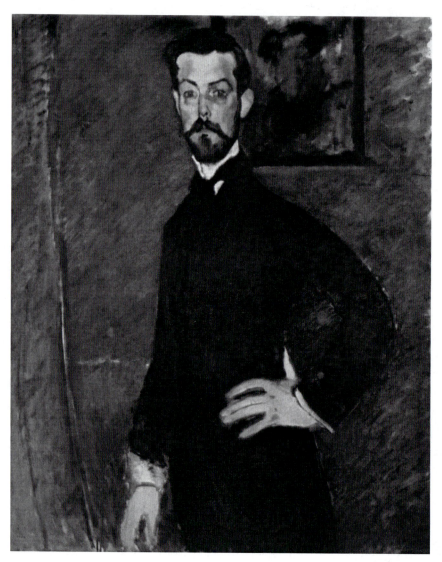

Figure 3.1 Portrait of Paul Alexandre (1909).

held the key to their psychologically charged atmosphere. Even when blank, sightless as in sculpture, they focus the attention hypnotically. As his career reached its climax, he began to paint some portraits with one eye "blind," the other seeing. "With one eye you look out at the world, with the other you look in at yourself," was his explanation.[13] Thinking of his work in his own terms, it becomes obvious that a central goal of his artistic vision was the revelation of the inner life of his subjects. To do this, he painted his most important subjects several times, often over a period of months or even years.

For example, his beloved friend, Paul Alexandre, was featured in a series of several paintings. The first, painted in 1909, is a fairly realistic, seemingly accurate representation.[14] The face is slightly, but not significantly longer than in life, and the eyes are open, blue, and staring directly outward. In the background, although muted, one can nevertheless discern a wall with an abstract painting on it. Alexandre's stance is almost defiant: with one hand on the hip and his open stare, he seems to be fully engaged with the viewer. There is little or no evidence here of the classic Modigliani economy of line. The next portrait painted approximately two years later, in 1911–1912 (Figure 3.2), shows a more pensive and abstracted Alexandre. The face is longer, the eyes more almond-shaped and virtually without pupils. The shape of the body is bulkier and less defined. Alexandre's hands, in direct contrast to the earlier rendition, are placed passively across his lap. The entire effect is one of thoughtful distraction, as if Alexandre is only marginally present at the sitting.

The final painting, dated 1913 (Figure 3.3), shows a drastically altered, yet completely recognizable Alexandre, with an elongated face and neck, pointed beard, and blind bright blue eyes. The background is totally muted, and Alexandre's right hand is placed passionately over his heart. In this portrait, as in the first, Alexandre seems wholly engaged with the viewer, yet here we see a figure of astonishing vulnerability, stripped, it would seem, of worldly pretensions. The sightless eyes convey exactly the kind of inward vision that Modigliani describes: this is a painting of a man's soul. As art critic Claude Roy has commented, upon viewing the three paintings:

> What is so remarkable here is the way in which, while accentuating distortions and progressively simplifying his brushwork, Modigliani succeeds in producing in each case a better likeness, both factually and psychologically. Anyone who, like the present writer, has met Dr. Alexandre, cannot fail to be struck by the way in which, in each successive portrait, the model becomes all the more his natural self, the more the painter's creative self comes to the fore.[15]

In this series of portraits we thus see the essential, reciprocal connection of the artist and his subject, as well as Modigliani's version of interpretative process, rendered in paint, rather than words. The blind eye is a metaphor

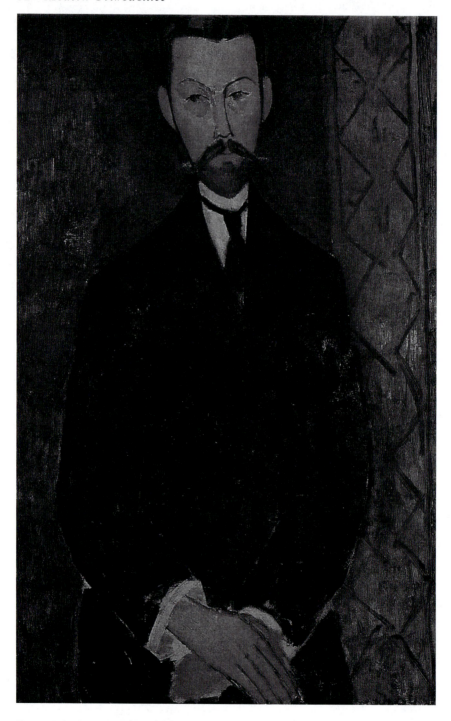

Figure 3.2 Portrait of Paul Alexandre (1911–1912).

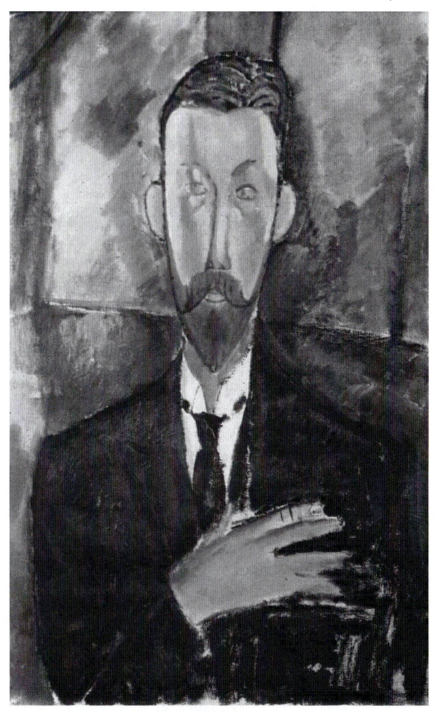

Figure 3.3 Portrait of Paul Alexandre (1913).

not only for the subject who must turn his vision inward, but also for the painter himself, whose eye must probe beyond the external features of the model into the depths of the soul.

While this idea of an "inward eye" clearly resonates with the theories being developed by Freud at the exact moment of Modigliani's most prolific period, it has other antecedents as well. Not coincidentally, for example, Franz Kafka was obsessed with the idea that we have knowledge of things only through our "inner perception." This, along with the view that consciousness is not layered, form the basis of what critics often call Kafka's "dream-like inner life" and the self-proclaimed subject matter of his narratives. For this perspective Kafka turned not only to Freud, but also to the even earlier philosophical/psychological writings of Franz Brentano, an Austrian psychologist who opposed experiment and espoused introspection as the best way of arriving at psychological truths.[16] Merging Brentano's philosophy with Freud's, Kafka wrote several narratives in which reality largely revolves around visual perception: what is actually "seen" with the eye is created by a vivid inner life. The most famous of these is *The Metamorphosis*, in which the central character, the young salesman Gregor Samsa, finds himself upon awaking one morning to have been transformed into a giant insect. Gregor's first apprehension of his metamorphosed self is a tangle of sensory impressions: visual images of his new, armor-plated chest and feebly waving legs, auditory impressions of his strangely non-human and incoherent voice. Significantly, these sensory impressions are indistinguishable from Gregor's awareness of his human subjectivity as brother, son, professional.

Because of his commitment to the "reality" of visual perception (and thus his insistence that his insect is more than merely "symbolic"), Kafka wants to tell a story in which the most authentic version of Gregor emerges through this process of physical change. Gregor's humanity exists in inverse proportion to his human appearance. Like the series of portraits of Alexandre, the portrait that Kafka paints of Gregor challenges the reader to reinterpret the particulars of the body. The more aware Gregor (and the reader) becomes of his physicality, the more "accurate" a psychological portrait Kafka paints of his subject. To fully interpret Kafka's narrative, the reader must also become a viewer, developing a concrete mental image of Gregor as a cockroach; a difficult task considering the divergence between Gregor's "human" voice and his insect-like appearance. Kafka was so concerned with this aspect of the story that he insisted that the illustrated edition of *The Metamorphosis* that appeared in 1915 not contain any pictures of the insect Gregor Samsa.

Although Kafka was clearly not a visual artist, this story attempts to bridge the distance between the realms of textuality and visual representation by making Gregor's visual appearance the center of the narrative, and absolutely imperative to its meaning. Like the relationship between the

material letters of the Torah and their spiritual significance, one cannot make sense of Gregor without "seeing" his shape. In this way, both Kafka and Modigliani validate the intractable lines and contours of material representation, offering up artistic interpretation not as means of eliding the physical, but of sanctifying it. Kafka thus intuits the intimate connection between the spiritual and the physical, the abstract and the concrete, that is central to Jewish thought:

> The imagery concept . . . is not a symbol, a metaphor, a circumscription, or a Jewish substitute for an abstract concept, but a unique mode with its own nature. Nor does the abstract equivalent, for example, "the completion of a task," exhaust the full meaning of "the blow of a hammer." Its particular, detailed representation is included within, and is part of, the generalized abstraction or category it is expressing. Perhaps the best definition is that the imagery concept is a special case, a concrete and characteristic example of a certain category of abstraction . . . Since the image is never far removed from the abstraction, it is always possible to make the transition from the general to the particular and back with facility.[17]

The bond between the image and its abstraction, described here by Adin Steinslatz explains, I think, why Modigliani, unlike many of his Modernist peers, never strayed into the realm of wholly non-representational art, and why Gregor, even as insect, never loses the idea of himself as a human being. Indeed, a large part of the power of Kafka's narrative is residual in the unexpectedly narrow gap between Gregor's human sensibility and his insect-like appearance. His absurdly matter-of-fact attitude toward his condition reveals how nearly completely his new physicality has integrated itself into his consciousness, revising his perception yet never eclipsing it. Straddling this complicated balance, Modigliani and Kafka craft representations that are unmistakably human, yet, nevertheless demand analysis.

In this precise aspect of his work, Kafka strays from Brentano's philosophy and allies himself with fellow German-Jew Sigmund Freud, for whom all images are ultimately determined by unconscious human impulses. Discussing Freud's relationship to the visual image, Peter Benson has noted the connection between fetishism and language, indicating that the displacements inherent in the formation of language provide a detour through which the fetish emerges completely in the visual field.[18] While Benson's argument has ultimate recourse to the erotic charge of the image once filtered through such a linguistic detour, the same principal of cathexsis can be applied here. Specifically, Benson describes the manner in which Freud, in the guise of art-critic, forgets who has painted a spectacular series of frescoes in the Orvieto cathedral. In forgetting the name of the painter, Freud reports:

So long as the painter's name remained inaccessible, the visual memory that I had of those series of frescoes and of the self-portrait which is introduced into the corner of one of the pictures was ultra-clear—at any rate more intense than visual memory—traces normally appear to me.[19]

Benson is quick to point out, with regard to the above quotation that "the displaced cathexis lost from the linguistic register had served to intensify the visual impression, including the name of the painter himself."[20] Kafka's narrative replicates this dynamic, as he draws an imagined visual imprint so stark that it produces an ultra-clear portrait, as it were, of the soulful character of Gregor Samsa. And while Kafka's textual image indeed causes us to stretch our interpretive vocabulary, it does so by providing an absolutely concrete description of Gregor-as-insect.

Kafka's portrayal of Gregor is thus useful in thinking about Jewish art in general, and Modigliani in specific, for several reasons. First, Kafka approaches his subject (in this case, Gregor) as a vehicle for radical transformation of a type that is inextricably linked to interpretive process. The title of the story, *The Metamorphosis* suggests that it is a story about such transformation, yet the really transformative element in the narrative is not residual in Gregor's change from man into insect—that happens before the first sentence—but rather in the transformation of the reader's understanding of the possibilities and limitations of the physical form. Kafka's effort to produce an authentic representation relies upon the presence of a striking visual image in a way that appears to depart from both conventional literary and Jewish tradition. In actuality, Kafka works the Talmudic distance between concrete and abstract to maximum effect here, and, in so doing, enforces a Jewish version of the linkage between the textual and visual/sensory realms. Like Modigliani, Kafka exercises an ever-increasing economy of form in order to articulate the "inner life" of his subject, an inner life whose true clarity is nonetheless still vulnerable to the detours of language.[21] For Modigliani, there is ostensibly no such obstacle. As Kafka describes the drama of the Samsa family, a drama whose pathology finally subsumes the tragedy of Gregor's metamorphosis, Modigliani offers us a picture, in 1915, of a bride and groom, and his own, wordless version of family pathology.

In this painting he departs from his usual confrontation with a single subject to show a couple that, while newly married, nonetheless communicates the anxieties of a divided family life. The most obvious element in the painting is the disproportionate relationship between the man and woman. The man, although he appears to stand slightly behind his wife, is the much larger of the two, so much larger, in fact, that the eye is immediately drawn to his figure. Unlike his wife, whose only visible features are the head and neck, the groom is shown from the head down to the middle of the chest, wearing a proper tuxedo and bow tie. The groom's clothing is split down

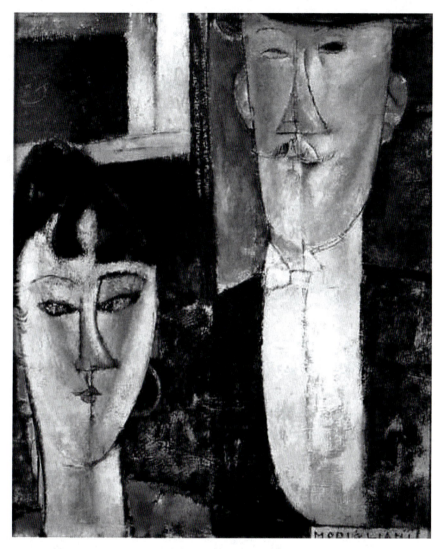

Figure 3.4 Bride and Groom.

the middle by a line that would seem to simulate an opening in his shirt, yet extends up through his tie and into his face, where it serves to accentuate his abstract disfigurement: his eyes, nose, and mustache are severely out of line with one another. As a result, he almost seems to have two faces.

Although its elongated, oval shape characterizes the bride's face, it is not divided in the same manner as the groom's. Her eyes are proportionate, blue, and without pupils. Her placement in the painting is off center, and her right ear is cut off by the edge of the canvas. The overall effect of the line going down the length of the groom's face is enhanced by a thick brown

line in the background of the painting that separates the couple and under-scores the essential differences between the backgrounds before which each is standing. The bride is set against a colorful wall containing what looks like a muted maroon window, the groom against a plain brown panel. The right side of the groom's face, that which is adjacent to the bride's, contains a pale blue, sightless eye, while the left side, more realistically proportioned, features a brown eye with the subtle shadow of a pupil.

Clearly, the male half of this portrait, while influenced into introspection by his blind right side, also retains membership in the outer world, the left side, as it were, of social etiquette (the tuxedo and distinguished mustache), commerce, and some version of tradition (he appears to be significantly older and more conventional than his bride). The wife, whose vision is turned completely inward, is significantly distanced from her husband, appearing to exist in a totally distinctive atmosphere. While the name of this couple is unknown, the relationship depicted here has its precedent in Modigli-ani's own family background, and reflects a series of divisions that mark his ambivalent connection with his personal history and Jewish heritage.

Born in Livorno, Italy, on July 12, 1884, Modigliani's childhood was char-acterized by the unspoken distance between his mother, an intellectual with little patience for social or religious norms, and his father, a man of tradi-tional upbringing with conventional familial expectations. Both his parents were from prestigious and once quite prosperous Jewish families of Sephardic origin. Unlike Marc Chagall, Chaim Soutine, and the other Jewish artists he would meet later in Paris, Modigliani had no knowledge of the poverty or anti-Semitism of ghetto life. On the contrary, for almost 300 years prior to his birth, the Jewish community of Livorno had enjoyed the special protection of the Medicis even as other communities suffered severe social prejudice.

His family, and in particular his mother, Eugenia Garsin Modigliani, was well respected and at the forefront of intellectual life in Livorno. His mother was indeed so accomplished and remarkable that Modigliani was known to have signed at least one of his drawings with his mother's maiden name of Garsin, and he was quick to admit that she had a most profound impact on the development of his personality. She grew up with three gener-ations of the Garsin family, all of whom lived in a large house in Marseilles, surrounded by history and tradition. One ancestor, a biblical scholar, had founded a school for Talmudic studies in Tunisia in the 18th century and Eugenia's father and grandfather debated theological questions with great fervor.[22] Raised in this atmosphere of enlightened intellectual inquiry, and educated at a French convent, Eugenia Modigliani wrote of her young life: "from eight in the morning to six in the evening I am a pupil in a worldly, Catholic, French institution, while at home I am Italian, Jewish, patriarchal and serious-minded."[23] The result of living in two worlds was that Eugenia felt an outsider in both and tended to be introspective and analytical.

Like the bride in her son's painting, Eugenia Garsin was the pensive wife of a conventional man. Her husband, Flamino Modigliani was deeply

attached to his family, in particular his father, Emanuele. Emanuele ruled the household even after Flamino's marriage, and expected his new daughter-in-law, Eugenia, to adhere to family tradition by kissing his hand and addressing him in the third person. In addition, the young bride was compelled by her husband and father-in-law to attend synagogue like the other Modigliani women, and to pay social calls at fixed times. Needless to say, these domestic arrangements were difficult and stifling for the secular, intellectual Eugenia. Anxious and depressed in what she perceived as a totally restrictive atmosphere, Eugenia channeled her frustration by writing poetry detailing her dissatisfaction with the traditional Jewish values propagated in the Modigliani home: virtue, kindness, abstinence, piety, social formality, and ritual observance.[24] The young Amedeo keenly felt the division between his father and mother. Caught in the middle of a battle between the secular life idealized and craved by his mother, and the more traditional atmosphere of his paternal home, Modigliani was a delicate child who was quickly acculturated into this struggle for ideological and theological power within the household. The crystallization of this conflict can be seen in his few paintings of domestic life, such as *Bride and Groom* and *Jacques Lipchitz and His Wife* (Figure 3.5).

The woman is always small, with more of her head showing than her body, and is placed in the corner or bottom of the painting. The husband is a figure of double identity, with a misshapen face and uneven eyes. Despite the parental disparity suggested by these paintings and Eugenia's disavowal of all things religious, Amedeo Modigliani learned the chapters of prescribed Jewish law traditionally recited on his thirteenth birthday, and wrote with pride in his mother's diary that in July 1897 that he had become a *bar mitzvah*.[25]

Whereas this appears to have been the end of Modigliani's relationship with institutional religion, it was only the beginning of his struggle to reconcile the dichotomy between the artistic and moral life that had dominated his childhood and would continue to powerfully shape his life. Several biographical anecdotes point to his ongoing identification with the Jewish people. Even during the middle years of his life, while he was living a wholly secular existence in Paris, he surrounded himself with Jewish peers, including Soutine, the Russian painter M. Chwat, Jacques Lipchitz, Kisling, Chagall, and Max Jacob, a Jew who had converted to Christianity. According to his friend Louis Latourrettes, one night in 1914, while drinking with friends in a café in Montremarte, Modigliani silenced a group of card players at a neighboring table who were making anti-Semitic comments by walking straight up to their table and telling them to their faces "I'm a Jew and you can go to hell."[26] Although he was encouraged by Max Jacob to convert, Modigliani flatly refused. In an overt condemnation of Jacob's actions, he began in 1915 to more vigorously seek out his roots, spending increasing amounts of time with Soutine and other Ashkenazi artists studying Rembrandt's portraits of Jewish faces from the Amsterdam ghetto, and speaking animatedly in a combination of Russian, French, and Yiddish. He made a drawing of Chana

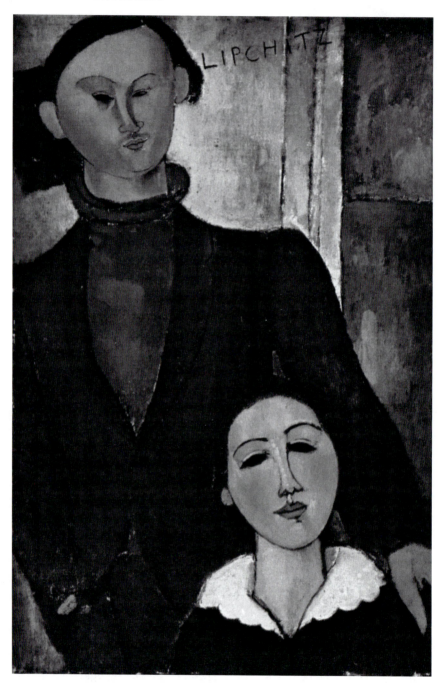

Figure 3.5 Jacques Lipchitz and Wife.

Orloff, a gifted sculptor from Palestine, and wrote her name in Hebrew letters across the top of her head. "I carry no religion," he told her, "but if I did it would be the ancient religion of my ancestors."[27]

For Modigliani "carrying no religion" meant carrying his religious impulses into art. This is immediately apparent upon viewing a self-portrait that Modigliani drew in 1908 (Figure 3.6).

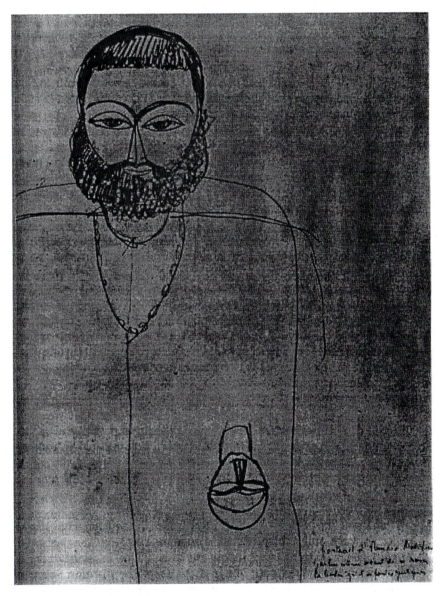

Figure 3.6 Modigliani, *Self-Portrait*.

In this drawing, he appears with the full facial hair and skullcap of a traditional *rebbe*. The shapeless tunic thrown over his figure accentuates prominent dark eyes and a large nose. The body, lightly sketched, is entirely secondary to the head, which is etched in bold decisive strokes. Within the vague outlines of this body however, Modigliani has drawn in a second, beardless head, floating upside down across his left side. This second head, though entirely hairless, contains the same disproportionately large eyes and nose, and appears darker than the background into which it is set. Most importantly, the second pair of eyes is without pupils, "blind" as it were. What will become the classic Modigliani style—two blind eyes, or, more often, one eye blind, the other seeing—is here more fully represented as two complete heads. As in the later work, this portrait is remarkable in its depiction of a dualistic vision, presenting the eyes that encounter the world, and those that point inward, into the labyrinth of the soul.

The dualistic nature of this self-portrait speaks to Modigliani's growing introspection, as well as to his desire to conjoin the Jewish tradition in which he was raised with his vocation as a bohemian Modern artist. The words "self portrait, before and after growing a beard" actually appear in the artist's handwriting on the sketch, complicating what is already a difficult visual commentary on his Jewish identity. The textual description provides a linguistic distraction from the assertively Semitic claim of the bearded self, yet reinforces the central image of Modigliani as an interpreter in the rabbinical mode. With this in mind, it appears that this self-portrait offers three versions of the artist: the deracinated, beardless, and blind "inner" self; the self that faces outward and carries with it the weight of race and tradition; and the artist who must for some reason account for his own image in words.

In large part the important work of this self-portrait thus takes place in the movement from the abstract to the concrete and back. In striking contrast to Modigliani's usual appearance, clean-shaven and dressed in typical Montremarte bohemian style, the Modigliani of the drawing assumes the face of his Talmudic ancestors and not of his artistic Parisian peers. While it is unclear, without the explanatory text, whether Modigliani is in the process of becoming the bearded Jew or leaving him behind, the co-existence of the ethnically particular external Jewish face and the featureless internal face rehearses the idea of co-existent abstract and specific realms of interpretation. These realms not only mirror the discourse of Torah study to which I have previously alluded, they also present a striking visual portrayal of the artist in the process of negotiating between the universality of artistic endeavor, and the particulars of Jewish identity.

Modigliani was certainly not alone in this attempt. Sander Gilman and others have recognized, in Freud's theory of psychoanalysis, the compelling drive to subvert Jewish difference to the universal, deracinated imperatives of sexuality. In *Difference and Pathology*, for example, Gilman traces the relationship between the Jewish joke and the hidden language of the Jew as anti-Semite:

In this medium Freud creates a language for himself which is neither that of women nor of Jews. Freud replaces both of these languages with the new language, the language of the unconscious. It is a language present in all human beings, one unmarred by the sexual or anti-Semitic politics of his day, or at least so Freud hopes. The exercise of collecting and retelling the Jewish jokes, of removing them from the daily world in which Freud must live to the higher plane of the new scientific discourse, that of psychoanalysis, enables him to purge himself of the insecurity he feels as a Jew in fin-de-siecle Vienna . . . The very structure of the joke embodies the distancing of existing attitudes and their replacement by a new discourse, the universal discourse of psychoanalysis.[28]

Modigliani's insertion of the featureless face in his self-portrait establishes his desire—like Freud's—to possess and propagate a universalist discourse, while simultaneously affirming his Modernist credentials. The utopic internal face, free of ethnic limitations, is clearly part of a series of Modernist conventions designed to unleash what is at the ostensibly racially blind center of creative consciousness.

Paradoxically, Modigliani's complicity with this kind of abstraction was as much a symptom of his conventionality as it was a concession to Modernist aesthetics. Although most critics focus on Modigiliani's unorthodoxy, both in his lifestyle (he was a profligate, a drunkard, and a voracious womanizer), and in his art (the highly experimental nature of his portraits in particular), he was actually very much drawn to tradition. Unlike most of the Italian poets and painters of the time, he staunchly refused to accept the doctrines of Futurism advanced by Marinetti in 1910, especially inasmuch as the Futurist manifesto included a "ten year ban on the nude."[29] He was immensely influenced not only by the conventional painters of the Renaissance period, but also, and much more profoundly, by the classical form of the caryatid, the female figure designed to bear weight. These figures were probably inspired most directly by figurines from the Ivory Coast, although there are also excellent examples of caryatids stemming from the Greek and Roman periods. While such recourse to classical and primitive models is now understood to be a commonplace of Modernist invention, during the time in which he worked such interest in conventional forms was yet another aspect of his personality that alienated him from the overall intellectual milieu.

Pablo Picasso was an important exception to this rule. Modigliani's use of African art was an echo of what was simultaneously appearing in Picasso's transitional paintings. In Picasso's portrait of Gertrude Stein, created in 1906 (Figure 3.7), he superimposes a flat, expressionless mask with two eye slits upon the angle of the rest of the face and body, a mask derived from the ancient Iberian reliefs he had seen at the Louvre. This painting of Stein, which Picasso labored over greatly, was one of a constellation

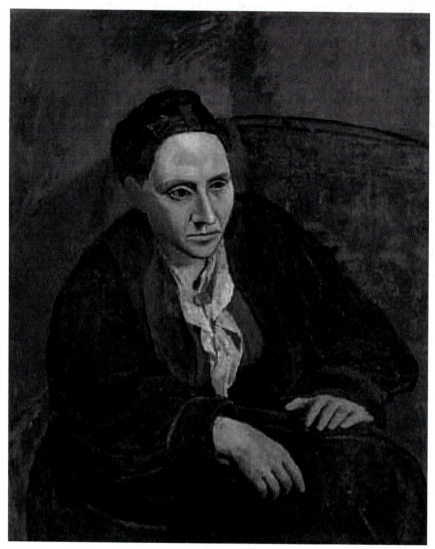

Figure 3.7 Portrait of Gertrude Stein.

of works that were highly referential to African sculpture and that would become the hallmark of his most significant creative period, culminating in the famous *Les Demoiselles d'Avignon* (Figure 3.8).

The shape and character of the eyes in particular, both in the portrait of Stein and in *Les Demoiselles* are deeply reminiscent of Modigliani's entire canon of work. There are, for example, marked similarities between Picasso's 1906 painting of Stein and Modigliani's famous work entitled *The Jewess* (Figure 3.9).

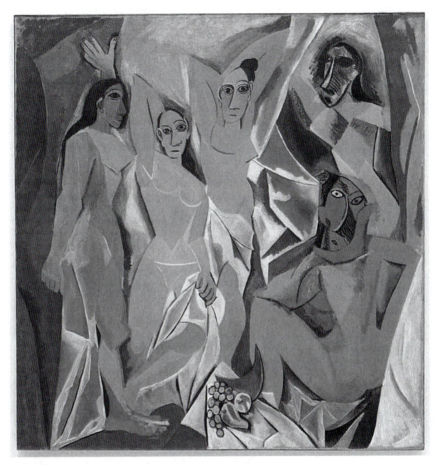

Figure 3.8 *Les Demoiselles d'Avignon* (1907).

Eyes, again, are prominent, and, while the mood, coloration, and positioning of the figures are nearly identical, Modigliani's Jewess, unlike Picasso's Stein, appears a figure of deep pathos.

All of this points to the complex relationship between African art and racial/ethnic identity that has been noted by several critics, most recently Michael North.[30] For the Jewish artist, this relationship bears the weight of common exile and shared darkness; when the secular Jewish artist appropriates the "mask" of African culture he gestures toward something not entirely dissimilar from Modigliani's masking himself as the bearded religious Jew in his self-portrait.[31] In both cases, the mask suggests the revival of an alien and ancient culture, one whose rituals and traditions inscribe both difference and authenticity. By using the mask of a seemingly archaic culture to create an original self-image, Modigliani incorporates

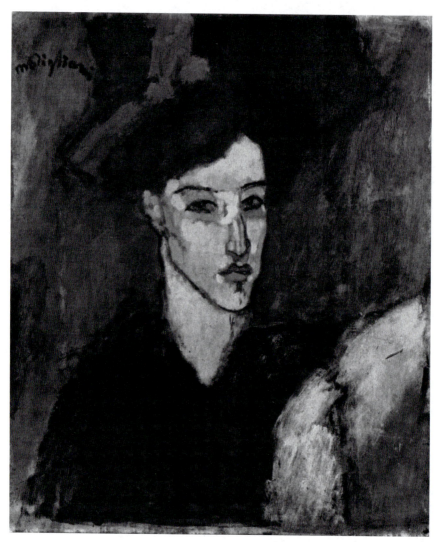

Figure 3.9 The Jewess.

the mythology of Jewish difference into the rhetoric of Modernist invention. In a similar manner, and taking his cue from Gertrude Stein, Picasso understood such masking as an act of supreme originality. Stein called her African-American inspired writing (in the story "Melanctha"), "the first definite step away from the nineteenth century and into the twentieth century in literature."[32] Such claims seem somewhat ironic in light of the implicit racism and anti-Semetism of many Modernist works, and Gilman's description of Freud's desire to universalize the Jewish experience by assimilating an alternative discourse are clearly resonant here. This irony

is compounded and complicated by the fact that Modigliani conjoins the forms of African art with the ethical imperatives and traditions of Judaism to produce such a discourse.

The African mask is a thus a trope of Modernism that mirrors, in its most common utilization, what is at the crux of Modigliani's work (as well as Jewish analytical method), namely, the apparent obfuscation of the face in order to exploit the inherent tension between the abstract and the concrete. In using the mask, Modigliani uses an African model in the service of a Jewish method. Hiding, disfiguring, or layering the details of personality result in the gradual illumination of these very details, as the viewer becomes ever more implicated in the process of visual interpretation. The successive repetitions of Modigliani's portraiture seduce the viewer into ever-increasing modifications of his or her impression of his subject, creating images that are more "accurate" than actual photographs. Modigliani validates the importance of such interpretive progression by repeatedly painting the same subject, each time with a different, and more evocative "mask."

The most compelling example of this repetition is seen in the proliferation of portraits that Modigliani painted of his lover and the mother of his child, Jeanne Heburterne. In each successive picture, we again see that the more abstract the canvas becomes, the more specific the psychological portrayal. Not coincidentally, the abstraction of Jeanne's image occurs in inverse proportion to the solidification of Jeanne and Amedeo's domestic arrangements. His most famous paintings of her are indeed so distinct from her actual physiognomy that one critic has commented: "No one has ever met a girl in the street who really looked like the Jeanne Heburterne we see in the twenty canvases on which Modigliani has immortalized her face."[33] Despite this, we can trace the beginning of his exploration to an actual photograph of Jeanne, taken during their first meeting. In this photo the very young Jeanne (she was a full fourteen years Modigliani's junior) appears in high boots, wearing a poncho-style blouse and long skirt. Her chestnut hair is piled in a high chignon, and she poses languidly, her head drooping to one side and her delicate fingers hanging loosely from the enveloping sleeves of her homemade gown. In this actual photograph she seems to mimic what had already become, by 1917, the signature elegant, elongated posture of the Modigliani model.

Painting Jeanne in 1918, Modigliani takes his cue from the photograph. In this portrait (Figure 3.10), Jeanne has the characteristic long face, aquiline nose, and eyes with pupils that stare directly out at the viewer. The presence of the focused stare is relatively unusual for Modigliani, and generally signals a representation of the "outer," more material aspects of personality. Although the features are distorted, the eyes and eyebrows are more realistically placed and the hair, long and framing the face, is in the mode of the very young girl that she was at the time of this sitting. The delicate, pointed chin and small pouted mouth give her an air of sultry innocence. This image of Jeanne thus combines the abstraction of her features

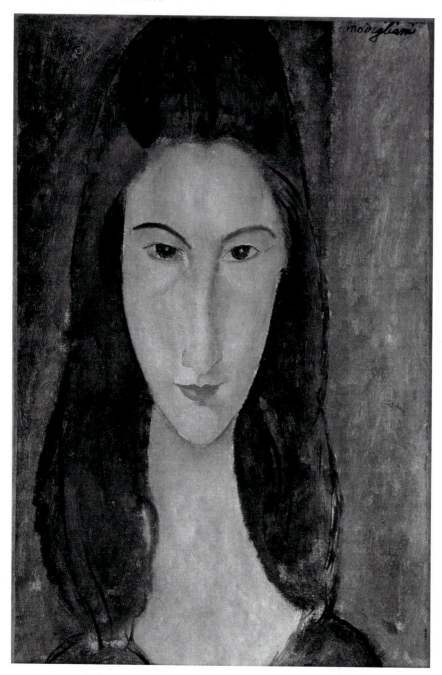

Figure 3.10 Portrait of Jeanne Hebuterne (1916).

with the "photographic" effect of her clothing, pose, and subjectivity as Modigliani's model and lover. The painting reveals Jeanne as she was at the time: a bohemian Parisian girl with her own artistic aspirations, and quite infatuated with Modigliani.

The radical transformation in Modigliani's understanding of Jeanne can be seen in a portrait painted just one year later, in 1919 (Figure 3.11).

In this painting, Jeanne is not the bohemian model, but rather a seasoned, pragmatic woman of ethnic inflection. Although she wears a cloche hat, very much the fashion in 1919, she looks modest and robust, rather than sophisticated. The coloration and facial lines of this painting are similar to that of Modigliani's portrait of Chaim Soutine (Figure 3.12).

Although Soutine's eyes, unlike Jeanne's, contain pupils (somewhat unusual for Modigliani), their size and placement on the face are virtually identical in the two portraits, as is the somewhat ruddy coloring of the skin. Soutine encapsulated, for Modiglaini, the essence of the Jewish artist. Wearing his *shtetl* background on his sleeve, Soutine was far less ambivalent about his ethnicity than Modigliani. The emphasized nose, large lips, and dark hair and eyes in Modigliani's portrait of Soutine underscore this impression.

Correspondences between the portraits of Jeanne and Soutine are particularly notable in light of the fact that during the course of his relationship with Jeanne he became increasingly concerned about the religious difference between them. A practicing Catholic from an extremely pious household (Jeanne's father, Achille Hebuterne, was a convert from Protestantism who became a "pillar of the Roman Catholic Church"),[34] Jeanne abandoned both her religion and her artistic ambition to bear Modigliani's children without the benefit of marriage. Although Jeanne herself was quite willing to accept Modigliani's Judaism, her family insisted upon a Roman-Catholic marriage ceremony. Modigliani was ultimately unable to agree to this, despite the fact that he wrote to his family on several occasions that he intended to marry Jeanne, and even went so far as to produce a written "marriage pledge." He was deeply troubled by the Heburterne's attitude toward his religious heritage, and, when pressed to legally follow through on his commitment to Jeanne, told his friend Alselmo Bucci:

> "I'm a Jew, you know. There is no 'Jewish question' in Italy. I'm a Jew and you know the family feeling we have. I can say that I have never known misery. My family has always helped . . . they never abandoned me."[35]

Modigliani's professed "family feeling" seems an odd excuse for his reluctance to legitimize his own growing family (Jeanne was pregnant with his second child at the time), and underscores a connection to Jewish identity that may well have resulted in his fantasy vision of Jeanne as the Jewish mother of his child: the ethnic sister of Chaim Soutine, rather than the gentile daughter of Achile Heburterne.

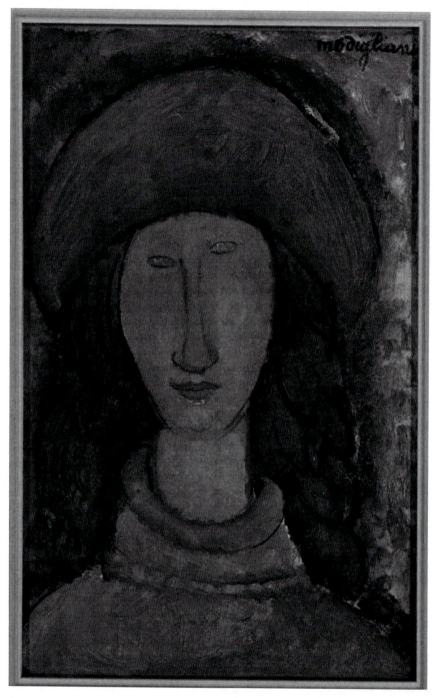

Figure 3.11 Portrait of Jeanne Hebuterne (1919).

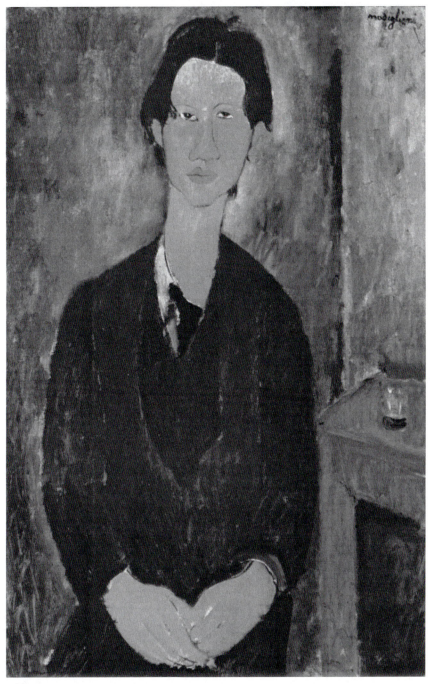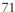

Figure 3.12 Portrait of Chaim Soutine (1916).

The trajectory of this desire to transform Jeanne, and the remnants of her actual transformation, can be traced in the several portraits that intervene, all painted during the year 1918 and 1919.

In Figures 3.13 and 3.14, for example, her face is slightly fuller, the hair more demure, the head tilted pensively to one side, and the eyes are, in contrast to the earliest portrayal, blue and blind. In both of these paintings, Jeanne is languid and thoughtful. In each portrait, one hand is resting in her lap while the other caresses her face or shoulder. The growing introspection and maturity conveyed by these paintings is realized even more fully in Figure 3.15, where we see Jeanne posed with both hands in her lap, hair piled in a demure chignon on her head, seemingly weary and disengaged. Finally, in Figure 3.16, Modigliani paints his lover pregnant. The eyes are now very uneven (see Figure 3.11), the shoulders are covered, and the hair is again braided, although she is now hatless.

These overlapping and evolving images of Jeanne betray the weight of her ever-increasing physical and psychological burdens. Her devotion to Modigliani was challenged, during the two and a half years of their relationship, by his excessive drinking and deteriorating health. Although Jeanne was quite accustomed to Parisian nightlife, Modigliani often left her alone while he visited cafés, coming home quite drunk and with the expectation that she would care for him in the manner of a wife, despite the fact that he refused to marry her. His volatile personality and their extreme poverty thrust Jeanne into periods of deep despair. When she became pregnant with their second child at the age of twenty-one, it became clear that she was destined to sacrifice any hope of fulfilling herself as an artist. Indeed, several critics have suggested that Jeanne's bravery was her complete and total willingness to step completely into Modigliani's world, to let his projection of her eclipse her true identity. His portraits of her elaborate this quite brilliantly, as they layer his vision of Jeanne atop her true physiognomy, literally re-shaping her face.

Yet, what we see here is not a full superimposition of identity, but the graceful and remarkable convergence of circumstance and desire, a mirror reflecting an ever-intensifying reciprocity of purpose. It is for this reason, I suspect, that the portraits of Jeanne are the most well known and beloved of Modigliani's works. In bringing Jeanne's spirit to the surface, the artist simultaneously lays his own bare. So deeply entwined were Jeanne Hebuterne and Amedeo Modigliani that without him she ceased to exist. Within hours of his death of tubercular meningitis on January 24, 1919, Jeanne, pregnant with their second child and inconsolable, threw herself from the window of her family home and was killed instantly.[36] The blurring of identity so poignantly exhibited by Modigliani's portraits of Jeanne threatens to vanquish the categories of "inner" and "outer" to which the artist claimed to be so attached. Not only is it impossible to situate the "inner" Jeanne in these paintings, it is difficult to discern where Jeanne ends and Modigliani begins. The "inner eye" becomes, in this context, a metaphor for the

artist's own blind eye, the eye that seeks to re-imagine the radically human center of the subject. Such an imaginative endeavor to reconstruct the subject is, as Yosef Hayim Yerushalmi has suggested regarding Freud, always already complicated by a residual permanent relationship with Judaism.[37] This is so not only by virtue of the process itself—Derrida's argument—but also by the underlying simultaneous set of assumptions that spiritual truth is materially both absent and present, concrete and abstract. The moral and

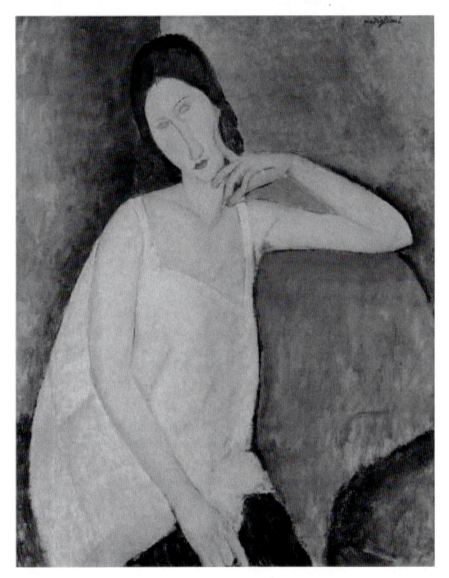

Figure 3.13 Portrait of Jeanne Hebuterne in a Chemise (1918).

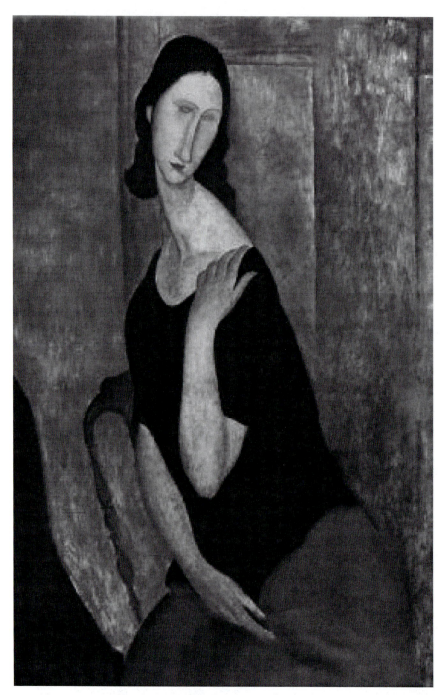

Figure 3.14 Portrait of Jeanne Hebuterne (1919).

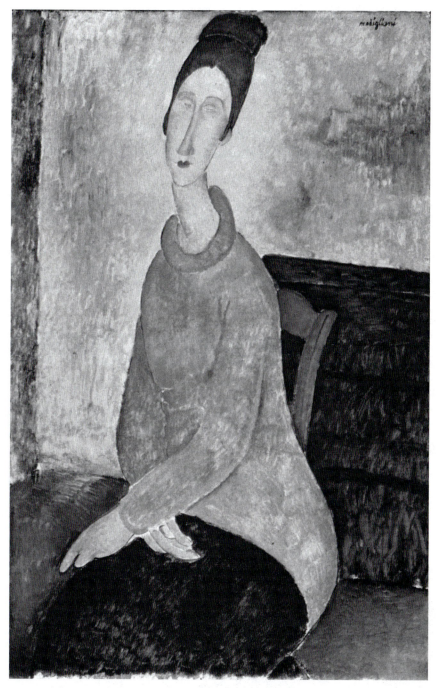

Figure 3.15 Portrait of Jeanne with yellow sweater.

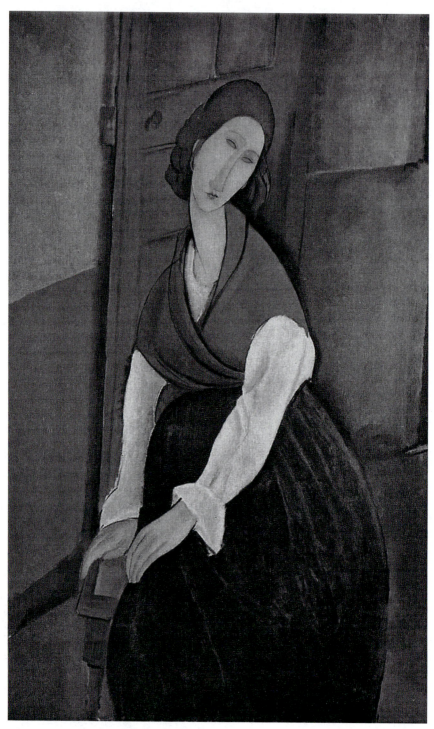

Figure 3.16 Portrait of Jeanne, 1919.

ethical imperative, from the Jewish perspective, is to attempt to recuperate the godly inner self with full awareness that this is a nearly impossible end-point. This effort is writ large on Modigliani's canvasses, nearly all of which depict the disfigured, yet supremely evocative human face.

From this same Jewish perspective, the human face contains the potential for both godliness and corruption. This dual potential, more than any other thing, provokes rabbinic concerns regarding idol worship, and sets in motion myriad *halackic* opinions. Most important of these—for this argument—is the distinction between two- and three-dimensional renderings of that which most nearly resembles God himself, the human face and figure. The Christian concept of spiritual truth embodied in the person of Jesus Christ, as well as the pagan custom of worshipping three-dimensional idols, resonates with rabbinic injunctions against the creation of objects possessing both dimensionality and human verisimilitude.[38] Jewish art, while certainly not forbidden by either the second commandment or the rabbis, must nevertheless adhere to the precise conceptions of dissimulation and two-dimensionality that mark the canon of Modigliani's work.[39]

This segregation between the materially accurate and the imaginatively abstract is not only a feature of Jewish aesthetic culture; it is also the site of a moral and theological debate that seeks to place Jewish art (and Jews) at the margins of such culture. This paradox is encapsulated in an argument between Kant and Hegel, each of whom firmly deny any Jewish affiliation with visual art. Kant, predictably preferring the abstract to the concrete, finds:

> The most sublime passage in the Jewish Law is the commandment "thou shalt not make unto thee any graven image . . . etc. This commandment alone can explain the enthusiasm that the Jewish people in its civilized era felt for religion when compared with other peoples, or can explain the pride that Islam inspires. The same holds true for our presentation of the moral law and for the predisposition within us for morality.[40]

Lurking beneath Kant's statement about the moral rigor of religion—in this case both Judaism and Islam—is the insistence that such rigor is achieved only by the strict avoidance of all sensate images and spiritual props. While morally superior, such a disembodied notion of Judaism reeks of inaccuracy and insantiates Jewish difference. Hegel agrees that Jews are different, yet sees the divergence as a sign of spiritual bankruptcy:

> Everything genuine in spirit and nature alike is inherently concrete and, despite its universality, has nevertheless subjectivity and particularity in itself. Therefore the Jews and Turks have not been able by art to represent their God, who does not even amount to such an abstraction of the Understanding, in the positive way that the Christians have. For in Christianity God is set forth in his truth, and therefore as thoroughly concrete in himself, as person, as subject, and more closely defined as spirit.[41]

Reviewing this debate, Kalman Bland articulates the notion that Kant and Hegel here create a "double-bind" for the Jews.[42] Taking Kant's position, Jews must relinquish visual art in order to maintain moral stature. Under Hegel's auspices, Jewish art is a betrayal of the essential abstraction of Jewish spirituality and a concession to Christian understanding. Yet, as we have seen, while Jewish theology posits a materially absent, and therefore abstract, God, it simultaneously insists upon the ongoing interpretation of material reality as a most fundamental form of spiritual pursuit. Furthermore, the process of imaginative, creative elaboration is, when properly pursued, a form of sanctity.

Thus, while the notion of Judaism as an anionic religion has been seized upon and assimilated by nearly all secular Jewish intellectuals and philosophers of the 19th century, including Karl Marx, Martin Buber, and Sigmund Freud, and a great many current thinkers, including Ozick and Geoffrey Hartman, such a notion is less a symptom of prohibitive Jewish law than one of pervasive cultural stereotype. The dichotomy, proposed by Hegel, between materially embodied Christian truth and the endlessly abstracted Hebrew God fails to account for the way in which Jewish artists like Modigliani use the visual image not to reconcile this dichotomy, but to wrestle a subtle moral profundity from its implications.

In 1918, Modigliani painted two little girls—one quite dark, the other fair and blue-eyed. While there is much to say about this extraordinary painting, I want to call attention in this context to the face of the honey-haired girl in white. With her vacant sky-colored eyes, porcelain skin, and misshapen features, hers is the shattered face of an angel. The eye of the artist, and of the viewer, is compelled to re-assemble it. This is a Jewish image of high moral stature.

Such assembly is clearly not the province of Jewish art alone. Yet, the most Romantic (and Orthodox) strains of Jewish thought recognize the idealistic endeavor to perfect the world—*tikkun olam*—in such efforts. American professor of philosophy and Judaic Studies Steven Schwartzchild articulates a version of this in a neo-Kantian essay published in 1987. Although Schwartzchild confirms Ozick's statement that the biblical ban on images, especially representations of God, explains "the striking poverty of plastic graphic arts in Jewish history," he goes on to claim that this

> Aboriginal aesthetic (for Jews and Gentiles alike) also explains why non-representational painters like Mark Rothko prove that "in modernism, art is assimilating Judaism . . . modernism depicts the world as it ought to be, not as it is . . . true aesthetics, Kantian and Jewish, subsumes art directly but decisively to ethics.[43]

The idealistic Modernism described by Schwartzchild demands an eye that looks inward and outward simultaneously, creating distortions at every turn.

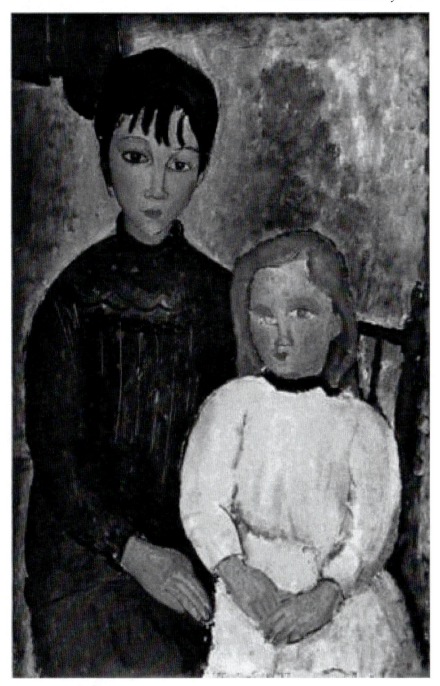

Figure 3.17 Two Girls.

Undoubtedly, this was Modigliani's vision. In his diary, Paul Alexandre, Modigliani's closest friend and largest collector, wrote "Recently, a reputable ophthalmologist wrote to me asking quite seriously if the 'distortions' of Modigliani's portraits might not simply be the result of defective eyesight."[44] Alexandre glibly relates this anecdote primarily to demonstrate how misunderstood Modigliani's work was in his time, yet at the core of this "joke" is an erudite insight regarding Modigliani's creative process as well as the reception of his art. The "defective eyesight" that caused Modigliani to render eyes, noses, and necks as elongated and misshapen has its root in the cultural imprint of Jewish ethics and the subtle vestiges of Jewish law. The more defective or "blind" the vision, the closer one becomes, in Jewish terms, to obtaining spiritual grace.

Yet, chillingly, this exact rhetoric of defective vision was used by Adolf Hitler at the height of his power to justify the removal not only of the Jews, but also of the "degenerate" forms of art that he saw as the German assimilation of Jewish culture. In his speech at the opening of an exhibit of the new "Modern art" Hitler comments:

> I have observed among the pictures submitted here, quite a few paintings which make one actually come to the conclusion that the eye shows things differently to certain human beings than the way they really are . . . here there are only two possibilities: either these so-called "artists" really see things this way and therefore believe in what they depict; then we would have to examine their eyesight-deformation to see if it is a product of mechanical failure or of inheritance.[45]

The "inheritance" of the Modern artist is, in Hitler's terms, the eye that sees something other than that which is materially present. Such defective vision refers not only to the visual art of Modern period, but also to the concepts of analytic scrutiny and "hidden language" that were the cultural contributions of many of the most secular German Jews. To restore godliness to the Third Reich involved the absolute restoration of an objective and concrete national vision. Furthermore, the facial distortions practiced by Modiglani, Picasso, and other Modern artists, were a threat to the purity of physical form endorsed by Hitler's fascist philosophy. Ironically, several years before Hitler delivered this speech, Modigliani was experimenting with renditions of the human face that accentuated the very characteristics Hitler deemed as Semitic, degenerate, and objectionable.

The activity of the eye is a central concept in rabbinic literature because it is at the heart of blessing and of curse. In one Talmudic verse it is written that blessing is only bestowed on that which is hidden from the eye.[46] From this comes the concept of the "evil eye"—the eye that wrests control away from God by taking visual possession of that which he most desires. This is, indeed, the corrupt underside of the participative process of interpretation to which Derrida alludes. If visual possession can be motivated by base

desire, and thus instigate a curse, so can the effort to reveal what is hidden from outward appearance be for a blessing. The definitive moment, the moment in which we discover the creative or destructive power of such an eye seems to me to be a moment very much like the one in which Gregor Samsa wrestles with the implications of his newly transformed self, trying to accommodate both his alien physicality and his ethical human soul. Gregor's moral machinations prove that he is no mere cockroach, but one who bears the burden of compassionate anxiety: the son who will be sacrificially smashed in his effort to reveal himself to the father. In this case, as in the case of Modiglaini's life and work, the blessing—the weight and solemnity of the recuperative effort—-is also the curse.

Thinking of the eye that is capable of both blessing and curse, I am compelled to return to a different, but only slightly different version of Modernism: the American Modernism of F. Scott Fitzgerald. In *The Great Gatsby* the powerful metaphor of the unseeing, and yet all-seeing eye appears in the form of an advertisement hovering hopefully over the barren land between Queens and Manhattan. The massive sign depicts nothing more or less than a huge set of omniscient eyes, the eyes of Doctor T.J. Eckleburg:

> But above the gray land and the spasms of bleak dust which drift endlessly over it you perceive, after a moment, the eyes of Doctor T.J. Eckleburg. The eyes of Dr. T.J. Eckleburg are blue and gigantic—their retinas are one yard high. They look out of no face but, instead, from a pair of enormous yellow spectacles which pass over a non-existent nose. Evidently some wild wag of an oculist set them there to fatten his practice in the borough of Queens, and than sank himself down into eternal blindness, or forgot them and moved away. But his eyes, dimmed a little by many paintless days under sun and rain, brood over the solemn dumping ground.[47]

This passage, canonical to the point of redundancy, informs the reader that the representation of the eye, even, as in this case, for commercial purposes, is at the core of the story that Fitzgerald has to tell. It is a story in which the huge cardboard eyes are the only real witnesses to the unfolding narrative events. Gatsby, frequently understood as a Jew, creates and recreates his own image, as well as the images of those around him, with the romantic vision of a true religionist, and under the watchful gaze of a distant, disembodied father. The reciprocity of this gaze, and its attendant guilt, anxiety, and struggle, serves to recuperate Gatsby's story—in many ways the story of the Jewish artist—from the wasteland of representation. Staring boldly back, Gatsby engages with the absent God long enough to transform his life into myth, a doomed (and very Jewish) endeavor, to be sure. Yet, it is one whose power motivates the machinery of Modern aesthetics in ways that Modigliani, howsoever prescient in 1917, could hardly have foreseen.

4 Of Mice and Melancholy
Jewish Graphic Novels of the Holocaust

"You either conserve tradition by giving it sacred and untouchable status, or make it more practicable, fungible, that is modernize it—but that is to play a game which could gamble away what you wish to transmit"

"Second generation" Holocaust survivor Art Spiegelman is willing to take this gamble. Retrospectively documenting his father's experience as an inmate at Auschwitz, he invokes what is often seen as a profound rupture in Jewish narrative. His seminal graphic novels *Maus I: My Father Bleeds History* and *Maus II: And Here My Troubles Began* bear witness not only to the unspeakable events his father endures, but also to the significance of the Holocaust as a definitive historical divider between Modernism and Post-Modernism.[1] If, as Dominick LaCapra suggests, it is not possible to talk about the Post-Modern without recourse to the Holocaust, it seems equally true that one cannot discuss Jewish cultural production in the 20th century without simultaneously interrogating that which is most surely at its core: the "bleeding of history" experienced by Vladek Spiegelman and countless others during the Holocaust. Indeed, the proliferation of Holocaust testimony and accompanying literary, historical, political, psychoanalytic, and philosophical attempts to analyze an event that by all accounts trespasses human understanding reinforces the urgent necessity to contextualize the Shoah within the broader discourse of global genocide as well as that of contemporary Jewish identity. These attempts, too numerous to name, nearly always concentrate on negotiating the difficult terrain of trauma, individual memory, and collective history.[2]

If critical attention is any indicator of success in this endeavor, Spiegelman's novels must be—and indeed have been—taken into serious account. Among the more compelling reasons for the now canonical status of these texts is precisely the manner in which they negotiate the difficulties of representation by employing innovative "post-structuralist" narrative strategies while simultaneously upholding an unspoken commitment to historical veracity howsoever difficult such a promise may be to actually keep. Spiegelman's keen understanding of the fundamental impossibility of rendering an "authentic" historical account is jeopardized by his equally pressing desire to keep faith with his literal and figurative parents. The books can indeed be understood as constructed by this profound ambivalence: the use of comic book form and animal typography calls attention to the

flawed and fictive nature of the endeavor, while the insertion of painstakingly researched details, actual photographs, and even diagrams and charts demonstrates a serious effort to instantiate historical veracity. Perhaps the most chilling of these features is a "map" of one of the four crematoria that indicates precisely where gold fillings were melted and corpses were moved via elevator from the underground gas chamber to the ovens where they were burned "2 or 3 at a time."[3]

Such details are framed by both Vladek Spiegelman's verbal exhortation that he is "an eyewitness," as well as the panels of sequential art that they reflexively occupy. Spiegelman thus actively applies strategies of visual "containment" to material which he knows is radically *un*containable; unmoored from ethical or rational explication, Vladek's memories are forced into a dubious (and ultimately false) approximation of a conventional plot. For many critics (and, I would argue, for the author himself) the fact that the text uses the now conventional Post-Modern stratagem of calling constant attention to its own status **as** text releases it from the double-bind of "telling" a traumatic history.[4] As Arlene Fish Wilner suggests, Spiegelman responds to Hayden White's notion that by virtue of the fact that they are either "reverential" or "objective," conventional historical studies lead to a repetition rather than a correction of, the past event; certainly not a desirable outcome in this case. Using a "unique narrative strategy" Spiegelman "evokes the perception that the coherence encouraged by figuration—analogy, metaphor, and other sorts of juxtaposition—is simultaneously necessary and impossible" offering readers the "illusion of comprehensibility and a constant reminder that any totalizing vision in which they may take comfort is not manifest in the events portrayed but is rather the product of moral and aesthetic choices fostered by human will and creativity."[5]

Wilner's claim that Spiegelman's narrative strategy enforces a "coherent" view of history while maintaining a necessarily ironic perspective on the objectivity of Vladek's (or any other) testimony enforces the familiar reading of the text as offering an expression of the human consequences of the Holocaust without recourse to dangerous sentimental attempts to explain the event in ethical or religious terms. In fact, while Wilner may be correct in naming the narrative as effective in producing the illusion of a "coherent" view of history, while still assigning events to "human agency," I would take issue with her contention that the narrative does not imply or invoke religious sentiment, although it does so in a nuanced and ambivalent manner. In addition to several significant textual moments wherein Vladek's vexed relationship with the quite specifically Judaic aspects of his heritage comes to the fore, there is also an overarching sense in which the text communicates not merely the psychological difficulties of traumatic memory, but the more challenging spiritual question of representing the sacred, transcendental, or sublime. Angelika Rauch comments on this as it appears in the work of survivor Elie Wiesel:

For Weisel, the Holocaust is an experience of God; as such the event no longer yields to categories of history, of time and place, but transcends those categories precisely on the level of meaning and interpretation. Yet, if it is an experience of God, a transcendental experience, as Wiesel says it is for him, then even a hermeneutical approach to interpretation seems inadequate in talking about the experience; how *do* you represent the unrepresentable?[6]

Weisel's understanding of the Holocaust as an "experience of God" resonates with other critics, who have convincingly explicated the "sublimity" of the event from the perspective of the perpetrators and attributed the stark contrast between "Modern" social mores and Nazi barbarism to redemptive religious theologies. Most notable of these is historian Saul Friedlander, for whom such "redemptive anti-Semitism" "was born from the fear of racial degeneration and the religious belief in redemption . . . Nazism was no mere ideological discourse; it was a political religion commanding the total commitment owed to a religious faith."[7] For both perpetrators and victims, then, emplacement of "meaning" is impossible within the confines of normative reality. Dominick LaCapra (and others) consigns this religious or transcendent element of the Holocaust to psychological pathology:

Such "barbarism" may perhaps be better apprehended as an uncanny return of the repressed in the form of phobic ritualism and paradoxical sacrificialism bound up with a desire for purification and regenerative, even redemptive, violence toward victims. Indeed, the sublime itself may be seen as secular sacred and involve the attempt to transvalue trauma into a disconcerting source of elation and transcendence.[8]

LaCapra's move prescriptively dismisses the possibility of real Divine intervention;[9] this would, of course, render his assessment both futile and unnecessary. More importantly, it would shut down the post-structuralist model by assigning ultimate responsibility to forces outside of discourse itself. In either case, it is clear that while innovative narrative strategies may help allay concerns regarding the potential false comfort offered by overly sentimentalizing the event, they do not remove the aspects of these strategies that have their roots in traditional cultural identities and Judaic modes of interpretation. I would go farther to assert that the narrative strategies of the text are **both** reverential and religious.

Indeed, and paradoxically, the very post-structuralist techniques that engender the book's efficacy as a memorial to Vladek (and, perhaps more importantly, Artie's mother, Anja), are rooted in a kind or reading and writing that intentionally confounds the relationship between the textually "constructed" and the "real" in ways that threaten to undermine the credibility of Vladek as a material witness. Indeed, when Artie finds out, at the

end of Volume I, that his father has destroyed his mother Anja's notebooks, he calls him a "murderer" and (for neither the first nor the last time in the series) implicitly equates him with the Nazi perpetrators.[10] This response belies the equivalence for Artie between Anja's burned notebooks and her vanished body, as well as his operative prioritization of textual expression over and above the experienced event itself. This resonates with the work of key post-structuralist theorists for whom the relationship between writing, death and power is inextricable. Indeed, both Derrida and Foucault note how writing is only necessary in the absence or "endless disappearance," of the writing subject,[11] emphasizing not only the absence of the author, but also the impossibility of ever connecting with the referent. Further, while Artie accuses his father of the brutal "murder" of his mother's testimony, it is he who has seized power over her narrative and, in Derridean sense, expedited her total erasure by writing her into (and thus out of) being.

I would argue, then, that the stakes of Spiegelman's gamble are higher than he either realizes or is willing to admit, and that they reflect a profound fissure between secular and sacred Judaic cultural imagination that predates, but is still a consequence of, the Holocaust. As has been discussed previously, the complex relationship with the text that is a function (or a remnant) of Judaic religious practice is also a key element of Modernist and Post-Modernist imaginative production. Similarly, the historical moment that marks the rupture between Modernist and Post-Modernist expression also opens into an alternative conceptualization of the relationship between traditional conceptions of Judaic spiritual tradition and the aesthetic artifacts of that tradition. This can be seen not only in the *Maus* texts I have been discussing, but also in the work of writers and artists who perished prior to the articulation of post-structuralist principles, but whose imaginative response to their unfathomable plight nevertheless partakes of them. Looking closely at *Maus* in relationship to a work of lesser fame but equal urgency, Horst Rosenthal's *Mickey in Gurs*, reveals a trajectory of writing that replaces the absent God of tradition with the absent body of the author, and a "bleeding" of the sacred into the secular. Most compelling, however, is the way in which Rosenthal's text (unlike Spiegelman's) evacuates the element of melancholy through greater proximity to the event and more avid engagement with the concept of the subject as radically expendable. Horst's text is thus ultimately more purely and authentically "Post-Modern" than its Post-Modern progeny. If the Holocaust is the brutal rending of the Modernist project, *Mickey in Gurs* is an artifact of the wound itself.

Readers familiar with *Maus* have undoubtedly been struck by the provocative epigraph to the second volume:

> Mickey Mouse is the most miserable ideal ever revealed . . . Healthy emotions tell every independent young man and every honorable youth that the dirty and filth-covered vermin, the greatest bacteria carrier in the animal kingdom, cannot be the idea type of animal . . . Away with

the Jewish brutalization of the people! Down with Mickey Mouse! Wear the Swastika cross![12]

This quote, cited from a 1930's newspaper article, modifies, in significant ways, its pithier predecessor from *Maus I: My Father Bleeds History*, Hitler's infamous statement "The Jews are undoubtedly a race, but they are not human." What is at stake in both quotes is the status of the Jew as a human body, and by extension, as a narrating subject. This is evidenced most powerfully by the mobilization of three visual images/objects: the *universal* mouse (here inextricable from the Jew herself); the specific mouse (Mickey); and the "Swastika cross," symbol of the Third Reich. These images are implicated in Jewish identity at the deepest levels. For example, in Miriam Katan's recent graphic memoir, *We Are on Our Own*, the opening page is black, with only the words "In the Beginning darkness was on the face of the earth."

The next two pages depict the mystical letters of Hebrew scripture conjoined with "And God said, 'Let there be light.' And there was light . . . And it was good." In a remarkable set of panels on the third page, the black Hebrew letter "aleph" appears to morph into the black swastika, stark against a red Nazi flag. The corresponding caption reads "And then, one day, God replaced the Light with the Darkness."[13]

These pages convey a sense of the close visual relationship between the aleph and the swastika, and the visual interchangeability between Judaic "light" and Nazi "darkness." The bright red of the Nazi flag undercuts the stated idea of fascist "darkness": because the page is more colorful and brighter when the swastika appears, the understanding that the swastika ushers in darkness seems counterintuitive and/or ironic. The ironic "brightness" of the swastika is also seen in the visual testimony of Charlotte Salomon, who was, like Rosenthal, imprisoned at Gurs before perishing at Auschwitz. Salomon's semi-autobiographical text, a theatrical piece consisting of 784 painted and scripted pages entitled "Life? Or Theatre?" depicts the events of her brief life, including the suicide of her mother and her own internment. In an early panel she portrays a parade, led by a German officer brandishing the Nazi flag with a swastika in the middle. Her text reads:

> "The swastika—a bright symbol of hope—the day for freedom and for bread now dawns—Just at this time, many Jews—who, with all their often undesirable efficiency, are perhaps a pushy and insistent race, happened to be occupying government and other senior positions. After the Nazi takeover of power they were all dismissed without notice. Here you see how this affected a number of different souls that were both human and Jewish![14]

In Salomon's text, as in Katan's, the visual image of the swastika is used to both connote and eclipse Jewish identity. Significantly, Salomon's narrative,

Figure 4.1 *We Are On Our Own*, Miriam Katin.

like Rosenthal's, *erases* a particular Jewish voice in favor of a disembodied narrative persona. As if attempting to simultaneously fulfill the prophecy of Hitler's quote that the Jews are a race, but are not human, Salomon describes the "hope" of the Swastika resulting in the disempowerment of the "pushy and insistent" **race** of Jews, again, speaking in the detached third person, not as a Jew, but as an observer. The bitterly cynical tone of the first lines of Salomon's caption is nearly identical to that of the "Mickey" character in Rosenthal's comic pamphlet, especially in its mocking equation of the swastika with hope and prosperity (in both cases represented by bread). Salomon's Jews, like Hitler's, are pushy and undesirable; "occupiers" of positions of power. The final line of Salomon's caption reveals a deeper ambivalence, as the Nazi takeover is described as impacting "souls that were both human and Jewish." While this statement takes aim at the notion of the Jews as a "nonhuman" race, it does so in a bizarre and

contestable manner. Salomon points out, in effect, that there are effected souls that are **both** Jewish and human, but by reiterating this dichotomy she subtly instantiates its potential veracity. Further, by attacking Jews (even in parody), and completely removing the narrative voice from a distinctive Jewish identity, Salomon's image and caption eerily communicate absence: the absence of a material Jewish witness. And, although both Salomon's and Katan's narratives present the swastika as an inverted symbol of Jewish writing, both of their texts rely heavily upon the interpretation of the visual narrative **in conjunction with** the caption for the release of the deepest levels of meaning. This calls in to question the "humanity" of Salomon and Katan's narration; in Katan's case because she must resort (as must Spiegelman) to the visual to express the transcendent nature of her subject, and in Salomon's case, because the narrative voice is disembodied and, again, cannot fully convey its message in language. If speech is what makes us human, what does this say about Jewish "speech" and, correspondingly, to Jewish "humanity" both during and after the Holocaust?

One way of thinking about this question is to more deeply examine the "alternative" ways of Jewish telling that dominate all of the Holocaust narratives we have in play, and how they address what has already been named as a crisis in representation. Spiegelman's framing quotes draw quite deliberate attention to one of the solutions of the problem: the allegorical relationship that empowers this narrative and is one of the characteristics that sets it apart from "traditional" testimonies: the representation of Jews as mice. This representation is similar, yet not wholly the same, as the corresponding representation of other identities in the text: Poles are pigs, Germans are cats, Americans are dogs, and French are frogs. Indeed, the second epigraph informs the reader that, although this novel will follow the "funny animals" pattern with some consistency, it is the mouse/Jew that will metaphorically engage Hitler's malevolent racial allegations. And, although Spiegelman's mice are not exactly Mickey, they share the distinction of being singled out by the Nazi regime as the most pernicious of all species, thus comprising the perfect vehicle to explode anti-Semitic constructions of Jewish identity and, at least according to the author, all such essentializing typologies:

> "Ultimately, what the book is about is the commonality of human beings. It's crazy to divide things down the nationalistic or racial or religious lines. And that's the whole point, isn't it? These metaphors, which are meant to self-destruct in my book—and I think they do self-destruct—still have a residual force that allows them to work as metaphors, and people still get worked up over that."[15]

The discourses of racism, anti-Semitism, and nationalism, although partaking of similar qualities, are quite distinct. Spiegelman's effort to universalize them by putting them under the same umbrella dislocates the very

specificity of the Jewish "mousiness" that inspires the epigraph, and we again see the displacement/erasure of the Jewish body (here a "human" body with a mouse head). While this is clearly an intended effect, the recourse to allegory must necessarily vanquish a large measure of human integrity.[16] As Benjamin asserts, the "distinguishing feature of the allegorical object is that it has no life of its own . . . Since the allegorical attribution is more or less arbitrary, the object itself alternates between the ostentation of its allegorical appearance, and the disconsolate character of its everyday appearance as a ruin or corpse."[17]

Further, although Spiegelman's attempt may be to "universalize" racial stereotypes, this effort naively diverts a long and significant tradition of equation between mice/rats and Jews that is worthy of attention in this context. In a seminal analysis of the complex and intimate link between Modernist poetics and deep intellectual anti-Semitism, Daniel T. McGee attends to the way in which the politically divergent American Modernist poets T.S. Eliot and Langston Hughes position Jewish speech and language as a discourse of meaningless and discordant noise: the sound of **rats** in the alley. McGee goes further to document how Wagner mobilizes the same trope in *The Ring*, wherein the singing parts of the *Nibelung* throughout the opera embody the "hissing, shrill, buzzing, and gurgling sound" Wagner associated with the Jewish manner of speech. Such stereotypes were apparently obvious to late 19th and early 20th century audience: "No doubt with Mime, Wagner intended to ridicule the Jews (with all their characteristics—petty intelligence and greed)—the jargon is textually and musically so cleverly suggested."[18] Enhancing this effect is the fact that the German word used by Wagner to signify the Jews' "petty intelligence" happens to be *"Rat."* This correspondence ultimately creates the sense that the dissonant and meaningless noise "does not merely represent the Jew in Wagnerian opera: it is the body of the Jew. The audience experiences the invading Jewish presence is dissonance, a subjective discomfort that can be resolved only by the removal of the offending sound."[19] The Jew's body is the body of the hissing rat; the same rat that f introduces in "Burbank with a Baedeker, Bleistein with a Cigar":

> The smokey candle end of time
> Declines.
> On the Rialto once.
> The rats are underneath the piles.
> The jew is underneath the lot.[20]

This Jew/rat rattles the bones in "The Waste Land" and in so doing reduces signification to destruction and decay, exposing a symbolic threat to all unity and meaning. The transformation of the body of the Jew into the rat that annihilates both bodies and meanings seems ironically prescient, since the post-structuralist "annihilation of meaning" has its

roots (as we have shown) in traditional rabbinic hermeneutics. As McGee writes of Eliot's Jews/rats:

> Identifying these rats as Jews, therefore, is tantamount to claiming that Bleistein is desecrating himself, that the corpse is the cause of its own defilement. Strange, but this imaginary plot in fact follows centuries of anti-Semitism, for the paradox of the rat as destroyer and destruction of meaning is nothing other than the fantasy of the self-hating Jew. In its Maurrasian form, moreover, this stereotype assumes a flawless logic, insofar as the only thing that can actually destroy meaning, as opposed to representing such destruction, is meaninglessness itself.[21]

The rat is the destroyer of meaning that thus destroys himself: the Jew not just as imagined by Hitler, but also, by Horst Rosenthal, a Jewish prisoner who was killed at Auschwitz.

Rosenthal's most notable work is a pamphlet entitled *Mickey Mouse in the Gurs Internment Camp*, written two years prior to his death. Born in Breslau in Lower Silesia, Rosenthal had moved to Paris the early 1930's to pursue a career as an artist and intellectual. Like many in his situation, he was captured and sent to a forced labor camp in Saint Cyprien. In September 1940, the Saint Cyprien camp was washed away in a storm and he was sent to Gurs. After a brief stint in a forced-labor camp, he was re-imprisoned in Gurs in 1942, and remained there until he was transferred to Auschwitz, where he perished.[22] The Gurs camp, the site of Rosenthal's story, was one of the earliest and most elaborate camps established in pre-war France. It was located in the Basque region of southwestern France, just to the south of the village of Gurs. Originally established in April 1939 (before the war with Germany and well before the occupation of France in June 1940), Gurs initially served as a detention camp for political refugees and members of the International Brigade fleeing Spain after the Spanish Civil War. In 1940, the French government began interning German-Jewish "enemy alien" refugees at Gurs along with French leftist political leaders who opposed war with Germany. After the French armistice with Germany in June 1940, Gurs fell under the authority of the Vichy regime. In October 1940, German authorities deported about 7,500 Jews from southwestern Germany across the border into the unoccupied zone of France. Vichy officials then interned most of them in Gurs. As is accurately depicted in Rosenthal's pamphlet, conditions in the Gurs camp during 1940 were exorable. It was overcrowded and there were constant shortages of food, water, and clothing. During 1940–41, 800 detainees died of contagious diseases, including typhoid fever and dysentery. Between August 1942 and March 1943, Vichy officials turned over nearly 4000 Jewish prisoners to the Germans, who sent the majority of them to the Drancy transit camp in Northern France. From Drancy, the majority of these prisoners were, like Horst Rosenthal, deported to Auschwitz.[23]

The hero of *Mickey Mouse in the Gurs Concentration Camp* is not exactly the rat that Wagner and Eliot equate with the Jew in their work, nor is it even Spiegelman's generic mouse. Rather, it is a very particular mouse that captures Rosenthal's attention: Mickey Mouse. The panels of the pamphlet depict a bewildered yet irrepressibly cheery Mickey Mouse (a precise replica of the Disney character, reproduced without the authorization of the Disney company), being arrested and detained in the Gurs concentration camp near the Pyrenees.

Here Mickey encounters a radically different reality than the one by which he is usually challenged and attempts to negotiate his way through

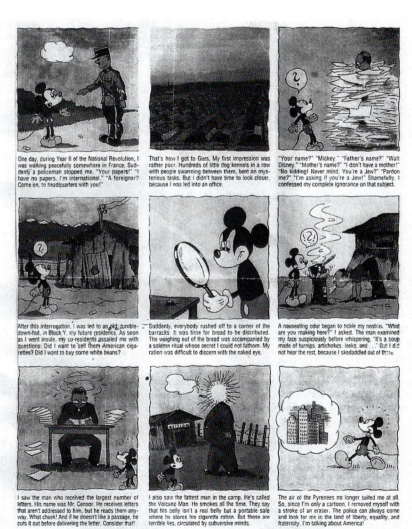

Figure 4.2 Mickey in Gurs, Horst Rosenthal (1942).

it, replicating, at least on the surface, the standard plight of the putative comic book hero, as well as, importantly, the antics of the popular Disney films. Although the overt similarities to *Maus*—**particularly** the substitution of the mouse for the Jew—are notable, what seems most striking here is the way in which these similar-yet-different "tellings" utilize parody, graphic illustration, collage, and—most importantly—displacement, transformation, or erasure of the "human" subjectivity and an embodied narrative voice in order to avoid even the pretense of sufficient representation. In this regard, Rosenthal's pamphlet anticipates Adorno's assertion that "there can be no poetry after the Holocaust," and replaces "poetry" with the self-reflexive irony that will become the hallmark of post-structuralist narrative. Indeed, Adorno's concern appears to be addressed by Rosenthal's stark and uncanny juxtaposition of the Mickey figure with the daily routine of the camp.[24] In her introduction to *Considering Maus: Approaches to Art Spiegelman's "Survivor's Tale" of the Holocaust*, Deborah Geis suggests that that by focusing on this very problem, Post-Modern writers such as Spiegelman resist such aestheticizing impulses as Adorno describes by "forcing the contemplation of events into a transgressive realm or medium by calling for the unfamiliar, the unsettling."[25] A good example of this is the account of Joseph Czarnecki, a Polish photojournalist who found among the relics of Auschwitz drawings of "elegant bathroom mirrors that mocked the camp's stark reality"[26] The mocking, caustic voice, already established as "Jewish" not only in its sound, but in its destructive effect, is, in Rosenthal's pamphlet, curiously transformed into the voice of Mickey Mouse, who, by the time of Rosenthal's writing, was already a figure of mass popularity across the United States and Europe. Looking back at the *Maus II* epigraph that appeared in the Nazi journal *The Dictatorship* in 1931, it is clear that for at least a segment of the German population, Mickey Mouse's Americanness was synonymous with its Jewishness, and its Jewishness was proof of its trashiness and degeneracy. With this in mind, the image of Mickey was taken up by many counter-critics, who saw it as a symbol of reason against "swastika and persecution" and urged patrons of Disney films to buy Mickey Mouse pins and wear them as an anti-Nazi statement.[27] The fact that both of these responses were so extreme is testament to the power that Disney exerted. There was, indeed, a "Mickey Mouse mania" that swept Germany after the first Mickey Mouse film was shown there in February, 1931, prompted, in part, by the many favorable press reviews of the film as a "glittering slapstick" that dallied with "complete madness in the course of re-securing the natural order of things"[28]

The characterization of Mickey as a rebellious rabble-rouser, although quite different from his contemporary image, was the essence of the character as originally imagined by Walt Disney. The early Mickey of *Steamboat Willie* fame, for example, was primarily intended for adult consumption, and was therefore "only partially civilized: uninhibited, bare-chested, rough and ready to the point of sadism . . . like most cartoon characters

of the period, he blithely trafficked in fistfights, drownings, dismember-
ments."[29] This early *nasty* Mickey got watered down nearly immediately as
a result of the establishment of the Mickey Mouse Club in the late 1920s,
but what emerged was still not the squeaky-clean rodent of today. Rather,
he was, during the time that Rosenthal was probably imagining him, "a
playful, conniving underdog, like Huck Finn or Charlie Chaplin's tramp."[30]
Early Mickey Mouse cartoons feature a pesky, ratty creature creating mis-
chief, indulging in vaudeville, and low-life, and, as the *Film-Kurier* put
it in February 1930, "he was a beast living in jazz rhythm—every step a
dance move, every movement syncopated."[31] The Jew/rat (and implicitly,
African-American) constellation of associations with Mickey provoked
Walter Benjamin to respond emphatically to what he saw in the cartoons
as the ultimate—and urgently needed—rejection of the "civilized" bour-
geois subject.[32] In Mickey Mouse, Benjamin found a vessel to express the
chaos of his own historical moment. In 1931 he wrote "Mickey Mouse
proves that a creature can still survive even when he has thrown off all
resemblance to a human being."[33] Clearly, even at this early stage, Benja-
min foresaw the destruction that would be the hallmark of his era. He saw
these forces of destruction, chaos, and barbarism as the calling card of the
Modernist movement, going so far as to say in his essay, "Karl Kraus" that
the prototype for the self-respecting Modernist is not the *Ubermensch*, but
the *Unmensch*: the cannibal that devours his adversary in the savagery of
his wit.[34] This *Unmensch* is reminiscent of Eliot's rat under the corpses, but
Benjamin sees him as not just a destroyer, but also a redeemer: young and
cheerful, (like Mickey Mouse), he eradicates everything, including himself,
his own body. For Benjamin, the cartoon realizes the end-point of capital-
ist property relations (later transformed into Nazi policy): "one's own arm,
indeed one's own body can be stolen."

Seizing control of this discourse, Rosenthal is the ultimate *Unmensch*.
He "steals" his body from himself, first detaching it from his own subjec-
tivity, and then "erasing" it entirely.

Projecting fraught subjectivity onto an animal (or insect) of analogous
vulnerability is within the Eastern European literary tradition, and the
particular characterization of Jew as vermin proceeds, as we have seen,
the rise of the Third Reich. Describing the genesis of *Maus*, Spiegelman
acknowledged his debt to Kafka, who was, among the many other things
we have already discussed, a creator of dark animal stories. In his effort to
authentically render his father's experience of the Holocaust, Spiegelman
powerfully combines the Kafkaesque with the comic:

> What happened in *Maus* was the absolute shock of an oxymoron: the
> Holocaust is absolutely the last place one would look for something
> to be made in the form of comics, which one associates with essen-
> tially trivial, simplified matter. So those two things came together and
> ignited an explosion that I was able to harness.[35]

This characterization of the comic genre as "trivial and simplified" is, ironically, no longer true (if it ever was) largely as a result of Spiegelman's own work. And, although there are some humorous moments in *Maus*, Art's subjectivity—that of a creature looking searching for "truth" within the shambles or ruins of history—is more akin to Kafka's animals than to Mickey Mouse. As Benjamin notes regarding Kafka's allegorical animals

> This much is certain: of all of Kafka's creatures, the animals have the greatest opportunity for reflection. What corruption is in the law, anxiety is in their thinking. It messes a situation up, yet it is the only hopeful thing about it. However, because the most forgotten alien land is one's own body, one can understand why Kafka called the cough that erupted from within him "the animal." It was the most advanced outpost of the great herd.[36]

What Spiegelman's mouse/*Maus* persona, and Rosenthal's Mickey have in common is the re-appropriation of the symbolic terrain of the rat/mouse. Although these mice share the destructive and degenerate nature of Eliot's rats, their deconstruction of unified meaning offers the only hope for redemption once the human being has been reduced to bare life. Like Kafka's cough, the mouse represents the disruptive energy that makes the creature aware of its own dehumanization. Yet, as we will see by looking closely at his text, Rosenthal's use of Mickey Mouse specifically considerably complicates this symbolic order.

In addition to *Mickey In Gurs* Rosenthal wrote two other booklets, neither of which utilize the Mickey Mouse persona but both of which adopt the same comic tone. All three texts powerfully communicate the bitter conditions of the camp by combining graphic representations of the bleak barracks, the abusive officials, and the starving inmates with bitingly sarcastic running commentary that makes the unspeakable sound like the quotidian. Like the *Maus* volumes, the remarkable power of these narratives is largely derived from the graphic form itself, in particular, the popular and decidedly lowbrow "comic" genre. The comics offered a unique order of representation for Jews in both Europe and America during the first half of the 20th century. As a minority with a long, complex, and ambivalent relationship to visual reproduction, Jews were heavily represented in the comic book industry from its inception. Comics were, in many ways, an ideal medium for the Jewish artist who had an intuitive relationship with the text and an increasingly emergent (and increasingly assimilative) visual imagination. The fusion of word and text enabled such artists to play off their own hermeneutic tradition to great effect: juxtaposition, irony, allegory, and multiplicity of meaning are standard fare within the genre. Further, the "cartoon" (both in the form of paper comics and films) speaks to the historical position of the Jew. As Esther Leslie has noted "The cartoons are object lessons in the actuality of alienation.

Disney's world is a world of impoverished experience, sadism, and violence. That is to say, it is our world."[37] It was most certainly the world of the European Jew in the 1930s.

It is therefore not surprising that it is American Mickey Mouse, not Eastern European Horst Rosenthal, who finds himself at the Gurs camp "one day, during Year I of the National Revolution."[38] This first panel, which depicts a confused Mickey in conversation with an officer bearing a not entirely coincidental resemblance to the Fuhrer, establishes not only the sardonic tone that will prevail throughout the short pamphlet, but also the intimate correspondence between this quite adult text and traditional narrated children's stories. The "magical" appearance of Mickey in this clearly alien landscape underscores this correspondence. Mickey's attempt to situate himself historically—"Year I of the National Revolution"—hearkens to the already completely fallen ideals of the French Revolution, and simultaneously alludes to the corruption and violence of the National Socialist Revolution. The "fairy-tale" of France is merged with, and articulated by, American capitalism. Indeed, the naive "faith" in articulated national ideologies is set up from this very first moment as the ultimate form of infantilism.

The allusion to the undercurrent of darkness that is nearly always present in children's literature in general, and the Mickey Mouse franchise in particular, resonates with later versions of this story as well, including Spiegelman's own. In a coda to *Maus* in *Tikkun* magazine in 1992, Spiegelman offers four new lithographs intended to continue the process of retrieval begun by the original texts. In one lithograph, the now quite familiar mouse-headed Art is shown in his living room with his daughter, Nadja. Nadja holds a Mickey Mouse doll, a pet cat rests on an easy chair, and on the wall behind, shadowing this scene of American domestic tranquility, are the silhouettes of Jew-mice being hung from the gallows.[39] The vexed relationship between the Mickey Mouse doll that is not even an intended representation of a human, and the clearly "human" (as their mouse heads hang low) bodies of the suffering Jews depicted on the wall accentuates the limits and possibilities of art **and** capitalism: the doll that Nadja holds is made possible by the her father's ultimately lucrative telling of Vladek's story (Art is himself the first to admit this) as well as the permanent fixing of Mickey as an icon of capitalism *par excellence*. What the image communicates is the bizarre "magical" transformation of suffering Jewish bodies into dolls that are themselves caricatures of both conventional anti-Semitic tropes and vanished/disfigured Jewish subjectivities. Mouse Vladek has somehow become limp, stuffed, and silent Mickey: source of revenue and symbol of corruption. As Ariel Dorfman would have it:

> Disney uses animals to trap children, not to liberate them . . . once
> the little readers are caught within the pages of the comic . . . animals
> become transformed, under the same zoological form and the same

smiling mask, into monstrous human beings . . . Beneath all the charm of the sweet little creatures of Disney . . . lurks the law of the jungle: envy, ruthlessness, cruelty, terror, blackmail, exploitation of the weak . . . all the relationships in the Disney world are compulsively consumerist; commodities in the market place of ideas.[40]

Dorfman's Mickey is the twisted (inverted) fulfillment of Benjamin's dream/nightmare of mechanical reproduction. In hundreds of homes, hundreds of Mickeys lurk, the shadows of history reflecting back their own empty images.

But at Gurs camp, there is only one Mickey Mouse—and he is clearly a cipher. This is made abundantly apparent when the officer in Panel 1 asks for his "papers" and he replies: "I have no papers. I'm international!"[41] Mickey mistakes the officer's intent: the "papers" are meant to demonstrate not just national, but also racial identity. The scene is comical partially as a result of this intentional "misunderstanding." Just as Mickey fails to understand the officer's true agenda, the officer fails to see that the creature standing before him has no human identity. The officer thus attempts to ascribe national/racial identity to a symbol, and Mickey's counter statement, that he is *international* suggests that what he symbolizes knows no national boundaries; it can be (and indeed is) aggressively exported and endlessly replicated. In fact, what Mickey symbolizes *is* multiplicity, mischief, and "magic." Mickey's answer also parodies the utopic inclination of many assimilated secular Jews who did not Jewishly identify but were nonetheless persecuted as Jews. The "floating" nature of Mickey's cartoon identity brings the intractability of Rosenthal's own racial profile into stark relief.

As a result of the encounter with the officer in Panel 1, Mickey is taken to Gurs. In the remarkable second panel, Rosenthal juxtaposes what appears to be an actual photo of the camp with Mickey's voiceover: "That's how I got to Gurs. My first impression was rather poor. Hundreds of little dog kennels with people swarming between them, bent on mysterious tasks. But I didn't have time to look closer, because I was led into an office."[42] The space between Panels 1 and 2 elides the physical movement of Mickey to the camp, and indeed, although he claims to be "led" into an office, being "unreal" his compliance is assumed. His description of the barracks at Gurs as "hundreds of dog kennels" reveals the depth of degradation experienced by the inmates, underscored, again, by Mickey's perspective as a curious observer. The tasks are "mysterious": work is a "foreign" concept to Mickey. The mystification of labor is played on here, as is the alienation of Mickey from human experience. The "people" Mickey sees in Panel 2 are already just barely people; living in dog kennels, they "swarm" like ants.

In the next panel, Mickey faces a difficult interrogation by an official as he is confronted with the question of his "true" identity: "Your name?"

"Mickey." "Father's name?" "Walt Disney." "Mother's name?" "I don't have a mother!" . . . "Never mind." "You're a Jew?" "Pardon me?" "I'm asking if you're a Jew!" "Shamefully, I confessed my complete ignorance on the subject."[43] Mickey's answer fully reflects a moment of Jewish subjectivity in peril. With Walt Disney as a father, it is no wonder that Mickey is completely ignorant on the subject of his Jewish identity; not only was Walt Disney most decidedly *not* Jewish, he was a reputed anti-Semite.[44] In traditionally Jewish terms, Mickey's paternity would not matter, since Jewish identity is determined matrilineally. In terms of Mickey's physical appearance, and how can he be anything other than Jewish, being that he appears to be a *mouse* (in other words, not human)? From Mickey's/Rosenthal's perspective, this must be some kind of mistake; he is not a mouse, he is *Mickey Mouse*, and thus his central identity is **American**, not Jewish. In reality, he is a work of imagination that mobilizes a vast constellation of overlapping and contradictory ideologies.

This complex problem brings us back to Spiegelman's vexed relationship with his own typologies, voiced at the beginning of his second volume, as he attempts to situate his French wife, Francoise, within the narrative. After trying several different sketches, including Francoise as a frog, a dog, a bunny rabbit, and a moose, he tells her that he is not sure what kind of animal to make her, to which she indignantly replies, "A mouse of course."[45]

When he protests that she is French, she suggests a bunny rabbit, rather than the frog, as a representation of the French. But the bunny is "too sweet and gentle," replies Art, reminding Francoise of the French legacy of anti-Semitism, including the Dreyfus Affair and the Nazi collaborators. Franciose defers to this, but insists that, if Art is a mouse, she is also a mouse, since she converted, even if said conversion occurred only to please Art's father, Vladek. Art then self-consciously spoofs his own categories as well as the dominant logic behind them by imagining Francoise as a French frog who is "magically transformed" by the Rabbi into a "beautiful mouse."[46] Like in a Disney cartoon, objects are radically mutable, but the same "magic" that enables their transformation affirms their status **as** objects.

In this respect, Art mockingly calls attention to the random way that Jewish identity is conferred, implying that his representative typology is ideologically determined; a bunny rabbit is too sweet to stand in for the sly French, and Francoise ultimately counts as a Jew not because of her birth or her appearance, but because she has herself chosen this identity. Further, Francoise is, at least in this context, more of a Jew than she is an American, as is Art, since neither is represented as a dog. Paradoxically, it is only because they *are* American that they *can* choose to be mice (as Rosenthal's Mickey learns), being a "mouse" is not an intentional choice at Gurs, but a physical reality. Art's father, Vladek, knows this too, and it is what causes him to be afraid for his wife, Anja, as they attempt to escape from the Poles because her "appearance" is more "Jewish."[47] Thus, although Mickey is the symbol of everything that allows one to be an identity, rather than a

body, he here becomes the victim of his own ideology. In other words, it is possible to understand Mickey as being represented by a mouse *because* as a mouse he embodies the type of radical individualism that fascist ideology associates with both Americans and Jews—as troubling as this would be to Walt Disney. Additionally, the imaginative "magic" of typology, here very clearly associated with American liberal democracy, comes at the cost mimetic representation of the "real" material subject.

Yet, both Francoise and Art choose to be represented as mice not to ally themselves with Americans (if this were the case they would be dogs), but rather to participate in the exercise of collective memory that constitutes Jewish identity in post-Holocaust America, which is, paradoxically, also an exercise in retaining the absence of human subjectivity that marks the survivor. As Walter Benn Michaels puts it,

> Art's parents remain mice to mark the distinctiveness conferred on them by the Holocaust; Art and his children remain mice to mark the fact that this distinctiveness, the distinctiveness of the European Jew is retained by, indeed inherited by, the American Jew. All *Maus's* other Americans are dogs because none of them has inherited the Holocaust.[48]

The "inheritance" of the Holocaust is precisely the failure to have *fully* survived. After an embarrassing scene in which the stingy Vladek returns a partially used box of cereal to the supermarket, Art comments to Francoise: "I'd rather kill myself than live through all that . . ." Francoise replies: "What? Returning groceries?" Art: "No, everything Vladek went through. It's a miracle he survived." Francoise: "Uh-huh. But in some ways he didn't survive."

Survival, as Francoise is here thinking of it, depends not exclusively, or even primarily, upon the quality of "present-mindedness" that enabled Vladek to emerge from Auschwitz physically unscathed, but rather upon a deeper awareness of one's own ethical center. In a now canonical scene early in *Maus II,* Art is seen talking with his Holocaust survivor therapist, Pavel, about the logic of survival:

Pavel: So, do you admire your father for surviving?

Art: Well, sure I know there was a lot of luck involved, but he WAS amazingly present-minded and resourceful . . .

Pavel: Then you think it's admirable to survive. Does that mean it's NOT admirable to NOT survive?

Art: Whoosh. I think I see what you mean. It's as if life equals winning, so death equals losing.

Pavel: Yes. Life always takes the side of life, and somehow, the victims are blamed. But it wasn't the BEST people who survived, nor did the best ones die. IT WAS RANDOM![50]

Pavel's insistence that life or death in the camps was random sits uncom-
fortably with the implicit message of Vladek's narrative, which features
numerous cases of him surviving precisely because of his resourceful and
pragmatic nature. Similarly, Mickey's status as an "outsider" at Gurs keeps
him at a safe distance from the profoundly disturbing decisions the inmates
at both Gurs and Auschwitz were compelled to make in order to "survive."
The Nazi tactics of forcing Jewish prisoners into positions of brutality
toward one another are well documented.[51] In reality, the role of "free will"
under the extraordinary circumstances of the camps is quite contestable.
Both Primo Levi and, more recently, Giorgio Agamben have described the
unique nature of the survivor, the man (or woman) who is able to "adapt"
to the environment and rituals of the camps.[52] In many ways, this "present-
mindedness" that Art attributes to his father is both a blessing and a curse,
since this quality which enables him to maximize his chances for living
through the event, also makes it impossible to situate himself *vis-à-vis* the
larger history of his people:

> Survival often depends upon one's ability to make snap judgments
> about seemingly impossible "choices." In this sense an essential element
> of Jewish culture—an ethically valid life lived in accordance with the
> sacred rhythms and rituals codified in the commandments—becomes
> irrelevant because impossible: during the Nazi terror; life is lived in
> the moment, cut off from historical contexts and thus from God's holy
> covenant as both past and future dissolve into chaos.[53]

With this in mind, it is no surprise that the image of the stereotypical
miserly Jew that is an important part of Art's perception and representa-
tion of his father is also a key element in Rosenthal's pamphlet. In the fifth
panel, we see Mickey with a looking glass eyeing a nearly imperceptible
piece of bread, noting that the weighing of the bread is accompanied by
a serious ceremony involving secrets that he cannot fathom. As Mickey
examines the crumb under a magnifying glass, the allusion to the sacred
rituals of Jewish communal eating are converted into debased rituals of
individual barbarism. In the text under this image Mickey exclaims "By the
time I got my share, you could hardly see it with the naked eye!"[54] Pnina
Rosenberg cites this ritual as indicative not only of the minute portions that
the inmates were allowed, but also of the hostility and suspicions towards
ones fellow inmates that were aroused when bread was being distributed.[55]
These rituals of deprivation in the camp are also emphasized by Rosenthal
in panels 4 and 6. In panel 6, after the "bread" examination, Mickey is
seen outdoors standing next to a pot of boiling liquid. A man (seeming to
be a prisoner) is bent over the pot, using his breath to stoke the fire. The
caption reads: "A nauseating odor began to tickle my nostrils. 'What are
you making here?' I asked. The man examined my face suspiciously before

whispering 'it's a soup made of turnips, artichokes, leeks, and . . . ' But I did not hear the rest, because I skedaddled out of there." The unsavory nature of the soup made from root vegetables and clearly intended to feed masses is emphasized, as is Mickey's lack of personal hunger—he is not human, after all—as he "skedaddles" away, showing his consistently playful attitude toward the entire "adventure." His investment in the politics of the camp is low because he is only an imaginary reproduction, the empty shell of an absent identity.

Neither Art nor Francoise manifest any affinity for Jewish theology, and they clearly do not buy into the concept of racial Jewishness, but they do feel a deep, albeit guilty, connection to Vladek and what he represents. Further, as LaCapra has noted, the urgent desire to obtain redemption through memory plays a role in Art's testimony,[56] and this desire is itself part and parcel of a Jewish sensibility that has its roots in Judaic traditions of reading, writing, and interpretation. Although *Maus* does not fall victim to sentimentality, it elevates the act of memorial and transmission to the status of the sacred. The events or objects depicted pale in comparison to the act of telling. In this case, the transmission supersedes and, to a large extent, elides the object itself. Angelika Rauch compares this concept of tradition to Benjamin's use of Kafka's work to define "experience":

> Significantly, Walter Benjamin's interest in the issue of tradition is not in the specifically Jewish tradition that might be isolated as a cognitive object in Kafka's texts. Rather, his interest is in Kafka's attempt to keep tradition alive through the transmittability of something that neither has the status of an object nor submits to any conceptual categories. This "something" for Benjamin is the nature of experience. It is an unfinished or un-worked through experience. The distance between the experience of the past and the present memory is bridged by texts and the activities of reading and writing, as well as by commentary and interpretation. In fact, in the Jewish tradition of midrash, the truth of God's words does not lie in their meaning—this meaning is forever unknowable—but in their interpretability. It is what distinguishes literature as a written tradition from myth and, at the same time what protects it from becoming obsolete.[57]

It is in precisely this context that Mickey gains full credibility as a Jewish witness at Gurs. Rosenthal's replacement of his own Jewish body with that of the inquisitive cartoon character places him in the position of interpreter, calling attention not only to the bizarre "inhuman" conditions of the camp, but also to their resistance to analysis. To assist in this, the "voice" of *Mickey in Gurs* exhorts the reader to try to decipher the incomprehensible. For example, in panel 5, Mickey is shown staring up at a man sitting behind a large desk, who he says is "the man who received the largest number of letters." Calling him Mr. Censor, he goes on to say that the man

"receives letters that aren't addressed to him, but he reads them anyway. What cheek! And if he doesn't like a passage, he cuts it out before delivering the letter. Consider that!" Mickey's rhetorical exclamations here are not cries of despair, but rather amazement and indignation, as if it is impossible for him to fathom his current situation. Interestingly, as the absurdity of Mickey's plight increases, the physical size of his character relative to the other objects in the depicted decreases. In panel 1, he is shown as a little more than half the size of the officer, but by the time we reach the final three panels, Mickey appears to have significantly shrunk, until the final panel, when he "removes himself with the stroke of an eraser."[58] Indeed, this concluding moment fully realizes the power of the written text over and against the ultimately expendable material object. So fully is the voice of the pamphlet embedded in text that the "experience" remains in Gurs while the object (Mickey) is already apparently absent.

With this in mind, it is also important to note that the pamphlet does not offer anything but the strong implication that the text corresponds to the thoughts of the Mickey Mouse character in the drawings. Just as experience is textually embedded and severed from object, so is the subjective voice alienated from the Jewish body. This is an apt metaphor not only for the traumatic moment of the Shoah but for the continuing aporia of Holocaust testimony that is deeply enmeshed in the Post-Modern consciousness. When Mickey "erases" himself in the final panel, he relocates to America "the land of liberty, equality, and fraternity" and a nexus of ironic associations is ushered in. The sardonic jab implies that the ideals of the French Revolution, no longer viable in France, have relocated, as Mickey himself intends to do, to America. Such a suggestion is poignant precisely in its absurd and brutally playful suggestion that ideals and identities—unlike bodies—are both transferable and recoverable, appearing and disappearing as needed. Indeed, the image of Mickey *was* banished in France during the War. Here Rosenthal seems to anticipate the loss of favor that American iconography would suffer in Vichy France, publicly mourned in the article, "Au Revoir, Mickey," by Leon Bancal, editor of the Marseille daily, *Le Provincial*.[59] In this article, and its companion piece, "Bonjour Mickey," written when Mickey's image was again allowed in Europe, Bancal names Mickey as the symbolic beacon of freedom and goodness that he has become, and equates the return of the Disney franchise with the literal liberation of the country:

> You didn't come back alone. We were hoping you wouldn't. I'm not just talking about your faithful companions: the delicate and tender Minnie, your sweetheart, Donald, the eternal grumbler, and the long-faced Pluto. I am thinking of all of those young men with clear eyes and suntans who wear the initials "U.S." on their caps, and who, with their friends on this side of the ocean, the British and also the Russians (whom we don't see because they are so far away) bring back to us an exiled goddess, Liberty. How welcome you all are.[60]

The confusing and constant personification of ideas in Bancal's formulation is particularly interesting in that it seems to reduce the entire historical moment to an infantile cartoon. Ironically, while Bancal is waiting for the return of the Disney characters and their Allied cohorts, he is himself a prisoner at a camp similar to Gurs, where he describes his life as "an animated cartoon, which was both interesting and painful."[61] The happy animated Mickey is this international in the truest sense of the word: he is both inside the camp as comic consciousness of the prisoner and outside its walls, preparing to re-assert his presence in the post-war society that he himself will liberate. More importantly, Bancal's Mickey, created and disseminated by the Disney corporation, is welcomed back into French society, while Rosenthal's Mickey is left largely unnoticed in the Paris archive. This resonates with the profound absence articulated by Shoshana Felman and Dori Laub as they named the Holocaust an "event without witnesses." because "no one can bear witness from the inside of death, and there is no voice for the disappearance of voice."[62] Because this is profoundly true, the truth of human suffering must be taken on faith, a faith whose remnant is most eminently expressed in the multifarious voices of the Jewish imagination.

Notes

NOTES TO THE INTRODUCTION

1. See, for example, Geoffrey Hartman, *The Third Pillar: Essays in Judaic Studies* (Philadelphia: University of Pennsylvania Press, 2011), Hana Wirth-Nesher, *Call it English: The Languages of Jewish American Literature* (Princeton, NJ: Princeton University Press, 2006), and Yuri Slezkine, *The Jewish Century* (Princeton, NJ: Princeton University Press, 2004).
2. Maren Linnett, "Introduction: Modernism's Jews/Jewish Modernisms," *Modern Fiction Studies* 51, no. 2, (Summer 2005): 252.
3. Ibid.
4. Chana Kronfeld, *On the Margins of Modernism: Decentering Literary Dynamics* (Berkeley: University of California Press, 1996), 2.
5. Foremost among those non-Jewish critics who have begun or continue to explore what has come to be known as the religio-ethnic nexus are T.J. Jackson Lears, Paul Giles, Jenny Franchot, Thomas J. Ferraro, Wesley Kort, Ann Janine Morey, and Robert Orsi.
6. Dennis Taylor, "The Need for A Religious Literary Criticism," *Religion and the Arts* 1, no. 1 (Fall 1996): 124–150.
7. Jonathan Freedman, *The Temple of Culture: Assimilation and Anti-Semitism in Literary Anglo-America* (Oxford: Oxford University Press, 2000), 28.
8. Ibid., 17.

NOTES TO CHAPTER 1

1. *Babylonian Talmud*, (Brooklyn: Mesorah Publications, 1994), Tractate Megillah 9a.
2. Naomi Seidman, "The Secret Language of the Jews: A Midrash on Mistranslation," *Pakn Treger* (Fall 1998): 19.
3. Or, configured another way, " . . . And Reb Ilde: "What difference is there between choosing and being chosen when we can do nothing but submit to the choice?"" Edmond Jabès, *Le Livre des Questions* (Paris: Gallimard, 1963), 132.
4. See T.S. Eliot, "Tradition and the Individual Talent," *Norton Anthology of Theory and Criticism*, edited by Vincent B. Leitch, (New York: W.W. Norton & Company, 2001), 1092.
5. See Harold Bloom, *The Anxiety of Influence* (New York: Oxford University Press, 1997).
6. Seidman, "Secret Language of the Jews," 18.

7. Indeed, on the religious front, a tragedy of contemporary Jewish life is the politically charged confrontation between the Orthodox, who pray nearly exclusively in Hebrew and understand themselves to be "authentic" Jews, and their Hebrew-challenged brethren. Although clearly an issue that transcends linguistic ability, the divisions caused by liturgical revisionism and "translations" of ritual obligation are real and at the forefront of this discourse. On the literary front, critic Walter Benn Michaels, writing in *Our America: Nativism, Modernism, and Pluralism* (Durham, NC: Duke University Press, 1995), 182, with passionate disinterest about the possibility (or non-possibility) of language as an "authentic" link to a persistent identity has this to say: "But what exactly would be lost if everybody in Quebec stopped speaking French and no one ever again thought of him our herself as a Jew? Why would someone who used to speak French but now speaks English think of himself as having lost his identity? Why would what he used to do (speak French) determine his identity in a way that what he now does (speak English) does not? My point here is not that nothing would be lost or even that nothing valuable would be lost. French-speaking in Quebec would be lost, and insofar as French might be understood as a particularly viable language, something particularly valuable would be lost. But without some real way of explaining how what people used to do but no longer do constitutes their real identity, while what they actually do does not, it cannot be said that what the former French-speakers, current English speakers have lost is their identity. My point then, is not that nothing of value is never lost but that identity is never lost." Michaels' logic relies on the problematic assumption that identity bears neither historical weight nor spiritual significance. His concession to the value of what can be lost assumes that there is no facet of identity that will seek its recovery. Indeed, we have no current critical language to account for such a longing. Nevertheless, the religious argument and the literary argument become one when those Jews, for example, who cannot quite understand themselves as religious Jews without Hebrew, rescue it from the junk heap as a means of returning to a more fulsome Jewish identity.

8. The formulation of this reciprocity is inherent in the linguistic turn. Or, "if, as Derrida asserts, the danger of writing, from Plato's point of view, is that it threatens the interior and the immanent with infection from the outside, then the permeability of external signification with the interior world (of memory/presence) is established. This merely shows that Plato's effort to separate speech from writing, and memory from history, is a lost cause, because memory also partakes of the tools of signification. At the same time, if one accepts Ankersmit's notion of experience impressing itself upon the mind, this permeability works both ways, wherein experience may not only impress itself upon mind/memory, but may also be transferred to more prosthetic means of representation, like writing and historical texts. That is, if representation can get *in*, then surely (past) experience can get *out*." See Eric L. Berlatsky, *The Real the True, and the Told: Postmodern Historical Narrative and the Ethics of Representation* (Columbus: Ohio State University Press, 2011).

9. I am not suggesting here that literary genres other than Modernism, or any writing at all, accomplishes univocal meaning—such a proposition is absurd. Rather, I am affirming what is now a truism: that Modernism as a literary genre is particularly multivalent in its formal qualities, as would be apparent in a mere glance at the techniques of Joyce, Eliot, Faulkner, or Henry Roth.

10. Stephane Mallarme, "Crisis in Poetry," in *Selected Prose, Poems, Essays, and Letters*, trans. Bradford Cook (Baltimore, MD: Johns Hopkins University Press, 1956), 38.

11. This analysis of Joyce comes from Neil Davison. See Neil R. Davison, *James Joyce, Ulysses, and the Construction of Jewish Identity: Culture, Biography, and 'the Jew' in Modernist Europe* (Cambridge: Cambridge University Press, 1996), 7.

12. In Jacques Derrida, "Edmund Jabès and the Question of the Book," *Writing and Difference* (Chicago: University of Chicago Press, 1978), 65. Derrida's analysis of Jabès' book bears heavily on my readings, particularly in its recognition of the "incommensurable destiny which grafts the history of a 'race born of the book' onto the radical meaning as literality, that is, onto historicity itself." I also note with interest Derrida's division, in this essay as well as at the end of "Structure, Sign, Play," between the "rabbinical" and "poetic" modes of interpretation. The "rabbinical" mode of interpretation is one which seeks a final truth, and which sees interpretation as an unfortunately necessary road back to this original truth. The "poetical" mode of interpretation does not seek truth or origin, but affirms the play of interpretation. My own analysis is focused on those Jewish writers who find themselves in the uncomfortable position of trying to straddle this apparent dichotomy.

13. For a more thorough discussion of the psychology of Jewish difference, and its linguistic implications, see Sander L. Gilman, *Jewish Self-Hatred: Anti-Semitism and the Hidden Language of the Jews* (Baltimore, MD: Johns Hopkins University Press, 1986).

14. For an excellent analysis of voice and language in Roth's novel, see Wirth-Nesher, "Christ, It's A Kid!: Jewish Writing and Modernism: Henry Roth," *Call it English: The Languages of Jewish American Literature* (Princeton, NJ: Princeton University Press, 2006). In this essay, Wirth-Nesher places Roth's novel within a tradition of assimilative journey enacted through language: "The theme of Americanization in this novel is enacted in the multilingual word play as it moves from the sacred to the profane, from the holy to the secular, and from liturgy to literature. *Call it Sleep* encompasses more than ethnic writing in the social historical sense; it concerns the place of secular literature in the journey to America and to English," 84.

15. The close relationship between Talmudic hermeneutics and Modern and Post-Modern writing has been examined extensively by a host of critics. See, for example, Robert Alter, *Canon and Creativity: Modern Writing and the Authority of Scripture* (New Haven, CT: Yale University Press, 2000); Geoffrey Hartman, *The Third Pillar: Essays in Judaic Studies* (Philadelphia: University of Pennsylvania Press, 2011), and Susan Handelman, *The Slayers of Moses: The Emergence of Rabbinic Interpretation in Modern Literary Theory* (Albany: State University of New York Press, 1982).

16. Robert Alter refers to *Call It Sleep* as "the fullest American assimilation of Joyce." See Robert Alter, "Awakenings: Review of Henry Roth, *Shifting Landscape* and *Call It Sleep*," *The New Republic* 198, no. 4 (January 25, 1988): 33–37.

17. Neil Davison comments on this: "On June 16, the identity which Bloom discovers in every meeting and under every rock is ultimately a Jewish one. That discovery becomes, for Bloom, moreover, the moral core of his own *Yiddishkeit* and suggests the broader idea of a Joycean *Menschkeit*. And there can be no doubt that Joyce knew the puzzle that he was creating: it is not random that Bloom's non-quarter of blood is matrilineal, nor that he is the uncircumcised son of an immigrant convert who, in his final years returned to practicing Judaism. " Similarly, Roth explores the question of racial versus "cultural" Jewish identity. It would thus appear no accident that Roth's protagonist, David, is assumed by his father (and later the Rabbi), to be less than fully Jewish. The key difference between David and Bloom is that while

David turns out to be racially a "real" Jew, Bloom's Jewishness is finally manifest in the kind of cultural *menschkeit* to which Davison alludes. By allying David's racial Jewish identity with a discourse of authenticity, Roth subtly enforces the idea that there can be such thing as a "real" Jew, and establishes the significance of this category. Indeed, Roth offers no alternative but a *halackically* genuine Jewish identity, since David's non-Jewish blood, if it does exist, comes from the father and thus "doesn't count." Joyce, on the other hand, seems intent on proving that Bloom can be the prototypical Jew with only a marginal racial claim, but a strong moral one. Davison, *Construction of Jewish Identity*, 10.

18. The conflict and consequence of "cultural" and "racial" constructions of Jewish identity is also evident in *Finnegans Wake*. As Maren Linett has noted: "*Finnegans Wake* records the historical tension of an inconspicuous Jew, assimilated into European society and often indistinguishable from his gentile counterparts, and a visible and oppressed Jew who found with dismay that his Jewish 'race' robbed him of his cultural birthright." See Maren Linett, "The Jew's Text: 'Shem the Penman' and 'Shaun the Post,'" *James Joyce Quarterly* 45, no. 2 (Winter 2008): 263–280.

19. The possibilities for imaginative transformation of identity through the varying dialects of Modernism are explored with great insight by Michael North in *The Dialect of Modernism: Race, Language, and Twentieth Century Literature* (Oxford: Oxford University Press, 1994). Interestingly, North's analysis of the fascination of American Modernist writers with African-American culture begins with an example of the Jew slipping in and out of the "role" of blackface. Al Jolson's mask seems to bear resemblance to Henry Roth's narrative in its apparent effort to "become modern by acting black" (ibid., 8). The novel is. I would argue, trying to both become and veer away from being Modern, since the "Modern" voice, in this context, is that of traditional Judaism.

20. See Brian McHale, "Henry Roth in Nighttown, or Containing Ulysses," *New Essays on Call It Sleep* edited by Hana Wirth-Nesher (Cambridge: Cambridge University Press, 1996), 75–105.

21. For Joyce, there is only shifting consciousness, whereas for David (like the Talmudic sages) there is a realm of the real (or an "authentic" translation), but to find it demands both interpretive skill and deep faith.

22. Henry Roth, *Call It Sleep* (New York: Farrar, Straus and Giroux, 1934), 9.

23. Ibid., 11.

24. Ibid., 195.

25. Ibid.

26. Ibid., 92.

27. Daniel T. McGee, "Dada Da Da: Sounding the Jew in Modernism," *English Literary History* 68, no. 2 (Summer 2001): 501–527.

28. Harold Fisch, *The Jerusalem Bible* (Jerusalem: Koren Publishers, 1992), Ex 30: 12–13.

29. Handelman, *The Slayers of Moses*, 198.

30. The location of the toilet in the cellar solidifies the anti-Semitic link between Judaic language/interpretation and excrement, a link that can be traced back to Martin Luther, who wrote in his second pamphlet, *On Shem Hamphoras and the Descent of Christ*: "I, a damned goy, cannot understand where they have their great skill in interpreting except, perhaps, that when Judas Iscariot hung himself and his bladder burst and his gut split. Perhaps the Jews had their servants there with their golden pots and silver bowls to catch Judas' piss and other reliques (as they are so called). Then they ate and drank the shit mixed with piss to become so sharp-eyed in interpreting the Scripture.

They see things in Scripture that neither Isaiah nor Matthew, nor all the angels saw, and we damned *goys* can never hope to see." Quoted in Gilman, *Jewish Self-Hatred*, 60. Roth here assimilates and plays with Luther's version of Jewish language, since only after escape to, and ascension from, the cellar is David able to interpret his mother's speech.

31. There is a long tradition of anti-Semitic tropes of the Jewish female as seductress. See Gilman, *Jewish Self-Hatred*. Additionally, Jewish interpretation is prominently figured in many accounts as the "effeminization" of language: " . . . the male poet fills poetic forms with meaning as one pours wine into an amphora, the fake poet becomes obsessed with the meaningless jar itself and, in forgetting its content, comes to embody its empty materiality. Jewish barbarism replaces the well-wrought urn with the undone, castrated body. The synonymy of effeminization and barabarism is not simply redundant, for the description of Jews as effeminization and barbarism is not simply redundant, for the description of Jews as effeminate effectively underscores the universalism of Maurrasian anti-Semitism. Because gender is a difference across all cultures, imagining the Jew as woman rules out any version of anti-Semitism that defines Jewish otherness as cultural difference." McGee, "Dada Da Da," 510. With this in mind, the "seduction" is not only sexual, but linguistic, and actually located in religious, not cultural, difference.

32. Roth, *Call It Sleep*, 344.

33. Hana Wirth-Nesher, *Call it English: The Languages of Jewish American Literature* (Princeton, NJ: Princeton University Press, 2006), 80.

34. Roth, *Call It Sleep*, 220.

35. Ibid., 221.

36. Harold Bloom, *Kabbalah and Criticism* (New York: Seabury, 1975), 74.

37. There are many traditional sources that discuss this *kabbalistic* aspect of Torah. One of the best of these is Nathan T. Lopes Cardozo, *The Torah as God's Mind: A Kabbalistic Look into the Pentateuch* (New York: Bep-Ron Publications, 1988).

38. Roth, *Call It Sleep*, 295.

39. See, for example, Anzia Yezierska, *Bread Givers* (New York: Persia Books, 1925), wherein the heroine Sara Smolinsky, equates her Jewish identity with the filth and squalor of her family's Lower East Side ghetto apartment. One of her first moves as an economically independent "secular" Jew is to find herself a clean, plain space, and clean, plain clothing.

40. Roth, *Call It Sleep*, 93.

41. Ibid., 94.

42. Karen R. Lawrence, "Roth's *Call It Sleep*: Modernism on the Lower East Side," *New Essays on Call It Sleep*, edited by Hana Wirth-Nesher (Cambridge: Cambridge University Press, 1996), 110.

43. Roth, *Call It Sleep*, 93.

44. Ibid., 106.

45. Ibid., 88.

46. This is, at this point, a cultural studies truism. Gregory M. Matoesian writes in *Reproducing Rape: Domination through Talk in the Courtroom* (Cambridge: Polity Press, 1993), 10. "The analysis of ideology is fundamentally concerned with *language*, for language is the principal medium of meaning (signification) which serves to sustain relations of domination." Pierre Bourdieu writes, "Language is not only an instrument of communication or even knowledge, but also an instrument of power. One seeks to be understood but also to be believed, obeyed, respected, distinguished." What this means for the newly American Jew (the man of the book) then, is that he is trapped in a situation where what was once the center of his faith has become the

dangerous center of a power relationship in which he is invariably on the "outside."

47. Roth, *Call It Sleep*, 88.
48. This resonates in debates over objectionable art and photography. Returning to the idea of crosses, Andre Serrano's famous piece "piss Christ" depicts the image of a wooden crucifix that seems to have been photographed through gauze or a dirty lens. In actuality, it is floating in urine. Without examining the aesthetic merit of the photograph or its moral implications, the pragmatic effect of the piece is to only offend *after* the viewer has had the actual composition of the photograph labeled and explained. Wendy Steiner comments: "the Serrano affair makes a distinction between the visual object (Christ on a crucifix) and it's verbal label ("piss Christ"). What does this imply about the moral values of a visual versus a visual system of expression?" Steiner's question about the morality of visual system is salient to the argument I have been making about Roth's text, since it implies that the universality of the visual system evades moral judgment, albeit only in the radically theoretical moment before language enters. See Wendy Steiner, *The Scandal of Pleasure: Art in the Age of Fundamentalism* (Chicago: University of Chicago Press, 1995), 11.
49. Roth, *Call It Sleep*, 402.
50. Ibid., 402.

NOTES TO CHAPTER 2

1. Fisch, *Jerusalem Bible*, Isa 3:16.
2. By most literal level of analysis, I am not implying transparency, but rather a stage of analysis that is infinitely knowable because it is apparent from close examination of the text only, and is, to a certain degree, self-referential. While there are forty-one additional levels of Hebrew scriptural analysis, many of these are dependent upon more complex knowledge, and the higher levels are "in the realm of God" and thus virtually inaccessible to the human intelligence.
3. Geoffrey Hartman, *Criticism in the Wilderness* (New Haven, CT: Yale University Press, 1980), 8.
4. Ibid., 9.
5. Nathanael West, *Miss Lonelyhearts and the Day of the Locust: Two Novels by Nathanael West* (New York: New Directions, 1933), 62.
6. James F. Light, *Nathanael West: An Interpretive Study* (Chicago: Northwestern University Press, 1974), 24. During West's tenure at Brown there was a strong interest in Catholicism among the students, and West occasionally contributed to the bull sessions some of the lore he had accumulated from is considerable reading in the lives of the saints. Like many such readers, he read with skepticism, not so much for spiritual inspiration, but for "the perversities and oddities in the medieval Catholic writers."
7. In the opening pages of the novel, we learn that the protagonist, Tod Hackett, is, despite his appearance, "really a very complicated young man with a whole set of personalities, one inside the other, like a nest of Chinese boxes." West, *Day of the Locust*, 60.
8. Gary Giddins, *Voice Literary Supplement*, March 1982, 187.
9. It serves a certain version of my argument to press the fact that these two authors were of assimilated German-Jewish lineage. In addition to this most obvious biographical similarity, I note for the record that they were also from families for whom the acquisition of linguicity was of paramount importance.

Canetti himself was the master of Ladino, Bulgarian, German, and English. West's aunt and mother were also well versed in several languages. Although a first-generation American, West was nonetheless exposed to the tactical consequences of exile, and also of the inadequacy of acquired language to fully usurp the "mother tongue." When, in *Auto-da-fe*, Fischerle tells Kien that "stipendium comes from French and means exactly the same as 'capital' does in Jewish," Kien swallows in silence but thinks "by their etymology shall ye know them!" Elias Canetti, *Auto-da-fe*, trans. C.V. Wedgewood (New York: Noonday Press, 1947), 180.

10. Nathanael West himself addresses this in his first novel, *The Dream Life of Balso Snell*, "You once said to me that I talk like a man in a book. I not only talk, but think and feel like one. I have spent my life in books; literature has deeply dyed my brain its own color. This literary coloring is a protective one—like the brown of a rabbit or the checks of a quail—making it impossible to tell where literature ends and I begin." See Nathanael West, *Two Novels by Nathanael West: The Dream Life of Balso Snell and A Cool Million* (New York: Noonday Press, 1934), 47.

11. Elias Canetti. *The Torch in My Ear* (New York: Farrar, Straus and Giroux, 1982).

12. Ibid.

13. West, *Locust*, 184.

14. Ibid., 60.

15. The tension between art and prophecy in the Judiac tradition has been investigated with great acuity by Geoffrey Hartman: "The ambivalence surrounding imagination centered on this contrast between its low position in the hierarchy of faculties and its sublime function in prophecy. Prophecy is therefore defined by Maimonides as "the most perfect development" of the imaginative faculty, and includes vision and dream (which the rabbis called the "unripe fruit of prophecy") as its two principal modes. See Geoffrey Hartman, "On the Jewish Imagination" in *The Third Pillar: Essays in Judaic Studies* (Philadelphia: The University of Pennsylvania Press, 2011), 173.

16. I am here referencing the final moments of *The Day of the Locust*, when Homer Simpson is brutally attacked by the mob.

17. Canetti, *Auto-da-fe*, 10.

18. Ibid., 15.

19. This is, obviously, a vast simplification of the complex series of biblical laws that govern traditional Jewish marriage, as well as their cultural manifestations. See *Babylonian Talmud*, Tractate Shevuot 30b, as well as more contemporary sources such as: Avraham Peretz Friedman, *Table for Two: Making a Good Marriage Better* (Jerusalem: Targum Press, 1992); Michael Kaufman, *The Woman in Jewish Law and Tradition* (London: Jason Aronson, 1993); and Lisa Aiken, *To Be A Jewish Woman* (Jerusalem: Jason Aaronson, 1993).

20. Canetti, *Auto-da-fe*, 40–41.

21. Ibid., 36–37.

22. See, for example, Frank Lentricchia's controversial and now classic work on this subject, "Writing After Hours," *Ariel and the Police: Michel Foucault, William James, Wallace Stevens* (Madison: University of Wisconsin Press, 1988).

23. For a more thoroughgoing analysis of this dilemma, see Robert Alter, *Canon and Creativity*.

24. Canetti, *Auto-da-fe*, 175.

25. Ibid., 176.

26. Ibid., 177.
27. Although neither Kien nor Hackett are portrayed as Jews, they nevertheless seem more acculturated to Old Testament justice than the merciful *ethos* of the Gospels. Although this is often presented as a theological dichotomy, the Hebrew God being the God of Justice, and the Christian God one of mercy, in fact Judaism (as Christianity) envisions a Deity that equally possesses the potential for both attributes. Interestingly, this is often imagined in terms of "handedness": with his left hand, God dispenses Justice, with his right hand, Mercy or Compassion. This resonates with West's narrative, wherein Homer Simpson struggles valiantly to control his hands; hands that are capable of compassionate and nurturing acts, but that also, as we find out at novel's end, contain the potential for the violent enactment of retaliatory "justice."
28. Ibid., 178.
29. Ibid., 183.
30. Ibid.
31. Ibid., 18
32. Ibid., 364.
33. West exercises all kinds of anti-Semitic tropes in *The Dream Life of Balso Snell* and *A Cool Million*. The main character, Balso, as he explores the bowels of the horse, sings this inspirational song: "Round as the Anus/Of a Bronze horse/Or the tender Buttons/Used by Horses for Ani . . . Round and Ringing Full/As the Mouth of a Brimming Goblet/The Rust-Laden Holes/In our Lords Feet/Entertain the Jew-Driven Nails." In addition to the obvious invocation of the Christ-killing Jew, he also makes reference to Gertrude Stein, problematic to West for both her Jewishness and her (as Hemingway put it) "emasculating lesbianism."
34. West, *Locust*, 62–63.
35. Ibid., 64.
36. Ibid., 134.
37. Matthew Roberts, "Bonfire of the Avant-Garde: Cultural Rage and Readerly Complicty in *The Day of the Locust*," *Modern Fiction Studies* 42, no. 1 (Spring 1996): 61.
38. Theodor Adorno and Max Horkhiemer, *Dialectic of Enlightenment*, trans. John Cumming (New York: Continuum, 1972), 135.
39. Denis De Rougement articulates this phenomenon in *Love in the Western World*, trans. Montgomery Belgion (New York: Schoken Books, 1990), 66. "But the goal and end of the spirit is also the end of limited life, of physical life obscured by immediate multiplicity. Eros, the object of our supreme Desire, intensifies all our desires only to offer them up as sacrifice. The fulfillment of love is the denial of any particular terrestrial love, and its Bliss of any particular terrestrial bliss. *For the standpoint of life*, it is only this Love which is the absolute woe." De Rougement goes on to explain how such transformative religious desire is the ultimate impetuous for romantic passion and imaginative expression.
40. See Walter Benjamin, "Theses on the Philosophy of History," *Illuminations: Essays and Reflections*, edited by Hannah Arendt (New York: Schocken Books, 1988), 253–267.
41. Many contemporary writers share this ambivalent conception of God. E.L. Doctorow writes of a Deity whose most striking quality is his distance from human event: "Does the average astronomer doing his daily work understand that beyond the celestial phenomena given to his study, the calculations of his radiometry, to say nothing of the obligated awe of his professional life, lies a truth so monumentally horrifying—the ultimate context of our striving, this conclusion of our historical intellects so hideous to contemplate—that even

ones turn to God cannot alleviate the misery of such profound, disastrous, hopeless infinitude? That's my question. In fact if God is involved in this matter, these elemental facts, these apparent concepts, He is so fearsome as to be beyond any human entreaty for our solace, or comfort, or the redemption that would come of our being brought into his secret." E.L. Doctorow, *City of God* (New York: Random House, 2000), 4.

42. Fisch, *The Jerusalem Bible,* Prov 31:10–31.

43. Jay Martin, *Nathanael West: The Art of His Life* (New York: Farrar, Straus and Giroux, 1970), 22.

44. Ibid., 133.

45. Ibid.

46. Susan Edmunds, "Modern Taste and the Body Beautiful in Nathanael West's *The Day of the Locust," Modern Fiction Studies* 44, no. 2 (Summer 1998): 307.

47. West, *Locust,* 68.

48. Ibid., 127.

49. This contains interesting echoes of the anti-Semitic rhetoric of physical cleanness and purity that was very much in circulation at the time the novel was written. West would himself know something about the diseases that could come from Faye's promiscuous behavior, since he contracted gonorrhea during the summer of 1933 and was never entirely cured. Indeed, he suffered from an enlarged prostate gland as a result of his condition and was thrust into deep melancholy as a result. His early experiences in Los Angeles were this very much affected by this sexual "deformity" and it was a significant contributor to his initial perception of the city. See Light, *Nathanael West: An Interpretive Study,* 267.

50. West, *Locust,* 115.

51. In the biblical narrative, it is Sarah's modesty and dignified hospitality that merit her the blessing of a miraculous pregnancy at the age of ninety. Sarah's guests, in an inversion of Faye and Homer's visitors, are angels on their way to visit and assess the corrupt cities of Sodom and Gomorra. In contrast, the motley crew assembled at the Simpson abode appears to be comprised of emissaries from those ancient cities.

52. Ibid., 115.

53. Ibid., 99.

54. Ibid., 140.

55. Ibid., 41.

56. Ibid., 146.

57. Ibid., 147.

58. Ibid., 156.

59. See the discussion of miscegenation and Modernism in Walter Benn Michaels, *Our America.*

60. West, *Locust,* 155.

61. Ibid., 61.

62. This brings the argument back to Hartman, who comments in "Religious Literacy," *Conservative Judaism* 40 (1988), 28, on the relationship between Judaic thought and Jewish art: "Art, both visual and verbal, has transmitted Catholic tradition with an extraordinary power of illustration. There is, however, no Jewish Dante or Tintoretto. Even in the Modern period, when there is a liberation of Jewish thought into forms of art, two matters impede full development. One is a lingering distrust of visual culture—an iconoclastic streak that always—when it comes down to the wire—side with Abraham. The other is simply the continuing power of a tradition that nourishes that streak. Is not the art of Judaism an anti-art, comprised in what Zunz called

'rabbinic literature,' the great line of Biblical commentary through which the tradition flows?" This complex relationship between Judaic tradition and aesthetic visual culture will be addressed more fully in my next chapter.

NOTES TO CHAPTER 3

1. Fisch, *Jerusalem Bible*, Exodus 1:1–2.
2. During his childhood, West was very interested in drawing and sketching, and had hopes of making an occupation in the visual arts. Quentin Reynolds acknowledges that "when West entered Brown he apparently still regarded himself as an artist . . . West was not considered primarily a writer at college . . . there is abundant evidence that he was keenly interested in new modes of art at a time when avant-garde was often no less comic than cartoons and was sometimes separated from them—as in the drawings of Benchly and Picasso—only by a thin line . . . His contemporaries at Brown regarded him as an artist and noticed his drawings. The description of West in his senior yearbook, the *Liber Brunensis* (1924), for instance, declared that "he passes the time in drawing exotic pictures, quoting strange and fanciful poetry, and endeavoring to uplift *Casements*." As West matured, he increasingly focused his attention on writing, rather than drawing, yet even in his writing he manifests a clear attachment to the visual image. His ambivalence regarding the switch from visual to literary art during the years immediately following his graduation has been noted by several of his biographers, and he attempted at several times during his career to reconcile these two passions by, for instance, proposing a book of popularized short biographies of painters. See Jay Martin, *Nathanael West: The Art of His Life* (New York: Farrar, Strauss and Giroux, 1970), and Victor Comerchero, *Nathanael West: The Ironic Prophet* (Syracuse, NY: Syracuse University Press, 1964).
3. For a particularly fine analysis of this tension, see Geoffrey Hartman, "On The Jewish Imagination," *The Third Pillar*, 172.
4. To quote: "In the beginning God created the heaven and the earth. And the earth was without form and void; and darkness was on the face of the deep. And a wind from God moved over the surface of the waters. And God said, Let there be light: and there was light. And God saw the light, that it was good: and God divided the light from the darkness. And God called the light Day, and the darkness he called Night. And there was evening and morning, one day." Interestingly enough, God's act of naming does not so much generate, but clarify and distinguish, the elements of the universe. The act of naming is nonetheless virtually inextricable from the act of creation, since, from the perspective of the Jew, materiality exists so that it can be named, or to put it more bluntly, the world was created by and for the text of the Torah, and not the reverse. Fisch, *Jerusalem Bible*, Gen 1:1.
5. Cynthia Ozick, "Previsions of the Demise of the Dancing Dog," *Art and Ardor* (New York: Alfred P. Knopf, 1983), 278.
6. "And God said, Let us make Mankind in our image, after our likeness: and let them have dominion over the fish of the sea, and over the birds of the air, and over the cattle, and over all the earth, and over every creeping thing that creeps on the earth. So GOD created Mankind in his own image, in the image of God he created him; male and female he created them. Fisch, *Jerusalem Bible*, Gen. 1:37.
7. Derrida, "Question of the Book," 67.
8. It is important to note that the artistic implications of interpretive repetition do not negate the absolute authority of the original text as spoken by God.

Indeed, it is my argument that one of the key functions of the second commandment is to enforce the essentially unique nature of God's word.

9. "Judaism is a religion of time aiming at the sanctification of time. Unlike the space-minded man to whom time is unvaried, iterative, homogeneous, to whom all hours are alike, qualitiless, empty shells, the Bible sense the diversified character of time. There are no two hours alike. Every hour is unique and the only one given at the moment, exclusive and endlessly precious." See Abraham Joshua Heschel, *The Sabbath* (New York: Farrar, Straus and Giroux, 1951), 8.

10. David Abram, *The Spell of the Sensuous* (New York: Vintage, 1996), 243.

11. Cardozo, *Torah as God's Mind*, 13.

12. For a very different, but equally fascinating version of a similar impulse, see Susan Howe, *The Birth-mark: Unsettling the Wilderness in American Literary History* (Hanover, NH: Wesleyan University Press, 1993). In this book, Howe details the significance of the "marginalia" found on the pages of actual manuscripts by Emily Dickinson, Mary Rowlandson, Nathaniel Hawthorne, and others. In so doing, she makes a compelling argument for an "orthodoxy in letters."

13. June Rose, *Modigliani: The Pure Bohemian* (New York: St. Martin's Press, 1991), 120.

14. All images in this chapter are fair-use versions from Wikimedia.

15. Claude Roy, *Modigliani* (New York: Rizzoli International Publications, 1985), 32.

16. Judith Ryan, *The Vanishing Subject: Early Psychology and Literary Modernism* (Chicago: University of Chicago Press, 1991), Chapter 8. Interestingly, Ryan equates Brentano's denial of metaperception, or the idea that we can perceive ourselves perceiving, with Kafka's despair over the problem of finding an "Archimedian point" or transcendent vantage point, from which to move the world.

17. Adin Steinsaltz, "The Imagery Concept in Jewish Thought," *Shefa Quarterly* 1 (1978): 57–58.

18. Peter Benson, "Freud and the Visual," *Representations* 45 (Winter 1994): 103

19. Sigmund Freud, "The Psychopathology of Everyday Life," in *Fragment of an Analysis of a Case of Hysteria, Standard Edition of the Complete Psychological Works*, edited by James Strachey (London: 1953), volume 6.

20. Benson, "Freud and the Visual," 105.

21. Kafka's "minimalist expression" is understood in another way by Chana Kronfeld, who sees it as an articulation of his complicity in the larger tradition of Yiddish culture: "What also needs to be explored is Kafka's possible alignment—not in terms of influence but as historicized intertextual affiliation—with the general project of Yiddish minimalist expressionism whose resistance to the citational model was articulated in the aesthetic principles of *nakete linyes* (naked lines) and *nakete lider* (naked poems)." See Chana Kronfeld, *On the Margins of Modernism: Decentering Literary Dynamics* (Berkeley: University of California Press, 1996), 11–12.

22. The Garsin link to Jewish intellectual tradition included a reputed familial tie to the Jewish apostate philosopher Spinoza. Eugenia's great-grandfather had married one Regina Spinoza, and the family claimed to be descended from the philosopher, although the descent was likely collateral, since Spinoza never married nor was he known to have fathered any children. See Rose, *Modigliani: The Pure Bohemian*, 16.

23. Ibid., 17.

24. One such poem, entitled "Fierce Wish" begins thus: "I wish to proclaim the Kingdom of Force:/To hang a Jew on every tree./To loose from prison every

thug,/To flay every person of virtue." See Rose, *Modigliani: The Pure Bohemian*, 22.

25. Ibid., 24.
26. Roy, *Modigliani*, 83.
27. Rose, *Modigliani: The Pure Bohemian*, 132.
28. See "Freud and the Jewish Joke," in Sander Gilman, *Difference and Pathology: Stereotypes of Sexuality, Race and Madness* (Ithaca, NY: Cornell University Press, 1985), 189–190.
29. Jean Cassou, *The Sources of Modern Art* (London: Thames & Hudson, 1962).
30. See Michael North, *The Dialect of Modernism: Race, Language and Twentieth Century Literature* (Oxford: Oxford University Press, 1994).
31. The similarities between African and Jewish cultural positioning are many and multiform Sander Gilman notes that in late 19th century Vienna "the association of the images of 'blackness' and 'Jewishness' was a test case for the interrelationship of images of difference. The black and the Jew were associated not merely because they were both 'outsiders' but because qualities ascribed to one became the means of defining the difference of the other. The categories of 'black' and 'Jew' thus became interchangeable at one point in history. The line between the two groups vanished, and each became the definition of the other." Gilman, *Difference and Pathology*, 35. Also see Michael Gilroy's excellent discussion of African and Jewish narratives of exile in *The Black Atlantic: Modernity and Double-Consciousness* (Cambridge, MA: Harvard University Press, 1993).
32. North, *The Dialect of Modernism*, 61.
33. Roy, *Modigliani*, 133.
34. Rose, *Modigliani: The Pure Bohemian*, 164.
35. Ibid., 173.
36. Modigliani's friend, the sculptor Chana Orloff, offered this ironic comment when she went to visit Jeanne just hours before her suicide: "She is calm as a statue. Too calm. It frightened me. Jeanne had just come back from a visit to the maternity clinic, but they told her it was too soon and sent her away." Orloff's equation of Jeanne and statue seems chillingly correct in this context; she had long before stiffened herself to the tragic consequences and eventual immortality of art. See Frank S. Wight, "Reflections of Modigliani By Those Who Knew Him" *Italian Quarterly* (Los Angeles: University of California Press, 1958).
37. In Yosef Hayim Yerushalmi's *Freud's Moses: Judaism Terminable and Interminable* (New Haven, CT: Yale University Press, 1991), Chapter 4.
38. The *halackha* here is quite complicated, and, as is usual in the determination of Jewish law, is drawn almost entirely from the text of the Torah itself. In this case, both Rabbi Hirsch and Maimonedes interpret the language of the second commandment as separating the idea of a *likeness* from that of a *carved image*. A *carved image* is a three-dimensional, accurate representation of a thing, while a *likeness* is a symbolic image, which may be sculpted, drawn, or produced in any other way. Since the Hebrew word *psel* (idol) corresponds exactly (within the text of the Torah) to a carved image and not exactly to a likeness, the laws and restrictions regarding the creation of a carved or sculpted three-dimensional image are qualitatively different from those regarding both two-dimensional or concave images.
39. It is likely coincidental, but nonetheless interesting, that Modigliani, although he claimed to love sculpture more than any other art form, never made a name for himself as a sculptor, despite several attempts to do so. In the years 1909–1910, after studying the works of Brancusi with great

interest, he ordered a large piece of sandstone to be placed in his studio. From this one piece of stone, he chiseled numerous caryatids; simple, elegant women with elongated heads and sad, secretive expressions. The sculptures were so remarkable that one of his early buyers, Augustus John, commented on the stone heads: "For some days afterward I found myself under the hallucination of meeting people in the street who might have posed for them . . . Can Modi have discovered a new and secret aspect of reality?" If he had (or perhaps because he had), it appears that he was unable to pursue it through his vexed relationship with carving. In the summer of 1913, while on vacation with his family in Livorno, he appears to have followed the suggestion of his family to throw the sculptures in the moat, since all but a rare few of them totally vanished after 1914. See Jacques Lipcitz, *Amedeo Modigliani* (New York: Harry N. Abrams, 1952). It should be further noted that there is a famous rabbinic ruling regarding the situation of an observant Jew who wished to become a famous artist. As part of his training, he was required to sculpt. He consulted his *Rebbe*, informing him in no uncertain terms that he had no intention of becoming a sculptor, it was just a step along the road to becoming a painter. The Rabbi consulted the law and told him to go ahead and do the sculpting, but be certain to destroy the heads as soon as they were completed, lest they should fall into the wrong hands and be used as idols. See Rabbi Yissocher Frand, audiotape entitled *Yisro-Avodah Zarah: Dolls and Statues* (Baltimore: Yad Yechiel Insitute, 1985).

40. Emmanuel Kant, *Critique of Judgment*, trans. Warner S. Pluhar (Indianapolis, IN: Hackett, 1987), 135

41. G.W.F. Hegel, *Aesthetics: Lectures on Fine Art*, trans. T.M. Knox (Oxford: Clarendon, 1975), I:70.

42. Kalman Bland, *The Artless Jew: Medieval and Modern Affirmations and Denials of the Visual* (Princeton, NJ: Princeton University Press, 2000), 35.

43. Steven S. Schwartzchild, "Aesthetics," *Contemporary Jewish Religious Thought: Original Essays on Critical Concepts, Movements, and Beliefs*, edited by Arthur A. Cohen and Paul Mendes-Flohr (New York: Scribner, 1987), 6.

44. Noel Alexandre, *The Unknown Modigliani* (Paris: Mercatorfonds, 1993), 60.

45. Adolf Hitler "Speech Inaugurating the 'Great Exhibition of Modern Art' in Munich 1937," *Modernism: An Anthology of Sources and Documents*, edited by Vassiliki Kolocotroni (Chicago: University of Chicago Press, 1998), 560.

46. *Babylonian Talmud*, Tractate Tannis 8b.

47. F. Scott Fitzgerald, *The Great Gatsby* (New York: Charles Scribners' Sons, 1925), 25.

NOTES TO CHAPTER 4

1. See Dominick LaCapra. *Representing the Holocaust*. (Ithaca, NY: Cornell University Press, 1994), 188: "the Holocaust is more less the repressed divider or point of rupture between modernism and postmodernism. In this light, the postmodern and the post-Holocaust become mutually intertwined issues that are best addressed in relation to each other."

2. See, for just a few examples, Dominick LaCapra, *History and Memory after Auschwitz* (Ithaca: Cornell University Press, 1998); LaCapra, *Representing the Holocaust*; Giorgio Agamben, *Remnants of Auschwitz* (New York: Zone Press, 2002); Eric Santner, *Stranded Objects: Mourning, Memory and*

Film in Postwar Germany (Ithaca, NY: Cornell University Press, 1990); Raul Hilberg, *The Destruction of the European Jews* (New York: Holmes and Meier, 1985).

3. Art Spiegelman, *Maus II: A Survivor's Tale: And Here My Troubles Begin* (New York: Pantheon, 1991), 70.

4. Arlene Fish Wilner, "'Happy, Happy Ever After': Story and History in Art Spiegelman's *Maus*," *Considering Maus: Approaches to Art Spiegelman's "Survivor's Tale" of the Holocaust,* edited by Deborah R. Geis (Tuscaloosa: University of Alabama Press, 2003), 105. One effect of Art Spiegelman's *Maus* is to provide historical documentation of the Holocaust. Spiegelman's text additionally succeeds in affecting hearts and minds precisely because it is neither "reverential" nor "objective" in the common sense, rather it is—to use a term that Ozick has applied to civilization and which cannot be applied to conventional narratives—"custom built."

5. Ibid., 105–106.

6. Angelika Rauch, "The Broken Vessel of Tradition," *Representations* 53 (Winter 1996): 77.

7. Saul Friedlander, *Nazi Germany and the Jews* (New York: Harper Collins, 1997), as quoted in LaCapra, *History and Memory*, 3–4.

8. LaCapra, *History and Memory*, 3–4.

9. In fact, LaCapra notes the limitations of psychoanalysis as a method for explicating religious phenomenon, and acknowledges the permeability of the boundaries between sacred and secular in this respect: " . . . certain religious practices or discourses might be richer than existing forms of psychoanalysis in the manner in which they address certain problems, including those formulated in psychoanalytic terms as acting-out and working-through. In any case, the notion of secularization should not be taken to justify a reductive and uncritical use of psychoanalysis in attempting to understand or account for religious phenomena." See LaCapra, 184.

10. Art Spiegelman, *Maus I: A Survivor's Tale: My Father Bleeds History* (New York: Pantheon, 1986), 159.

11. See Michel Foucault, "What is An Author?" *The Norton Anthology of History and Criticism,* edited by Vincent B. Leitch (New York: W.W. Norton & Company, 2001), 1622–1636.

12. Spiegelman, *Maus II,* epigraph.

13. Miriam Katan, *We Are on Our Own* (Montreal: Drawn and Quarterly, 2006), 2–3.

14. Charlotte Salomon, "Life? Or Theatre?" (Collection, Jewish Historical Museum Amsterdam [1942] 1998), 192. As quoted in "Painting As Performance: Charlotte Salomon's "Life? Or Theatre?" *The Drama Review* 47, no. 1 (Spring 2003): 97–126.

15. Art Spiegelman, "Art for Art's Sake," interview by J. Stephen Bolhafner, *Comics Journal* 145 (1991), 146.

16. Not all critics read the animal typology as allegorical. For example, Adam Gopnik asserts: "It's extremely important to understand that *Maus* is in no way an animal fable or an allegory like Aesop or *Animal Farm*. The Jews are Jews who just happen to be depicted as mice, in a peculiar, idiosyncratic convention. There isn't any allegorical dimension in *Maus*, just a convention representation." See Adam Gopnick, *The New Republic* 196 (1987), 31.

17. Walter Benjamin, *The Origin of German Tragic Drama,* trans. John Osborne (London and New York: Verso, 1998), 177.

18. Marc Weiner, *Richard Wagner and the Anti-Semitic Imagination* (Lincoln: University of Nebraska Press, 1995), 103–94 as quoted in Daniel T. McGee, "Dada Da Da," 501–527.

19. McGee, "Dada Da Da," 516.
20. T.S. Eliot, *The Complete Poems and Plays: 1909–1950* (New York: Harcourt, Brace & World, 1971), 23.
21. McGee, "Dada Da Da," 517
22. Pnina Rosenberg, "Mickey Mouse in Gurs—Humor, Irony, and Criticism in Works of Art Produced in the Gurs Internment Camp," *Rethinking History* 6, no. 3 (2002): 275.
23. "Gurs," United States Holocaust Memorial Museum Holocaust Encyclopedia, last modified January 6, 2011, accessed March 2011. http://www.ushmm.org/wlc/en/article.php?Moduleid=10005298.
24. See Theodor Adorno, *Negative Dialectics*, trans. E.B. Ashton (New York: Continuum, 1973) for the original theorization of this problematic. For a more detailed structured reading of Adorno's work in relation to Spiegelman's, see Michael Rothberg's excellent article, "We Were Talking Jewish: Art Spiegelman's *Maus* as 'Holocaust' Production," *Considering Maus: Approaches to Art Spiegelman's "Survivor's Tale" of the Holocaust,* edited by Deborah R. Geis (Tuscaloosa: University of Alabama Press, 2003), 137–158.
25. Deborah R. Geis, introduction to *Considering Maus: Approaches to Art Spiegelmans's "Survivor's Tale" of the Holocaust* (Tuscaloosa: University of Alabama Press, 2003), 1.
26. Stephen Lipman, *Laughter in Hell: The Use of Humour during the Holocaust* (North Wale, NJ: Jason Aronson, 1991), 161.
27. See Esther Leslie, *Hollywood Flatlands: Animation, Critical Theory and the Avant-Garde* (London: Verso, 2002), 81.
28. Ibid.
29. Jesse Green, "Building a Better Mouse," *New York Times*, April 18, 2004.
30. When asked (in 2004) how he would renovate Mickey for current times, Art Spiegelman replied: "Make him gay. He's half way there anyway. Keep the voice the same as it's been; beyond having him take a passionate interest in Broadway musicals and occasionally wearing pink shirts, you don't have to do much. You can just change the world around him. As quoted in Green, "Building a Better Mouse."
31. Leslie, *Hollywood Flatlands*, 81.
32. Ibid.
33. Walter Benjamin, *Selected Writings, Volume II: 1927–1934* (Cambridge, MA and London: The Belknap Press of Harvard University), 213
34. Walter Benjamin, *Gesammelte Schriften* 7 vols, edited by Rolf Tiedemann and Herman Schweppenhauser (Frankfurt am Main: Suhrkamp Verlag, 1972–1989), Vol. II.I., 354, as quoted by Esther Leslie in *Hollywood Flatlands*, 82.
35. True enough, however, it is worth mentioning that one of the first "texts" of surrealism is a graphic novel/collage. Max Ernst's *Une Semaine de Bonte* depicts circumstances nearly as absurd as the regular routine at camps like Gurs. Max Ernst *Une Semaine de Bonté: A Surrealist Novel in Collage* (New York: Dover Publications, 1976).
36. Walter Benjamin, "Franz Kafka: On the Tenth Anniversary of his Death" in *Illuminations: Essays and Reflections*, edited by Hannah Arendt (New York: Schocken Books, 1968), 132.
37. Esther Leslie, Hollywood Flatlands, 83.
38. Horst Rosenthal, *Mickey Mouse in the Gurs Internment Camp,* 1942, Archives of the Memorial de la Shoah, Paris.
39. Art Spiegelman, "Saying Goodbye to *Maus,*" *Tikkun* (Sept.–Oct. 1992): 44–45.

40. Ariel Dorfman and Armand Matterlart, *How to Read Donald Duck: Imperialist Ideology in the Disney Comic*, trans. David Kunzle. (New York: International General, 1975), 34–36.
41. Rosenthal, *Mickey Mouse in Gurs*, 1.
42. Ibid, 1.
43. Ibid.
44. Anthony Lane, "Wonderful World," *New Yorker* (December 11, 2006): 36.
45. Spiegelman, *Maus II*, 11.
46. Ibid., 12.
47. Spiegelman, *Maus I*, 136.
48. Michaels, *The Shape of the Signifier*, 131.
49. *Maus II*, 90
50. Ibid., 45.
51. See, for the most famous and insightful example, Primo Levi's *Survival in Auschwitz* (New York: Classic House Books, 2008).
52. See Giorgio Agamben, *Remnants of Auschwitz.*
53. Wilner, "Happy, Happy Ever After," 115
54. Rosenberg, "Humor, Irony, and Criticism," 278.
55. Ibid.
56. LaCapra, *History and Memory*, 177.
57. Angelika Rauch, "The Broken Vessel of Tradition," *Representations* 53 (Winter 1996): 75.
58. Rosenthal, *Mickey in Gurs.*
59. Leon Bancal, "Of a Mouse and Friends, and Passage from Cell to Liberty," *International Herald Tribune*, September 7, 1994.
60. Ibid.
61. Ibid.
62. Shoshana Felman and Dori Laub, *Testimony: Crises of Witnessing in Literature, Psychoanalysis and History* (New York and London: Routledge, 1992), 232.

Bibliography

Abram, David. *The Spell of the Sensuous*. New York: Vintage, 1996.

Adorno, Theodor. *Negative Dialectics*. Translated by E.B. Ashton. New York: Continuum, 1973.

Adorno, Theodor and Max Horkheimer. *Dialectic of Enlightenment*. Translated by John Cumming. New York: Continuum, 1972.

Agamben, Giorgio. *Remnants of Auschwitz*. New York: Zone Press, 2002.

Aiken, Lisa. *To Be a Jewish Woman*. Jerusalem: Jason Aronson, 1993.

Alter, Robert. "Awakenings: Review of Henry Roth, *Shifting Landscape* and *Call It Sleep*." *The New Republic* 984, no. 4 (January 25, 1988): 33–37.

Alter, Robert. *Canon and Creativity: Modern Writing and the Authority of Scripture*. New Haven, CT: Yale University Press, 2000.

Alexandre, Noel. *The Unknown Modigliani*. Paris: Mercatorfonds, 1993.

Artscroll Chumash. Brooklyn, NY: Mesorah Publications, 1996.

Artscroll Siddur. Brooklyn, NY: Mesorah Publications, 1990.

Babylonian Talmud. Brooklyn, NY: Mesorah Publications, 1994.

Bancal, Leon. "Of a Mouse and Friends, and Passage from Cell to Liberty." *International Herald Tribune,* September 7, 1994.

Baskett, Sam S. "An Image to Dance Around: Brett and her Lovers in *The Sun Also Rises*." *The Centennial Review* 22 (Winter 1978): 93–105.

Benjamin, Jessica. *The Bonds of Love: Psychoanalysis, Feminism, and the Problem of Domination*. New York: Pantheon Books, 1988.

Benjamin, Walter. "Franz Kafka: On the Tenth Anniversary of his Death," in *Illuminations: Essays and Reflections*. Edited by Hannah Ardent. New York: Schocken Books, 1988, 111–145.

———. *The Origin of German Tragic Drama*. Translated by John Osborne. London and New York: Verso, 1998.

———. "Theses on the Philosophy of History," in *Illuminations: Essays and Reflections. Edited by* Hannah Arendt. New York: Schocken Books, 1988.

———. *Selected Writings, Volume II: 1927–1934*. Cambridge, MA and London: The Belknap Press of Harvard University Press, 1999.

Benson, Peter. "Freud and the Visual." *Representations* 45 (Winter 1994): 100–117.

Berkovitch, Sacvan. *The Rites of Assent: Transformations in the Symbolic Construction of America*. New York: Routledge, 1993.

Berlatsky, Eric L. *The Real, the True, and the Told: Postmodern Historical Narrative and the Ethics of Repression*. Columbus: Ohio State University Press, 2011.

Bland, Kalman. *The Artless Jew: Medieval and Modern Affirmations and Denials of the Visual*. Princeton, NJ: Princeton University Press, 2000.

Bloom, Harold. *The American Religion: The Emergence of the Post-Christian Nation.* New York: Simon and Schuster, 1992.

———. *The Anxiety of Influence.* New York: Oxford University Press, 1997.

———. *Kabbalah and Criticism.* New York: Seabury, 1975.

Bloom, Steven G. *Postville: A Clash of Cultures in Contemporary America.* New York: Harcourt, 2000.

Boyarin, Jonathan. *Storm from Paradise: The Politics of Jewish Memory.* Minneapolis: University of Minnesota Press, 1992.

Boyarin, Jonathan. *Thinking in Jewish.* Chicago: University of Chicago Press, 1996.

Bradbury, Malcolm. *The Modern American Novel.* New York: Penguin Books, 1992.

Bruccoli, Matthew. *Correspondence of F. Scott Fitzgerald.* New York: Random House, 1980.

Canetti, Elias. *Auto-da-fe.* Translated by C.V. Wedgewood. New York: Noonday Press, 1947.

———. *The Torch in My Ear.* New York: Farrar, Straus and Giroux, 1982.

Cardozo, Nathan T. Lopes. *The Torah as God's Mind: A Kabbalistic Look into the Pentateuch.* New York: Bep-Ron Publications, 1988.

Cassou, Jean. *The Sources of Modern Art.* London: Thames & Hudson, 1962.

Chabon, Michael. *The Amazing Adventures of Kavalier and Clay.* New York: Random House, 2000.

Comerchero, Victor. *Nathaniel West: The Ironic Prophet.* Syracuse, NY: Syracuse University Press, 1964.

Davison, Neil R. *James Joyce, Ulysses, and the Construction of Jewish Identity: Culture, Biography and "the Jew" in Modernist Europe.* Cambridge: Cambridge University Press, 1996.

De Rougemont, Denis. *Love in the Western World.* Translated by Montgomery Belgion. New York: Schoken Books, 1990.

Deleuze, Giles and Feliz Guttari. *Anti-Oedipus: Capitalism and Schizophrenia.* Minneapolis: University of Minnesota Press, 1983.

Derrida, Jacques. *Limited, Inc.* Chicago: Northwestern University Press, 1988.

———. *Writing and Difference.* Chicago: University of Chicago Press, 1978.

Doctorow, E.L. *The Book of Daniel.* New York: Vintage, 1971.

———. *City of God.* New York: Random House, 2000.

Dorfman, Ariel and Armand Mattelart. *How to Read Donald Duck: Imperialist Ideology in the Disney Comic* Translated by David Kunzle. New York: International General, 1975.

Eagleton, Terry. *The Ideology of the Aesthetic.* Oxford: Blackwell, 1990.

Edmunds, Susan. "Modern Taste and the Body Beautiful in Nathanael West's *The Day of the Locust.*" *Modern Fiction Studies* 44 (Summer 1998): 306–329.

Eliot, T.S. "Tradition and the Individual Talent," in *Norton Anthology of Theory and Criticism.* Edited by Vincent B. Leitch. New York: W.W. Norton & Company, 2001, 955–961.

———. *The Complete Poems and Plays: 1909–1950.* New York: Harcourt, Brace & World, 1971.

———. *The Waste Land and Other Poems.* New York: Harcourt, Brace, Jovanovich, 1930.

Ernst, Max. *Une Semaine de Bonté: A Surrealist Novel in Collage.* New York: Dover Publications, 1976.

Felman, Shoshana and Dori Laub. *Testimony: Crises of Witnessing in Literature, Psychoanalysis and History.* New York and London: Routledge, 1992.

Ferraro, Thomas J. *Ethnic Passages: Literary Immigrants in Twentieth-Century America.* Chicago: University of Chicago Press, 1993.

Fiedler, Leslie. *Love and Death in the American Novel.* New York: Anchor Books, 1966.

Fisch, Harold. *The Jerusalem Bible.* Jerusalem: Koren Publishers, 1992.

Fishkin, Shelley Fisher and Jeffrey Rubin Dorsky. *People of the Book: Thirty Jewish Scholars Reflect on their Jewish Identity.* Madison: University of Wisconsin Press, 1996.

Fitzgerald, F. Scott. *The Beautiful and the Damned.* New York: Charles Scribner's Sons, 1922.

———. *The Great Gatsby.* New York: Charles Scribner's Sons, 1925.

———. *Tender is the Night.* New York: Charles Scribner's Sons, 1933

———. *This Side of Paradise.* New York: Charles Scribner's Sons, 1920.

Friedman, Avraham Peretz. *Table for Two: Making a Good Marriage Better.* Jerusalem: Targum Press, 1922.

Foucault, Michel. *The History of Sexuality: An Introduction.* Translated by Robert Hurley. New York: Random House, 1978.

———. "What is an Author?" in *The Norton Anthology of History and Criticism.* Edited by Vincent B. Leitch, 1622–1636. New York: W.W. Norton & Company, 2001.

Franchot, Jenny. *Roads to Rome: The Antebellum Protestant Encounter with Catholicism.* Berkeley: University of California Press, 1994.

Frand, Yissocher. *Yisro-Avodah Zarah: Dolls and Statues.* Baltimore, MD: Yad Yechiel Institute, 1985. Audiocassette.

Frederic, Harold. *The Damnation of Theron Ware or Illumination.* New York: Penguin Books, 1986.

Freedman, Jonathan. *The Temple of Culture: Assimilation and Anti-Semitism in Literary Anglo-America.* Oxford: Oxford University Press, 2000.

Freud, Sigmund. *Dora: An Analysis of a Case of Hysteria.* Edited by Philip Rieff. New York: McMillan, 1963.

———. *The Interpretation of Dreams.* New York: Avon, 1953.

———. *Introductory Lectures on Psychoanalysis.* New York: W.W. Norton and Company, 1966.

———. *Moses and Monotheism.* New York: Vintage, 1939.

———. "The Psychopathology of Everyday Life," in *Fragment of an Analysis of a Case of Hysteria, Standard Edition of the Complete Psychological Works.* Edited by James Strachey. London: The Hogarth Press, 1953. Volume 6.

Friedlander, Saul. *Nazi Germany and the Jews.* New York: Harper Collins, 1997.

Geis, Deborah. Introduction to *Considering Maus: Approaches to Art Spieglemans's "Survivor's Tale" of the Holocaust.* Tuscaloosa: University of Alabama Press, 2003.

Giddins, Gary. *Voice Literary Supplement*, March 1982, 187.

Gilman, Sander L. *Difference and Pathology: Stereotypes of Sexuality, Race and Madness.* Ithaca, NY: Cornell University Press, 1985.

———. *Jewish Self-Hatred: Anti-Semitism and the Hidden Language of the Jews.* Baltimore, MD: Johns Hopkins University Press, 1986.

Giles, Paul. *American Catholic Arts and Fictions: Culture, Ideology Aesthetics.* Cambridge: Cambridge University Press, 1992.

Gilroy, Paul. *The Black Atlantic: Modernity and Double-Consciousness.* Cambridge, MA: Harvard University Press, 1993.

Girard, Rene. *Violence and the Sacred.* Baltimore, MD: Johns Hopkins University Press, 1972.

Gopnick, Adam. "Title of Article." The New Republic 196 (1987)0

Green, Jesse. "Building a Better Mouse." *New York Times,* April 18, 2004.

Grimes, Larry E. *The Religious Design of Hemingway's Fiction.* Ann Arbor: University of Michigan Press, 1974.

Jabès, Edmond. *Le Livre des Questions*. Paris: Gallimard, 1963.

Joyce, James. *Ulysses*. New York: Vintage, 1961.

Halsey, William M. *The Survival of American Innocence*. Notre Dame, IN: University of Notre Dame Press, 1980.

Handelman, Susan. *The Slayers of Moses: The Emergence of Rabbinic Interpretation in Modern Literary Theory*. Albany: State University of New York Press, 1982.

Hartman, Geoffrey. *Criticism in the Wilderness*. New Haven, CT: Yale University Press, 1980.

———. "Religious Literacy." *Conservative Judaism* 40 (1988): 21–31.

———. *The Third Pillar: Essays in Judaic Studies*. Philadelphia: University of Pennsylvania Press, 2011.

Hauerwas, Stanley. *The Peaceable Kingdom*. Notre Dame, IN: University of Notre Dame Press, 1983.

Hawthorne, Nathaniel. *The Scarlet Letter*. New York: Bantam Books, 1965.

Hegel. G.W.F. *Aesthetics: Lectures of Fine Art*. Translated by T.M. Knox. Oxford: Clarendon, 1975.

Hemingway, Ernest. *Death in the Afternoon*. New York: Charles Scribner's Sons, 1932.

———. *A Farewell to Arms*. New York: Charles Scribner's Sons, 1964.

———. *For Whom the Bell Tolls*. New York: Charles Scribner's Sons, 1940.

———. *The Garden of Eden*. New York: Collier Fiction, 1986.

———. *A Moveable Feast*. New York: Charles Scribner's Sons, 1964.

———. *The Sun Also Rises*. New York: Charles Scribner's Sons, 1926.

Heschel, Abraham Joshua. *God in Search of Man: A Philosophy of Judaism*. New York: Farrar, Straus and Giroux, 1955.

———. *The Sabbath*. New York: Farrar, Straus and Giroux, 1951.

Hilberg, Raul. *The Destruction of the European Jews*. New York: Holmes and Meier, 1985.

Hitler, Adolf. "Speech Inaugurating the 'Great Exhibition of Modern Art' in Munich 1937," in *Modernism: An Anthology of Sources and Documents*. Edited by Vassiliki Kolocotroni. Chicago: University of Chicago Press, 1998, 560–3.

Hoffman, Ferderick J. *The Twenties: American Writing in the Postwar Decade*. New York: Viking Press, 1949.

Howe, Susan. *The Birth-mark: Unsettling the Wilderness of American Literary History*. Hanover, NH: University Press of New England, 1993.

Husserl, Edmund. *Shorter Works*. Brighton, England: Harvester Press, 1981.

Kant, Emmanuel. *Critique of Judgment*. Translated by Warner S. Pluhar. Indianapolis, IN: Hackett, 1987.

Katan, Miriam. *We are on Our Own*. Montreal: Drawn and Quarterly, 2006.

Kaufman, Michael. *The Woman in Jewish Law and Tradition*. London: Jason Aronson, 1993.

Kazin, Alfred. *On Native Grounds: An Interpretation of Modern Prose Literature*. New York: Harcourt Brace and Company, 1942.

Kenner, Hugh. *A Homemade World: The American Modernist Writers*. Baltimore, MD: Johns Hopkins University Press, 1975.

Kort, Wesley. *Bound To Differ: The Dynamics of Theological Discourses*. University Park: The Pennsylvania University Press, 1992.

Kristeva, Julia. *In the Beginning Was Love: Psychoanalysis and Faith*. Translated by Arthur Goldhammer. New York: Columbia University Press, 1987.

Kronfeld, Chana. *On The Margins of Modernism: Decentering Literary Dynamics*. Berkeley: University of California Press, 1996.

LaCapra, Dominick. *History and Memory after Auschwitz*. Ithaca, NY: Cornell University Press, 1998.

———. *Representing the Holocaust*. Ithaca, NY: Cornell University Press, 1994.

Lane, Anthony. "Wonderful World." *New Yorker* (December 11, 2006).

Lawrence, Karen R. "Roth's *Call it Sleep*: Modernism on the Lower East Side," *New Essays on Call It Sleep*. Edited by Hana Wirth-Nesher. Cambridge: Cambridge University Press, 1996.

Lears, T.J. Jackson. *No Place of Grace: Antimodernism and the Transformation of American Culture, 1880–1920*. Chicago: University of Chicago Press, 1981.

Lentricchia, Frank. *After the New Criticism*. Chicago: University of Chicago Press, 1980.

———. *The Edge of Night*. New York: Random House, 1994.

———. *Modernist Quartet*. Cambridge: Cambridge University Press, 1994.

———. "Writing After Hours," in *Ariel and the Police: Michel Foucault, William James, Wallace Stevens*. Madison: University of Wisconsin Press, 1988.

Leslie, Esther. *Hollywood Flatlands: Animation, Critical Theory and the Avant-Garde*. London: Verso, 2002.

Levi, Primo. *Survival in Auschwitz*. New York: Classic House Books, 2008.

Light, James F. *Nathanael West: An Interpretive Study*. Chicago: Northwestern University Press, 1967.

Linnett, Maren. "Introduction: Modernism's Jews/Jewish Modernism." *Modern Fiction Studies* 51, no.1 (Summer 2005): 249–257.

———. "The Jew's Text: 'Shem the Penman' and 'Shaun the Post,'" *James Joyce Quarterly* 45, no. 2 (Winter 2008): 263–280.

Lipcitz, Jacques. *Amedeo Modigliani*. New York: Harry N. Abrams, 1952.

Lipman, Stephen. *Laughter in Hell: The Use of Humour during the Holocaust*. North Wale, NJ: Jason Aronson, 1991.

Mallarme, Stephane. *Selected Prose, Poems, Essays, and Letters*. Translated by Bradford Cook. Baltimore, MD: Johns Hopkins University Press, 1956.

Martin, Jay. *Nathanael West: The Art of His Life*. New York: Farrar, Straus and Giroux, 1970.

Matoesian, Gregory M. *Reproducing Rape: Domination Through Talk in the Courtroom*. Cambridge: Polity Press, 1993.

McGee, Daniel T. "Dada da da: Sounding the Jew in Modernism," *English Literary History* 68, no. 2 (Summer 2001): 501–527.

McHale, Brian. "Henry Roth in Nighttown, or Containing Ulysses," in *New Essays on Call It Sleep*. Edited by Hana Wirth-Nesher, 75–105. Cambridge: Cambridge University Press, 1996.

Meeks, Wayne A., ed. *The Harper Collins Study Bible*. New York: Harper Collins, 1989.

Meyers, Jeffrey. *Hemingway: A Biography*. New York: Harper and Row, 1985.

Michaels, Walter Benn. *Our America: Nativism, Modernism, and Pluralism*. Durham, NC: Duke University Press, 1995.

———. *The Shape of the Signifier: 1967 to the End of History*. Princeton, NJ: Princeton University Press, 2006.

Moreland, Kim. *The Medievalist Impulse in American Literature*. Charlottesville: University Press of Virginia, 1996.

Morey, Anne Janine. *Religion and Sexuality in American Literature*. Cambridge: Cambridge University Press, 1992.

Nietzsche, Friedrich. *Beyond Good and Evil*. Translated by R.J. Hollingdale. New York: Penguin Books, 1973.

North, Michael. *The Dialect of Modernism: Race, Language and Twentieth Century Literature*. Oxford: Oxford University Press, 1994.

Ozick, Cynthia. *Art and Ardor.* New York: Alfred P. Knopf, 1983.

———. *Bloodshed and 3 Novellas.* New York: New American Library, 1977.

Rauch, Angelika. "The Broken Vessel of Tradition." *Representations* 53 (Winter 1996):

Reid, Randall. *The Fiction of Nathanael West: No Redeemer, No Promised Land.* Chicago: University of Chicago Press, 1967.

Riddel, Joseph N. *The Turning Word: American Literary Modernism and Continental Theory.* Philadelphia: University of Pennsylvania Press, 1966.

Roberts, Matthew. "Bonfire of the Avant-Garde: Cultural Rage and Readerly Complicity in *The Day of the Locust.*" *Modern Fiction Studies* 42 (1996): 60–73.

Rose, June. *Modigliani: The Pure Bohemian.* New York: St. Martin's Press, 1991.

Rosenberg, Pnina. "Mickey Mouse in Gurs—Humor, Irony, and Criticism in Works of Art Produced in the Gurs Internment Camp." *Rethinking History* 6, no. 3 (2002): 273–292

Rosenthol, Horst. *Mickey Mouse in the Gurs Internment Camp.* 1942, Archives of the Memorial de la Shoah, Paris.

Roth, Henry. *Call it Sleep.* New York: Farrar, Straus and Giroux, 1934.

———. *Mercy of A Rude Stream: Volume 1: A Star Shines Over Mt. Morris Park.* New York: St. Martin's Press, 1994.

Rothberg, Michael. "We Were Talking Jewish: Art Spiegelman's *Maus* as 'Holocaust' Production," in *Considering Maus: Approaches to Art Spiegelman's "Survivor's Tale" of the Holocaust.* Edited by Deborah R. Geis, 137–158. Tuscaloosa: University of Alabama Press, 2003.

Roy, Claude. *Modigliani.* New York: Rizzoli International Publications, 1985.

Rubin, William, ed. *Pablo Picasso: A Retrospective.* Boston: New York Graphic Society, 1980.

Rudat, Wolfgang. *A Rotten Way to be Wounded: The Tragicomedy of The Sun Also Rises.* New York: P. Lang, 1990.

Ryan, Judith. *The Vanishing Subject: Early Psychology and Literary Modernism.* Chicago: University of Chicago Press, 1991.

Salomon, Charlotte. "Live? Or Theatre?" Collection, Jewish Historical Museum Amsterdam, 1942; 1998.

Santner, Eric. *Stranded Objects: Mourning, Memory and Film in Postwar Germany.* Ithaca, NY: Cornell University Press, 1990.

Scholem, Gershom. *Major Trends in Jewish Mysticism.* New York: Shoken Books, 1961.

Schwartzchild, Steven S. "Aesthetics," in *Contemporary Jewish Religious Thought: Original Essays on Critical Concepts, Movements, and Beliefs.* Edited by Arthur A. Cohen and Paul Mendes-Flohr, 6. New York: Scribner, 1987.

Seidman, Naomi. "The Secret Language of the Jews: A Midrash on Mistranslation." *Pakn Treger* (Fall 1998): 19.

Slezkine, Yuri. *The Jewish Century.* Princeton, NJ: Princeton University Press, 2004.

Sollars, Werner. *Beyond Ethnicity: Consent and Descent in American Culture.* Oxford: Oxford University Press, 1987.

Spiegelman, Art. "Art for Art's Sake." Interview by J. Stephen Bolhafner. *Comics Journal* 145 (1991): 146.

———. *Maus I: A Survivor's Tale: My Father Bleeds History.* New York: Pantheon, 1986.

———. *Maus II: A Survivor's Tale: And Here My Troubles Begin.* New York: Pantheon, 1991.

———. "Saying Goodbye to *Maus.*" *Tikkun,* September–October 1992: 44–45.

Steiner, Wendy. *The Scandal of Pleasure: Art in an Age of Fundamentalism.* Chicago: University of Chicago Press, 1995.

Steinsaltz, Adin. "The Imagery Concept in Jewish Thought." *Shefa Quarterly* 1 (1978): 57–58.

———. *The Sustaining Utterance*. Translated by Yehuda Hanegbi. London: Jason Aronson, 1974.

Stoddard, Lothrop. *The Rising Tide of Color*. New York: Charles Scribner's Sons, 1922.

Taylor, Charles. *Human Agency and Language*. New York: Cambridge University Press, 1985.

Taylor, Dennis. "The Need for A Religious Literary Criticism." *Religion and the Arts* 1, no. 1 (Fall 1996): 124–150.

Torgovnick, Marianna. *Primitive Passions: Men, Women, and the Quest for Ecstasy*. New York: Knopf, 1997.

Twombly, Robert. *Frank Lloyd Wright*. New York: Harper and Row, 1973.

United State Holocaust Memorial Museum Holocaust Encyclopedia. "Gurs." Last modified January 6, 2011, accessed March 2011. http://www.ushmm.org/wlc/en/article.php?Moduleid=10005298.

Weiner, Marc. *Richard Wagner and the Anti-Semitic Imagination*. Lincoln: University of Nebraska Press, 1995.

West, Nathanael. *Miss Lonelyhearts and The Day of the Locust*. New York: New Directions, 1933.

———. *Two Novels by Nathanael West: The Dream Life of Balso Snell and A Cool Million*. New York: Noonday Press, 1934.

Williams, Raymond. *The Politics of Modernism: Against the New Conformists*. London: Verso, 1989.

Wilner, Arlene Fish. "'Happy, Happy Ever After': Story and History in Art Spiegelman's *Maus*," in *Considering Maus: Approaches to Art Spiegelman's "Survivor's Tale" of the Holocaust*, edited by Deborah R. Geis, 105–121 Tuscaloosa: University of Alabama Press, 2003

Wirth-Nesher, Hana. *Call it English: The Languages of Jewish American Literature*. Princeton, NJ: Princeton University Press, 2006.

———, ed. *New Essays on Call It Sleep*. Cambridge: Cambridge University Press, 1996.

Wight, Frank S. "Reflections of Modigliani By Those Who Knew Him." *Italian Quarterly* (Los Angeles: University of California Press, 1958).

Yerushalmi, Yosef Hayim. *Freud's Moses: Judaism Terminable and Interminable*. New Haven, CT: Yale University Press, 1991.

Yezierska, Aniza. *Bread Givers*. New York: Persia Books, 1925.

Ziff, Larner. "The Social Basis of Hemingway's Style," in *Ernest Hemingway: Six Decades of Literary Criticism*. Edited by Linda W. Wagner. East Lansing: Michigan State University Press, 1987.

Index